FORGED

FORGED

Why Fakes Are the Great Art of Our Age

Jonathon Keats

OXFORD
UNIVERSITY PRESS

OXFORD
UNIVERSITY PRESS

Oxford University Press is a department of the University of
Oxford. It furthers the University's objective of excellence in
research, scholarship, and education by publishing worldwide.

Oxford New York
Auckland Cape Town Dar es Salaam Hong Kong Karachi
Kuala Lumpur Madrid Melbourne Mexico City Nairobi
New Delhi Shanghai Taipei Toronto

With offices in
Argentina Austria Brazil Chile Czech Republic France Greece
Guatemala Hungary Italy Japan Poland Portugal Singapore
South Korea Switzerland Thailand Turkey Ukraine Vietnam

Published in the United States of America by
Oxford University Press
198 Madison Avenue, New York, NY 10016

www.oup.com

Oxford is a registered trade mark of
Oxford University Press in the UK and
certain other countries.

Library of Congress Cataloging-in-Publication Data
Keats, Jonathon.
Forged: why fakes are the great art of our age / Jonathon Keats.
p. cm
Includes bibliographical references and index.
ISBN 978-0-19-992835-4 (hardcover : alk. paper)
1. Art Forgeries. 2. Art and society. I. Title.
N8790.K43 2013
702.8'74—dc23 2012014451

 3 5 7 9 8 6 4 2

Printed in the United States of America
on acid-free paper

For Silvia. Sempre tanto.

CONTENTS

PART ONE
THE ART OF FORGERY

PART TWO
SIX MODERN MASTERS

CONTENTS

PART THREE
FORGING A NEW ART

THE ART OF FORGERY

I.

For most of the 19th century, the citizens of Naples and Florence quibbled over who owned Raphael's portrait of Pope Leo X. Both cities proudly displayed the painting. Neither could prove that the other's was a fake.

The confusion was as old as the Renaissance. Five years after Raphael completed the portrait in 1519, and three years after Leo died, Federico II Gonzaga, Marquis of Mantua, saw the picture while visiting Leo's Medici relatives in Florence. Federico praised it highly, hinting strongly that it would make a fine gift. Finally he asked for it outright when he met the new pope. The pontiff graciously interceded on his behalf.

Since the pope was infallible, the Medici patriarch Ottaviano couldn't ignore his request. Instead, he begged some time to have the portrait suitably framed and brought it to the studio of Andrea del Sarto.

Andrea was no frame maker. In the estimation of the Renaissance biographer Giorgio Vasari, he was an artist "in whose single person

nature and art demonstrated all that painting can achieve by means of draughtsmanship, coloring, and invention." In other words, he was just the man to duplicate Raphael's painting so that Ottaviano could retain the cherished original for his own collection.

On an identical wooden panel, Andrea meticulously brushed in the figures of Leo and two of his cardinals, which in Vasari's phrasing appeared "to be not painted, but in full relief."[1] Andrea imitated "the pile of the velvet, with the damask of the Pope's vestments shining and rustling, the fur of the linings soft and natural, and the gold and silk so counterfeited that they do not seem to be in color, but real." An intimate of Ottaviano's household (and former apprentice to Andrea), Vasari witnessed the whole act. He records that Andrea even copied some stains on the picture's surface.

Such precautions were prudent, not so much because Federico was a connoisseur as because he was the patron of Giulio Romano, a former student of Raphael who had worked on Leo's portrait in Raphael's studio. The marquis esteemed Giulio's judgment and eagerly showed him Ottaviano's present as soon as it arrived. Giulio was convinced he could perceive his own brushstrokes.

And no one would have been the wiser had not Vasari himself come to Mantua.[2] Touring the marquis's collection, and seeing how convinced Giulio was by Andrea's ersatz Raphael, Vasari couldn't help but tell the truth. Giulio reacted as Vasari knew he would, echoing his own point of view. "I value it no less than if it were by the hand of Raffaello," said Giulio, "nay, even more, for it is something out of the course of nature that a man of excellence

1. One of the two cardinals happened to be Giulio di Giuliano de' Medici, the current pope Clement VII who decreed that Ottaviano give the painting to the marquis. Like arts patronage, the papacy was a Medici family business.

2. Raphael, the only other man who might have been able to detect the deceit, had died in 1520.

should imitate the manner of another so well, and should make a copy so like. It is enough that it should be known that Andrea's genius was as valiant in double harness as in single." Equally impressed, the marquis was no less pleased.

Values shifted over the ensuing centuries. While Andrea del Sarto was still venerated in the 1800s—ranking just a tier below Raphael and Michelangelo—skill was no longer valued as highly as authenticity. Whether the Pope's damask looked realistic was secondary to whether Raphael had painted it. Experts made a living assessing and documenting provenance. Eventually, Naples was humbled by scholarly consensus that Florence held the original portrait.

By the mid-20th century, the distinction between original and copy was brutally absolute. "Ottaviano de' Medici defrauded a fellow nobleman, and Andrea del Sarto received payment for a forgery," wrote the connoisseur Frank Arnau in *The Art of the Faker*, a 1961 collector's handbook written specifically to rout out forgers. "This accomplished imitator's motives for his course of action were just as unwarrantable as those of the man who commissioned him."

Emblematic of radical changes in how forgery is perceived, Arnau's criminalization of Andrea and Ottaviano exposes the difficulty of appreciating how people thought of fraud in other times and places. The meaning of forgery was as different in the Renaissance—and as foreign to contemporary culture—as the 16th-century meaning of art. In fact, forgery and art are deeply interrelated. They reflect the same societal interests, and they have always evolved together. The modern Western response to forgery is anxiety. The mood of modern Western art is anxious.[3] This is not a coincidence or an irony of modern life. Art and forgery

3. The scope of this book is Western, not because Eastern art is less significant, but because art and forgery in Asia historically belong to a separate tradition.

are two sides of the same conversation. And what they can tell one another is potentially profound.

Of course, every successful forger pays keen attention to art, not only the chemistry of technique but also the psychology of appreciation. These are the raw materials of deception. But artists and curators and collectors and viewers are attentive to forgery only as a matter of forensics. The perspective of former Metropolitan Museum of Art director and self-appointed "fake-buster" Thomas Hoving is typical. "I have to know the true condition of everything I come across," he wrote in his 1996 book, *False Impressions*. "I have to know that they are real." Despite his background as an art historian and his skill as a connoisseur, his concern with forgery solely as a felony is as simplistic as the position taken by Guy Isnard, who pioneered police investigation of art fraud in 1950s Paris. Isnard's stated purpose was to "fight the parasites who disfigure and misappropriate the contributions of authentic artists to beauty," as he explained in his 1974 memoir, *Vrai ou Faux—True or False*—the very title of which lays down the cop's rigid mind-set.

Art appreciation is not synonymous with crime investigation. While fraud may be illegal for justifiable reasons—and detectives like Isnard are needed to enforce the law—there's more to be seen in a forgery than concerns a courthouse, let alone a connoisseur obsessed with knowing what's "real." The point is not to anachronistically assume Vasari's point of view, but to look at past and present fakes for ourselves.

We need to examine the anxieties that forgeries elicit in us now. We need to compare the shock of getting duped to the cultivated angst evoked by legitimate art, and we need to recognize what the art establishment will never acknowledge: No authentic modern masterpiece is as provocative as a great forgery. Forgers are the foremost artists of our age.

II.

Fakes are arguably the most authentic of artifacts. Certainly, they're the most candid, once the dissimulation has been detected. To discover what ancient Egyptians or Romans lied about, and what they did not, is to penetrate the inner sanctum of their values and beliefs.

An especially pertinent Egyptian example is the Shabaka Stone, now in the British Museum, transplanted from the Temple of Ptah in Memphis. Ptah was the patron deity of the ancient city, and Memphite priests naturally believed he was the most important of all divinities. But the patron deity of Heliopolis, Atum, already had claim to creation of the world. The Memphites therefore reckoned, logically enough, that Ptah must have created the gods.

Carved in the 8th century BCE, the slab of black basalt corroborated Memphite theology by mimicking the language and layout used in Egyptian documents several millennia earlier, when Heliopolis was just gaining influence. The introductory dedication embellishes the pretense by explaining that the text was transcribed—from a "worm-eaten" papyrus in the temple archives—by order of the 8th-century pharaoh Shabaka.

Shabaka was a Nubian and had no stake in the regional rivalry between Ptah and Atum. What he was concerned with was the political stability of the 25th Dynasty, which depended on the loyalty of powerful Memphite priests. Memphis had only recently come under Nubian dominion, and Heliopolis was no longer politically significant. The Shabaka Stone was a royally sanctioned forgery, a sort of counterfeit currency with which Nubian power was purchased in exchange for Memphite prestige.

Though some details remain unknown—such as when the Memphite creation myth really originated—the Shabaka Stone

exposes the pragmatic relationship between politics and religion, in which gods and their deeds were freely hustled by humans. Hardly suitable for inclusion in official pharaonic chronicles, this facet of late-Egyptian culture is fossilized, so to speak, in the Shabaka confabulation.[4]

What the Egyptians did not choose to fake is also historically informative. While the archaeological record is rife with textual forgeries (often referencing apocryphal papyruses, inevitably worm-eaten) and ersatz gemstones are to be found even in King Tutankhamen's crown jewels, nothing has yet been excavated that we might call an art forgery.

In the 8th century BCE and after, tomb statues were often carved in the archaic style of the Old Kingdom, stiffly posed with short curly wigs that had been out of fashion for nearly two millennia, yet the hieroglyphic inscriptions revealed that the wooden figures were newly produced. To pass them off as genuinely antique would have been nonsensical because their value was essentially functional: They were desirable in the afterlife as doubles for the deceased, not in the aftermarket as exotic objets d'art. The Old Kingdom style of late-dynasty statues was an expression of heritage, which may have been overstated but wasn't intentionally deceptive. There was no art forgery as we know it because there was no art as we construe it.[5]

Imperial Rome would appear to be less foreign. Collectors from Cicero to Hadrian compulsively acquired marble and bronze

4. Of course, official histories contain their own confabulations. Read as period propaganda, they, too, are informative in their fraudulence.

5. This distinction was to confound modern forgers of Egyptian antiquities. The art historian Otto Kurz documented one pertinent case in *Fakes*, a collector's handbook from the 1940s, as a warning to 20th-century buyers. Describing a wall carving of a female servant copied from the funeral chamber of Ti in Sakkara, he noted that "the relief does not pretend to be a fragment but a complete composition." The contemporary forger allowed aesthetics to interfere with the servant's ancient magical purpose.

sculptures to decorate their homes. In the 2nd century CE, Hadrian's villa at Tivoli may have been the foremost place to see the masterworks of classical Greece, from Myron's *Discobolus* to Polykleitos's *Doryphoros* to Doidalsas's *Crouching Venus*. Yet there was something peculiar about the collection, at least to modern eyes: Not a single sculpture was a Greek original. The statues were made to fit the setting, following Greek models that were admired as prototypes but seldom physically imported from Greece.

For imperial Roman collectors, the design was paramount, and second to that was the quality of craftsmanship. An especially fine copy might even be boldly signed with the name of the copyist, who was admired in his own right.[6] The evident openness of wholesale borrowing from past masters, which we might pronounce forgery (or alternately plagiarism), is partly explained by a passage in Pliny's *Natural History*, where he encapsulates the art of previous centuries in terms of "innovators, together with the character and date of their inventions." The formal qualities of a sculpture or painting were technologies by which aesthetic effects were achieved. Once invented, they entered the public domain, to be replicated and modified as needed, yet forever bearing the innovator's name: a tribute along the lines of Hero's engine or Archimedes's screw.[7]

This technological model speaks to the creative outlook of an engineering people whose foremost originality was architectural. The major preoccupation with attribution on statuary concerned

6. "Apollonios, son of Archos from Athens, has made" reads the inscription on one typical piece, a 1st-century CE bronze bust from Herculaneum, modeled on a Hermes sculpted by Polykleitos three centuries earlier. Polykleitos is not mentioned, but he didn't need to be. His primacy would have been self-evident.

7. The art historian Thierry Lenain offers a slightly different though complementary gloss on Pliny in his book *Art Forgery*: "In a way reminding us of scientific discoveries, the greatest artistic innovations are 'signed' in that they have been introduced by someone whose name is known, but they are not a mirror of the 'author's' personality."

the name of the person depicted. Older inscriptions were sometimes overwritten with newer ones, saving the trouble and expense of erecting a new statue to honor the recently deceased. *Spolia*, as the reassigned statues were called, were seen as historical forgeries, and the censure of upstanding citizens could be severe. "I detest deceitful inscriptions on other people's statues," wrote Cicero in one of his *Letters to Atticus*. If Egyptian portrait figures were intended to accompany the deceased into the afterlife, their Roman equivalents were meant to stand in for dying memories here on earth. Changing the dedication wiped out the technological function of carved stone and cast bronze as records of the past.

Cicero's fury over *spolia* stands in stark contrast to his indifference to the provenance of sculptures he requested that Atticus ship to his villa in Tusculum. Like Hadrian several centuries after him, he was concerned with the atmosphere the sculpture would create, not with authorship. Hadrian wanted a pleasure palace fit for a latter-day Caesar. Cicero wanted an Academy to suit a Roman Plato. They collected classical sculpture as architectural details. In that context, there was nothing to be falsified.

III.

The first artist to be forged was St. Luke. According to legend, Luke painted a portrait of Mary holding the infant Jesus, with which Mary was so pleased that she graced it with her favor. The enormous painting—which could barely be supported by four men in procession—was allegedly carried from the Holy Land to Constantinople in the 5th century CE. For the next millennium, the icon was venerated as the *Hodeghetria* ("She Who Shows the Way"), and in turn it worked miracles, healing the sick and

protecting the city from invasion. Churchmen credited it with holding back the Saracens in 718. When the Turks invaded in 1453, Mary's favor proved less effective. The *Hodeghetria* was destroyed in the aftermath.

But it didn't matter, because by the 15th century there were numerous copies of the *Hodeghetria* spread throughout Byzantium, all venerated as St. Luke's portrait of Mary, each working miracles for its constituency. While they resembled the original in the pose of mother and child, they varied widely in facial expression and style of dress.[8] Even less like the Byzantine prototype were the Madonna of San Sisto and the Virgin of Cambrai. The former was a 9th-century Roman icon attributed to Luke as early as 1100 CE. The latter, painted in the mid-14th-century Sienese style, was brought to the French cathedral of Cambrai in 1440, also as Luke's handiwork. These were copied prolifically. For the clergy of Cambrai, it was a cottage industry. Three late-15th-century copies can be attributed to the brush of Petrus Christus. As with the *Hodeghetria*, production has never abated, and neither have reports of miraculous consequences.

Of course, there is no evidence that Luke painted any of these—even the ancient *Hodeghetria*—and every reason to doubt his involvement. Before the *Hodeghetria* became famous in Constantinople, painting was never mentioned as one of Luke's vocations. Most historians agree that the icon (or another like it) made the myth: The grandeur and the miracles could be explained only in terms of holy genesis, and the lengthiest description of the infant Jesus is to be found in the Gospel of Luke. He had the required access and also the prestige.

8. They also were conveniently available in many different sizes and formats. One version in the British Museum is an icon of an icon, showing church leaders venerating the *Hodeghetria*, which is supported on a dais by two winged angels.

His prestige was the important part and the impetus for forging his apocryphal painting. Luke's portraits of Mary were instances of pious fraud, and pious fraud was a consequence of relic veneration. Medieval Christians believed that saints could perform miracles from beyond the grave through their bodily remains. These relics, including bones and viscera, were preserved in churches where pilgrims went to seek divine intervention. To satisfy demand, remains could be broken up and parceled out to parishes, since even the smallest fragment was believed to be as potent as the whole cadaver. Indeed, anything could be sanctified by contact with a saint. Reliquaries were built to hold garments. Stones were collected from around saints' graves.

The most venerated materials were those associated with Jesus. Since his body was supposed to have ascended to Heaven, relics included fingernails and milk teeth and the foreskin of his penis. His crown of thorns was enshrined in La Sainte-Chapelle, erected by King Louis IX primarily for that purpose. (Compared to the thorns, the chapel was a bargain, costing less than a third of the crown's 135,000-livre price.) Given their spiritual and monetary value, these holy remains had a tendency to multiply. Three hundred years after Louis IX purchased Christ's crown, John Calvin made an inventory of thorns, finding large numbers in nearly twenty churches throughout Europe. "With regard to the crown of thorns, one must believe that the slips of which it was plaited had been planted, and had produced an abundant growth," he wrote in his *Treatise on Relics*, where he also noted that the amount of wood purported to come from the holy cross was enough to build a ship.

Such was the metaphysics of pious fraud, and though reformers challenged it, the counterfeiting of relics served the purpose of complementing the process of corporeal subdivision and supplying the plebeian demand for objects to venerate. Simply put,

Calvin didn't get it. The authenticity of relics was a matter of faith. If miracles were mediated by brambles and milk teeth, why should brambles and milk teeth not propagate by magic?

And why shouldn't portraits? Fundamentally, the *Hodeghetria* was a relic—allegedly painted by the hand of an Evangelist and graced by the Mother of God—that happened to be painting. Forgery was possible (as it had not been in Hadrian's pagan Rome) because authenticity was an issue. To medieval Christians, it was significant who physically made this particular icon, but once that was established by popular belief, the mechanism of pious fraud could counterfeit it, and each counterfeit could be looked upon as an original in its own right, as long as the counterfeit was seen to perform miracles. The performance of miracles was how every relic vouched for itself. Miraculous happenings might even tip off the faithful to the holy origin of an artwork in spite of its contemporary look. By this logic, a 15th-century Sienese Madonna became the authentic work of St. Luke.

IV.

Jesus also was an artist. According to a 6th-century legend, he once made a self-portrait for the Edessan king Abgar by passing a cloth over his face.[9] The miraculous origin of the *Mandylion*, as the color image was known, was confirmed by the *Mandylion*'s power to replicate itself on other surfaces. Byzantine depictions of the *Mandylion* from the 12th and 13th centuries show it next to the *Keramidion*, an identical portrait on tile. In an era before mechanical reproduction—several hundred years in advance of even the

9. Even in death, Jesus didn't lose his artistic touch. The Shroud of Turin is another self-portrait allegedly created by the miraculous transfer of his divine likeness to fabric.

earliest printing presses—the double image was as good a sign of divinity as the Holy Trinity.

By the Renaissance, Jesus' trick had been picked up by the foremost painters, for whom the perfect copy was the perfect means to show off God-given talent. Such was the motivation of the 15th-century Neapolitan artist Colantonio, who counterfeited the Flemish panels of Rogier van der Weyden and Jan van Eyck. One famous example, related by the poet Pietro Summonte in 1524, involved a portrait of Charles the Bold, lent to Colantonio by a merchant. Rather than returning the original, Colantonio gave back a copy "so similar that it was impossible to distinguish the one from the other." The dealer was fooled until Colantonio "revealed the beautiful deception."[10]

Still more beautiful were the intrigues of young Michelangelo. One day while still apprenticed to the Florentine painter Domenico Ghirlandaio, he was lent an old master drawing of a head to copy. He rendered it so precisely that, in the words of his first biographer, Ascanio Condivi, "when he returned the copy to the owner in place of the original, at first the owner did not detect the deception, but discovered it only when the boy was telling a friend of his and laughing about it." Even after the prank was found out, and the two sheets were laid side by side, nobody could decide which was the original and which was Michelangelo's work, artificially aged with smoke. According to Condivi, the incident "gained him a considerable reputation."

Vasari likewise admired Michelangelo's skill at counterfeiting drawings, which he presented as evidence of the artist's "heavenly" giftedness, an early sign of God's decision "to send down to earth a spirit with universal ability in every art and every profession... [who]

10. Tellingly, Kurz translates the phrase—"li scoverse lo bello inganno"—to read "revealed his successful trick."

might be acclaimed by us as a being rather divine than human." A man of the Renaissance, Vasari sought to redeem the world from religion by delivering it into the hands of artists. He achieved this rhetorical feat by making their work appear miraculous.

Another forgery of Michelangelo's advanced the humanist cause along a second trajectory. Having taught himself to sculpt in marble (and demonstrated his genius by counterfeiting a Donatello relief "so well that it seems as if by Donatello's hand, save that there may be seen in it more grace and more design"), Michelangelo chiseled a life-size sleeping Cupid. According to Vasari, Michelangelo's patron Lorenzo di Pierfrancesco de' Medici admired it highly. "If you were to bury it under ground and then sent it to Rome treated in such a manner as to make it look old," Lorenzo di Pierfrancesco advised, "I am certain that it would pass for an antique, and you would thus obtain much more for it than by selling it here." This was done, and the statue sold to Raffaele Riario, Cardinal of San Giorgio, for two hundred ducats. The cardinal had no idea that his ancient artifact was fake until rumors reached him that someone had seen the Cupid being made. Less liberal-minded than the Marquis of Mantua, he demanded a refund. "This affair did not happen without some censure attaching to Cardinal San Giorgio, in that he did not recognize the value of the work, which consisted in its perfection," chided Vasari, "for modern works, if only they be excellent, are as good as the ancient."[11] By Vasari's logic, Michelangelo's forgery was a bridge

11. Raffaele Riario eventually came to his senses, in Vasari's version of events. After rejecting the sleeping Cupid, he summoned Michelangelo to Rome and briefly served as his patron. Thomas Hoving was a tougher customer, preferring to brand Vasari a liar than to accept Michelangelo's chicanery. "The idea that one of the single most gifted artists in Western civilization gained renown because of his gifts as a forger and confidence man stretches the limits of credulity," Hoving wrote in *False Impressions*. "He was a man of unquestionable Christian morality who would never have stooped to fakery."

from the Renaissance back to imperial Rome, just as Roman copies were a conduit back to classical Greece. The counterfeit Cupid belonged to the same Renaissance rhetoric as paintings such as Giorgione's *Sleeping Venus* and Raphael's *School of Athens*. It provided a powerful argument that the Dark Ages had ended and a stunning example of how the classical past could be made present.

Yet the Cardinal was also a man of the Renaissance, and his reaction to Michelangelo's deceit was no less contemporary than Vasari's. Individual artists mattered in the 16th century. Emphasis was placed on their uniqueness and on the interrelationship of their life and work. With this cult of personality, focus shifted from craft to authorship and attribution. Vasari's multivolume hagiography picked up on this new conception of art and advanced it more effectively than any other book.[12] Every great master became a secular St. Luke.

V.

In 1506, Albrecht Dürer traveled to Venice in pursuit of an Italian engraver named Marcantonio Raimondi. The great German painter had learned that Marcantonio was counterfeiting his woodblock prints and selling them to collectors. When he arrived, Dürer found that seventy-four of his images had been pirated—including his pricey *Life of the Virgin* series—all engraved on copper plates with such precision that even the woodblock's natural texture was preserved. The paper on which Marcantonio

12. Vasari's approach was so radical that even he lagged behind. "What greater vanity is there than that of those who concern themselves more with the name than the fact?" he chided when writing about Cardinal Riario, while everywhere else doing all he could to promote Michelangelo's "celestial and divine" name.

printed was the same size as Dürer's. His ink was the same color. And in each print, he'd included Dürer's distinctive two-letter monogram. Complaining of lost profits, the German artist filed a grievance with the Venetian government. The city leaders ruled that Marcantonio had to remove Dürer's initials from his plates but allowed him to continue printing his images.

Dürer's plight was not confined to Italy. Several years later, a German counterfeiter began copying his prints within Dürer's native Nuremberg. Dürer again brought suit and again was found to have legal ownership of his name but not his designs. "A stranger who has sold prints in front of the Town Hall, among which are some bearing the mark of Albrecht Dürer, copied fraudulently, must engage on oath to remove all these marks … [or] these prints shall be seized and confiscated as spurious," read an edict issued by the city council on January 3, 1512.

By then, Marcantonio had quit counterfeiting and gained fame as Raphael's official engraver, making prints from Raphael's drawings "in such a manner as amazed all Rome," according to Vasari. "These works acquired such fame for Marc' Antonio that his engravings were held in much higher estimation, on account of their good design, than those of the [Dutch and Germans]." As might be expected, Marcantonio's engravings were widely counterfeited in their own right, complete with his and Raphael's monograms. Neither Marcantonio nor Raphael pressed suit. Replication by any means served their purpose, since the collaboration was intended primarily to broadcast Raphael's genius.

Engravings achieved what no panel or fresco could, even for an artist of Raphael's celebrity, because they liberated the image from the object. Yet mechanical reproduction also threatened the artist's claim to authorship at the moment authorship was becoming artistically important. The protection given to Dürer's monogram but not his designs prevented forgery by promoting plagiarism.

And in any case, the regulations could not be effectively enforced. Even if the artist's initials were kept off the engraver's plate, they were promptly and skillfully drawn in by the collector's pen. Printmaking fostered a market larger and less accountable than the patronage of clergy and noblemen. The market gave monetary value to an artist's name. In Dürer's time, this resulted in prints attributed to him that he never designed: Artists of less repute boosted sales of their pictures by plagiarizing his monogram.

The circumstances of forgery grew more tortuous, and the forms more diverse, as art meant more things to more people. If art could serve seemingly countless functions, from state propaganda to family inheritance to personal pleasure, how could there be a single definition of fakery? In the 17th century, Peter Paul Rubens complained bitterly about the piracy of his prints and sought legal protection, but he tolerated forgery of his paintings, and his studio produced copies of paintings by past masters on commission. In the 18th century, G.-B. Piranesi achieved great fame with his engravings of imaginatively reconstructed Roman antiquities, yet when he sold the pastiche antiques he'd illustrated, gentleman collectors denounced him as *il cavaliere composito*.[13]

Only in the legal arena was any consensus reached about the difference between real and fake, and only under duress. In the 1730s, William Hogarth was the most famous artist in England, his popularity with the public surpassed only by his popularity with publishers who were free to copy his engravings and to sell

13. His pastiches were condemned on grounds of authenticity, but the collectors attacking him always had their antique statues restored down to the fingertips and expected the marble to be bleached a perfect white. To a later generation of collectors, who couldn't abide the fakery of 18th-century restoration, Piranesi's inventions were embraced as authentic neoclassical sculptures.

them without paying him. Pirated editions of *A Harlot's Progress*—his titillating 1732 sequence of moralizing cartoons about a young woman's fall into prostitution—were sold on the streets of London within a week of official publication. The counterfeiters even brazenly took out newspaper ads.

Hogarth had an idea for a second series, *A Rake's Progress*, which he announced in late 1733, but he had no intention of giving it away. He appealed to Parliament, noting that published writing had been legally recognized as intellectual property since 1710 and arguing that an equivalent copyright should be granted for engravings.[14] Then he gave his case weight by refusing to publish until his prints were legally protected. He held back the highly anticipated images for a year and a half, until June 25, 1735, releasing *A Rake's Progress* on the day the so-called Hogarth Act went into effect.

The Hogarth Act gave artists the legal status sought by Dürer more than two centuries earlier. Granting a fourteen-year monopoly on published images and fining counterfeiters a shilling for every pirated copy, the law became a model for copyright protection throughout the Western world and would become increasingly significant as mechanical reproduction evolved with the industrial revolution.[15] Yet the more the industrial revolution promoted the image—and images promoted the industrial revolution—the more the art world retreated into the past, taking refuge in the unique object.

14. When Rubens was granted copyright on his engravings in the 17th century, the protection was unprecedented, a privilege given to him personally on account of his extraordinary political connections.

15. Before the industrial revolution, prints were luxury items, in part because production was labor-intensive and costly. According to Vasari, Marcantonio paid all the money he had for a suite of Dürer etchings. By Hogarth's era, a dozen prints could be sold on the street for one penny and still net a profit, especially if the content was pirated.

VI.

The Renaissance was reborn in 1830, in the person of a Tuscan laborer named Giovanni Bastianini. Teaching himself the rudiments of carving while working in a stone quarry, Bastianini refined his skills assisting the Florentine sculptor Girolamo Torrini on a statue of Donatello for the Uffizi. By the age of eighteen, he'd surpassed Torrini in the antique manner, leading a Tuscan dealer named Giovanni Freppa to wonder whether Bastianini might one day equal the mastery of Donatello himself. Freppa taught Bastianini reading and arithmetic and paid him a retainer of two lire a day. In return, Bastianini supplied him with marble nymphs and putti, passed off as antiquities, and a Madonna that was purchased as a 15th-century Desiderio da Settignano by the South Kensington Museum.

These successes encouraged Freppa to commission more ambitious forgeries. In the early 1860s, he contracted Bastianini to sculpt portraits of famous Renaissance figures—including the radical friar Girolamo Savonarola and the humanist poet Girolamo Benivieni—men admired anew in the 19th century. The statues sold for astronomical prices. The patriotic sculptor Giovanni Costa raised 10,000 lire to ensure the terra-cotta bust of Savonarola never left Italy. The Benivieni portrait got swept into an auction and was acquired for 13,600 lire by the Louvre. The curators attributed it to the school of Verrocchio and exhibited it adjacent to a Michelangelo.

Bastianini was not one to keep quiet about this achievement, nor was he one to back down when his skill was doubted by French experts.[16] The ensuing debacle led Costa to wonder whether his

16. He may also have been somewhat disgruntled to have earned only 350 lire for his efforts.

Savonarola bust was really made in the 15th century. He asked Bastianini directly. When Bastianini acknowledged authorship, Costa was pleased: Bastianini was a living link to a vaunted past, proof that the Italy of Savonarola and Benivieni survived. "Now Bastianini, if only for this bust, must be recognized as one of the greatest modern glories which Italy has so far had in the field of art," Costa wrote to the director of the Museo di S. Marco in Florence, where the bust was displayed. "If his morality was not on a par with his genius, the fault is largely that of our country, which nowadays will not recognize a living man who is gifted with sentiment and talent."[17] Costa was determined that Bastianini's gift not be wasted. He appealed to his close friend Sir Frederic Leighton, who secured for the sculptor a commission to create more work in the Renaissance style for the South Kensington Museum. The work was shown under Bastianini's own name as contemporary sculpture, together with the Madonna previously attributed to Desiderio da Settignano.

And it all looked strikingly contemporary. At precisely the same time that Bastianini began faking Renaissance statuary in Tuscany, the young British painters William Holman Hunt, John Everett Millais, and Dante Gabriel Rossetti founded the Pre-Raphaelite Brotherhood in London. Dedicated to reviving the naturalism of the 15th century, they swiftly influenced their peers—including Frederic Leighton—who took up the past with youthful abandon.

Paradoxically avant-garde, Pre-Raphaelite anachronism was a sincere attempt to escape the quagmire of academic art. Far more radically, it was a stand against modernity: a utopian vision of life before the industrial revolution, presented as a humanist

17. Costa's comment echoes Vasari's gloss on Michelangelo's Cupid, that "for modern works, if only they be excellent, are as good as the ancient."

alternative to steam-driven bleakness. "You must either make a tool of the creature, or a man of him," wrote the Pre-Raphaelite *éminence grise* John Ruskin in his 1853 tome, *The Stones of Venice*. "You cannot make both." An aesthetic respite from steel and coal, the handcrafted art object also embodied a political ideal. Bastianini was not only admired for his timely Renaissance subjects. A forgery hand-carved by him seemed more authentic than even the most original mass-produced image.

His case was not unique. In the 19th century, art forgery was a refuge for every craft, from glass blowing to intaglio cutting, as the mania for collecting spread to encompass the whole of human history. Carved wooden figures in the archaic Egyptian style and bronze castings of Roman statues imitating Greek models were just the beginning. Paleolithic flints, Byzantine enamels, Gothic ivories, Chinese porcelains, Turkish carpets, and Aztec masks are but a few examples of the counterfeit goods produced for museums and the marketplace.[18] Even if Ruskin's polemics could not block Queen Victoria's suspension bridges and railways, popular interest in the past and "primitive" artifacts bespoke an ambivalence about modern ways.

New finds attracted great crowds. For instance, in 1896 the Louvre exhibited a solid gold helmet, heavily decorated with scenes from the *Iliad*, with a Greek inscription from the Scythian king Saitapharnes to the Crimean people of Olbia. The magnificent ceremonial headdress, believed to have been crafted in the 4th century BCE, captured the public imagination because the Scythians were nomadic horsemen whose rediscovered culture offered a romantic escape from modern Europe. When scholars began to question the helmet's antiquity, newspapers defended it,

18. Practitioners of traditional crafts were further motivated by the apotheosis of oil painting as official art. They were creatively orphaned.

so seductive was the ancient fantasy. The scholars prevailed. In 1903, a Russian goldsmith named Israel Rouchomovsky confessed to the forgery, which he'd based on more prosaic Scythian antiquities illustrated in archaeological journals.

As Bastianini had been half a century earlier, Rouchomovsky was admired. Some of his fakes were exhibited under his own name and won him a medal in the 1903 Salon de Paris. Yet unlike the South Kensington Museum in the 1860s, the Louvre's *fin-de-siècle* salons were not exactly *au courant*. In fact, 1903 was the year the avant-garde defected to form their own salon a mile down the Seine.

Leading the charge were André Derain and Henri Matisse, artists the media would soon dub *fauves*, or wild beasts.

VII.

The art of our time is anxious. Gone are the reassurances of religion and reason and progress. The modern world is alienating, and almost every serious modern artist addresses our precarious position, drawing our attention to the inhumanity of the world we've built. The only solace is our cosmic insignificance.

The angst in modern art cannot be compared even to the most horrific imagery of the past, such as Hieronymus Bosch's merciless 15th-century depictions of eternal damnation. (Anything but senseless, the suffering in Bosch's Hell is evidence of divine justice. Bosch depicts an orderly universe in which everyone has a proper place.) Distress is no less reassuring in the epic secular works of the 18th and 19th centuries. (For instance, the dead bodies littering the foreground of Eugene Delacroix's great rendering of the French Revolution, *Liberty Leading the People*, merely add gravitas to the triumph of enlightenment.) As for pictures that identified social problems, typically they approached their

subject in the instructive mode epitomized by Hogarth. (Blatantly moralistic, *A Rake's Progress* shows the consequences of prostitution and gambling by depicting a young man's fall into debt and madness. Viewers were expected to learn by example.)[19] Provided that God was in command, or the world was governed by reason, anxiety was beside the point.

Pre-Raphaelitism was revolutionary because the Pre-Raphaelites perceived that society as a whole was rotten: an inhuman world that dehumanized people. Their art proposed a vividly appealing alternative. In painting and sculpture, they illustrated and embodied a premodern utopia. Gallantly naive, their art was a riposte to their anxiety about the world.

The avant-gardes that followed effectively gave up hope. The modern world was a dystopia. Alienation was the human condition. "I stood there, trembling with fright, and I felt a loud, unending scream piercing nature," wrote Edvard Munch in his diary on January 22, 1892, chronicling the experience that inspired his most famous painting, *The Scream*. He might as well have been describing the resonant pitch of art ever since.[20]

Dada took up alienation with the raw power of live performance. (At the Cabaret Voltaire in Zurich during the First World War, crowds convulsed with confusion as Tristan Tzara read poetry composed on the spot by drawing words out of a hat.) Surrealism was more prone to illustration, literally portraying nightmares

19. Francisco Goya's *Disasters of War* (1812–15) deliberately pushed this tradition past the limit of rational thought. For this reason, they are rightly considered the first modern art. But they were essentially unknown until they were finally published in 1863, thirty-five years after his death.

20. Futurism was a notable exception, unequivocally promoting modernity. "A roaring motor car which seems to run on machine-gun fire is more beautiful than the Victory of Samothrace," F. T. Marinetti famously proclaimed in his *Futurist Manifesto* of 1909. The same manifesto cheerfully refers to war as "the world's hygiene." By the sheer perversity of their optimism, the Futurists gave people good reason to be anxious.

and madness on canvas. Through the 1940s and '50s, Abstract Expressionism communicated the disquiet of modern life in pure paint. (The frenzy of drips spattering Jackson Pollock's oversize canvases keeps the eyes in constant motion.) Pop Art in the '60s addressed the mechanisms of dehumanization by satirically imitating the methods and aesthetics of mass production.

Even movements that seem far removed from the maelstrom of angst engage the trauma of modern existence. For instance, the Fauvism of Derain and Matisse—which portrayed the world in feverishly unrealistic colors—captured the disquieting intensity of everyday experience. More profoundly, Cubism broke the picture plane itself, questioning the logic of traditional perspective, provoking viewers to reconsider their perceptions, agitating assumptions about objective reality.

Questioning. Provoking. Agitating. These are the most productive attributes of modern art. Compelling art does not merely depict anxiety, but induces it, awakening us to the invidious conditions of the dystopia in which we live, so that the engine of progress does not make tools of us.

VIII.

Art forgery also provokes anxiety. Because art is a rare refuge from the mass-produced inauthenticity of the industrialized world, we are hypersensitive to any threat to the authenticity of art. When the art historian Max Friedländer wrote that "an original resembles an organism; a copy, a machine" in his seminal 1942 book, *On Art and Connoisseurship*, he was explaining how a connoisseur distinguishes between real and fake, but his choice of words shows an antagonism toward mechanization, a revulsion that he correlates with all copies, not only those wrought by mass production.

The association of a copy with dehumanizing technology would have been completely incomprehensible to Vasari. The condemnation of Andrea del Sarto by Otto Kurz was not so much about convicting a dead man as registering Kurz's own sense of betrayal. Andrea's copy and Giorgio Romano's inability to detect it question the assumptions of connoisseurship: that the original is inherently better, or can even be distinguished by the painter.

Modern forgeries are much more agitating to many more people than Andrea's deception, because the fraud reveals modern failings. The most famous case of the 20th century, in which a Dutch painter named Han van Meegeren sold laughably ersatz Vermeers to major museums by gaming the system of authentication, calls into question the integrity of traditional lines of authority. No less agitating, the British forger Eric Hebborn placed thousands of newly invented old master drawings in public collections, the majority of which remain undetected. His drawings have retrospectively reshaped the oeuvres of artists who lived centuries before him, provoking the question: Who makes history? Other forgers using other ruses have upset commonplace assumptions about culture and authenticity, belief and identity.[21]

In other words, art forgeries achieve what legitimate art accomplishes when legitimate art is most effective, provoking us to ask agitating questions about ourselves and our world. By this standard—the standard of modernity—we need to take art forgers seriously as artists and to acknowledge that their fakes are the great art of our age.

Crucially, their artistic merit is not aesthetic. The quality of their imitation is only marginally relevant, interesting only in the context of their swindle. The fact that van Meegeren's ersatz Vermeers were so inept, yet so widely accepted, shows how

21. These forgers, and the questions they raise, are the subject of part II.

dependent perception is on consensus. The fact that many Hebborn drawings are still in circulation, passing as genuine Rembrandts and Titians, leaves their oeuvres forever uncertain. The art of the forger includes the whole framework of fraudulence: how his pictures were presented, where they were shown, and what happened as a result. The art is the scandal. As a consequence, achievement comes at a price. To become a serious artist, the forger must get caught. The swindle must be exposed.

Forgeries make headlines. When a forger is found out, the scandal attracts more popular interest than the artists he faked ever got. That's because the social impact is real. Laws are broken. Markets are damaged. Reputations are ruined. Forgeries don't merely agitate the cultural elite. Recognizing the systemic weaknesses exploited by the swindler doesn't take the cultural knowledge required to appreciate the visual provocations in a Cubist painting. The language of deceit is universal. The aesthetic and intellectual barriers of high culture are leveled by a scandal.

Moreover, we can't opt out. Going to see *Autumn Rhythm* by Jackson Pollock is a voluntary act and requires the effort of visiting the Metropolitan Museum. Being defrauded, in contrast, is not a choice. Even those who aren't the victim (as collectors or curators or taxpaying citizens) are vicariously bamboozled, made to question how they'd have responded were the fraud directed at them. Legitimate art can only simulate the violations that forgeries perpetrate. In that sense, forgeries are more real than the real art they fake.

IX.

In May 2000, the world's two largest auction houses found themselves in a situation reminiscent of 19th-century Florence and

Naples. The spring catalogues of Christie's and Sotheby's both featured the same painting by Paul Gauguin, a minor canvas from 1885 called *Vase de Fleurs (Lilas)*, once owned by Sir Laurence Olivier. Each had reason to believe that theirs was authentic and that the other auction house must therefore be offering a counterfeit. To resolve the dispute, both submitted their canvases for side-by-side comparison at the Wildenstein Institute. Based on slight discrepancies in the brushwork, the painting consigned to Christie's was determined to be a copy and returned to the Muse Gallery in Tokyo. The canvas consigned to Sotheby's by Manhattan dealer Ely Sakhai sold several weeks later for $310,000. But Sakhai's triumph was brief. Within months, the FBI determined that the Muse Gallery counterfeit—which bore a genuine certificate of authenticity—had also originated in Sakhai's gallery.

The fake Gauguin was not Sakhai's first forgery. Over the past decade, he'd bought dozens of third-tier paintings by first-tier Impressionists such as Claude Monet and Pierre-Auguste Renoir, which he'd had precisely copied by assistants. The copies were usually sold in Asia with the original certificates. The originals were generally sold in the United States and Europe on their intrinsic merit. Since the work was too insignificant to attract much attention, owners of the original and the copy could be expected never to hear about one another. "The highbrow scam worked like a simple streetcorner shell game," reported the *New York Daily News* on March 11, 2004, when Sakhai was finally brought to trial.

The newspaper's analogy was a touch naïve. Investigating the case for *New York Magazine* following Sakhai's conviction, the writer Clive Thompson found out that the auction houses understood the basic pattern as early as 1997. "Every time we put a painting from [Sakhai] in, we'd get a phone call from around the world saying, What are you doing with my painting?" an unnamed

former Christie's employee told Thompson. The auctioneers continued selling Sakhai's wares and reaping commissions. The shell game was played not only with paintings but also with information. Only the concurrent appearance of the two Gauguins forced the auctioneers to be forthright. Any notion that capitalism makes knowledge more efficient—as the conservative economist F. A. Hayek influentially claimed—would appear to need serious reconsideration.

Vase de Fleurs (Lilas) is not a bad painting. The colors are vibrant, and the composition pleasant. It must have looked smart on Laurence Olivier's wall. But to make something profound out of Gauguin's bouquet took a counterfeit.

Max Friedländer had it all wrong. A *copy* resembles an organism. Out in the world, a fake takes on a life of its own, which even the counterfeiter cannot control. A forgery is alive with meaning.

Like so many painters, Gauguin sought to imbue his art with the vitality of nature. He should have become a faker.

SIX MODERN MASTERS

WHAT IS BELIEF?

Lothar Malskat
1913–1988

In the early hours of Palm Sunday, March 29, 1942, the Hanseatic city of Lübeck burst into flames. The conflagration was no accident, but the consequence of a strategic decision the previous month in London. Because British air raids on German factories were missing the mark—seldom striking within five miles of target—Winston Churchill decided instead to wage war on the "morale of the enemy civil population" by carpet bombing whole cities. Mainly built of dry old wood, and essentially undefended, ancient Lübeck was prime real estate for the Allies' first airborne *auto-da-fé*.

Two hundred and thirty-four planes dropped nearly three hundred tons of incendiary bombs, burning thousands of homes, as well as the merchants' quarter, the town hall, and several historic churches renowned throughout Europe for their Gothic architecture. The surprise attack spooked even Joseph Goebbels, the Nazi minister of propaganda, who confided in his diary that such raids had the potential to break the people's will. The Nationalsozialistische Volkswohlfahrt handed out oranges and apples, and the Luftwaffe retaliated with the so-called Baedeker Blitz, vowing to obliterate every town with a three-star rating in *Baedeker's Guide to Great Britain*.

Yet the Lübeck people were less impressed with fresh fruit—let alone cultural vengeance in Exeter and Bath—than with an unexpected revelation inside their own 13th-century Marienkirche. Hot enough to melt the church bells, the Palm Sunday fire peeled five centuries of whitewash off the walls, exposing enormous Gothic frescoes painted when the building was erected. Dubbed "the miracle of Marienkirche," the discovery was sheltered under improvised roofing until the war ended and structural repairs could begin.

By the summer of 1948, the church was fully enclosed again, and a generous sum of 88,000 marks was apportioned for the celebrated restorer Dietrich Fey to conserve the precious murals. Even from the ground, some twenty-five yards below the sooty apostles, people could see that the frescoes' condition was delicate. Climbing the scaffolding, Fey's assistant, Lothar Malskat, confirmed their gravest concerns. Scarcely a shadow of the original paint remained, as he later recalled, "and even that turned to dust when I blew on it." Preserving the miracle of Marienkirche would require a miracle worker.

Three years later, on the Lutheran church's seven-hundredth anniversary, the West German Chancellor Konrad Adenauer stood in the nave amid ministers and dignitaries. "Das ist erhebend, meine Herren!" he declared—*This is uplifting!*—and he lifted up his arms to rows of ten-foot-tall Gothic saints. Radiant in red, green, and ocher, the Marienkirche miracle became a sort of solace for a whole downcast nation. As in all miracles, however, there was an element of the inexplicable. Though nobody cared to examine the recent past, a comparison between the murals and photographs taken in 1942 showed that some of the saints had moved, and that Mary Magdalene had lost her shoes.

Dietrich Fey did not so much earn his reputation as inherit it. His father, Professor Ernst Fey, was a respected art historian and restorer

in Berlin, whose prestige was bolstered in the early '30s by the rise of the Nazi party and his talent for ingratiating himself with such self-styled connoisseurs as Luftwaffe commander-in-chief Hermann Göring. Accompanied by his son, Professor Fey restored paintings in churches throughout Silesia. He imparted to Dietrich his historical expertise, and the young man shared his aptitude for courting patrons. But Dietrich Fey lacked his father's touch with a brush. Securing important ecclesiastical commissions in the medieval Upper Silesian towns of Oppeln and Neisse, Fey und Sohn were in urgent need of an assistant by 1936, when a twenty-four-year-old housepainter named Lothar Malskat came asking for work.

The haggard appearance that Malskat had acquired by living on park benches belied his prestigious background. In his native East Prussia, he'd studied art at the Kunstakademie Königsberg, where his professors praised him for his "extraordinary, almost uncanny versatility."[1] Filled with optimism, he moved to Berlin, seeking fame, finding anonymity. Professor Fey put Malskat to work whitewashing his home. In return for the labor, Fey lent him books on ecclesiastical art. And gradually, in the old churches of Oppeln and Neisse, the professor taught Malskat his craft.

Then in 1937, Fey und Sohn brought Malskat to the ancient town of Schleswig, to assist them in a restoration of profound historical significance. The Schleswig cathedral, St. Petri-Dom, originated in the 12th century as a Romanesque basilica and gradually grew in physical stature as the province of Schleswig-Holstein increased in worldly power. Saint Petri-Dom was the seat of bishops for half a millennium and the burial place of King Frederick I of Denmark, whose tomb was carved in the 1550s by the renowned Flemish sculptor Cornelis Floris de Vriendt.

1. One professor also predicted that "a lot more will be heard from Lothar Malskat"—a monumental understatement.

Each stage in the cathedral's development is preserved in distinctive artwork. The earliest images, on the walls of the cloisters, or *schwahl*, were first painted around 1300. With the passage of centuries, though, the biblical scenes were gradually degraded by dampness, to such an extent that in 1888 church authorities hired the painter August Olbers to mend the damage.

Praised at the turn of the century, by 1937 the repairs were deemed a calamity because Olbers had restored by repainting. He could scarcely be blamed. By the standards of his time, restoration meant renovation, a perfectly reasonable (if slightly naïve) notion: The purpose was to let people see again what once had been. In the 1930s, a rather different (though equally naïve) principle was in place, that the restoration must in no way impinge upon the original work. Writing about the conservation of ecclesiastic painting in 1926, the Cologne art historian Otto H. Förster articulated the new orthodoxy. "There must be no element of addition, completion or other conjectured reconstitution of any supposed original state," he wrote. Olbers was guilty of all three affronts.

Down in the *schwahl*, Malskat and the Feys set to work, attempting to reclaim history by scraping away the paint with which Olbers had tried to recapture the past. But subtracting what their predecessor had done—whether on account of Olbers's pigments or the Feys' incompetence—left almost none of the original paint. A nearly seven-hundred-year-old national treasure had vanished, and Ernst Fey was legally responsible for the disappearance.

Most likely, Fey was the one to think of a fix. Unquestionably, Malskat was the one who achieved it. Over the next several months, the erstwhile housepainter whitewashed the brick, discoloring his lime with pigment to give the walls an ancient tint. Onto this fresh surface he painted freehand his own version of the murals. Necessarily, these were based on Olbers's 19th-century restorations,

reverse engineered to approximate the early medieval originals by reference to period examples in the professor's catalogues. Drawing his figures in earth tones, Malskat took up the spare 14th-century style with preternatural ease and an utter lack of inhibition. He rendered his father as a prophet and gave Christ the face of an old classmate. For the Virgin Mary, he had to look further afield to find a suitable model, choosing a woman already widely worshipped: the Austrian movie star Hansi Knoteck. Ernst Fey then aged the contour drawings using a procedure he called *zurückpatinieren*—a fancy word for rubbing them with a brick.

The critical response to the Schleswig restoration was ecstatic. Especially influential was the endorsement of Professor Alfred Stange, an eminent art historian at the University of Bonn who'd previously instructed the Nazi elite at the Reichsführerschule and remained a close confidant of Alfred Rosenberg, the chief party ideologue. Praising Fey for orchestrating a restoration "as restrained as it was careful," Stange lauded the reconditioned murals as "the last, deepest, final word in German art." And so they became in 1940, when Reichsführer-SS Heinrich Himmler ordered that Stange's illustrated book, *Der Schleswiger Dom und seine Wandmalereien*, be distributed to all German schools.

Within the Nazi context, the *schwahl's* educational value was significant. According to Stange, the paintings represented "an excellent demonstration of the ties, permanent because they spring from nationality, which bind Schleswig to the Saxonian-Westphalian area and its art." In other words, the murals could be used to promote Third Reich nationalism. Perhaps more important, the figures conformed to appropriate racial stereotypes, confirming the purity of the German bloodline. As Malskat later put it in an interview with the *Hamburger Abendblatt*, "I had to paint

the apostles as long-headed Vikings because one did not want Eastern round-heads."

The greatest zeal, though, was reserved for the so-called *Schleswiger Truthähnbilder*, eight paintings of turkeys embellishing a depiction of the Massacre of the Innocents. The turkeys were first pointed out by an independent historian named Freerk Haye Schirrmann-Hamkens in a 1938 article for a local newspaper. Schirrmann-Hamkens brought up the turkeys because their appearance in a mural allegedly painted circa 1300 was surprising: Turkeys are New World birds believed to have first been introduced to Europe by the Spaniards in the 1550s. Of course, Schirrmann-Hamkens couldn't question the authenticity of paintings that were under Himmler's protection. Instead, he used the paintings to question history. By his reckoning, the *Schleswiger Truthähnbilder* showed that Vikings had discovered America—and brought back gobblers to the Fatherland—centuries before Christopher Columbus was conceived.

Schirrmann-Hamkens's theory was bound to be popular. Already the Nazis were championing a 1925 tome by a Danish librarian arguing that the German explorer Didrik Pining had reached America in 1473.[2] A 13th-century Nordic conquest of America that brought turkeys to Schleswig was even better, serving to even more firmly establish the Teutonic supremacy of the German race (not to mention Germans' Viking pedigree). "The portrayals are based on a high degree of personal observation," Stange wrote of the turkeys in his 1940 essay. ("They are not, as so often, borrowed from reference books," he added, lest anybody think that the Vikings had merely raided a library.)[3] Turkeys in

2. Pining's German roots were first confidently established in 1933 (coincidentally concurrent with the rise of the Third Reich), significantly boosting the status of this new theory in Germany, if not in Denmark.

3. The strangeness of this line suggests the degree to which Stange was struggling to convince himself that the paintings were legitimate.

early medieval Germany became a part of the Nazi orthodoxy and were put to work on behalf of the Third Reich propaganda machine. "Aryan seafarers went to American long before Columbus did," a guidebook to St. Petri-Dom advised tourists. "Incidentally, Columbus is the descendant of Spanish Jews from Barcelona."

Dissent came from an unexpected source. Nearly eighty years old when Malskat's restoration was complete, August Olbers emerged from retirement to assert that the *Schleswiger Truthähnbilder* weren't proof of circumnavigation by Vikings because he himself had painted them in the late 1880s. Olbers explained that he had not intended to fool anyone. Unable to discern what had originally filled the wall space beneath the Massacre of the Innocents, and loath to leave it empty, he'd come up with a motif of foxes and turkeys to symbolize the guile and gluttony of the murderous King Herod.[4]

Malskat had seen Olbers's anachronistic turkeys and, untutored in ornithology, assumed that they belonged to the original medieval composition. He'd so liked the look of them that he'd doubled their number to eight. The zeitgeist of the Third Reich covered his mistake. In fact, even Olbers was unable to discredit the Fey und Sohn restoration and debunk the Viking legend. His recollections were disparaged as senile delusions, his memory challenged by experts who dutifully quashed their qualms about Fey's restoration. They endorsed the St. Petri-Dom forgeries as a sort of pious fraud—a splinter of the Holy Cross or a Shroud of Turin for the National Socialist state religion. Arcane art history could be debated, but the murals had become politically sacrosanct, and professing faith in their authenticity was tantamount to believing in the Fatherland.

4. Jesus refers to Herod as a fox in the Gospel according to Luke. The turkeys, of course, have no biblical antecedent.

Half a decade later, the Fatherland was kaput. Captured by Allied forces, Himmler committed suicide. Rosenberg was convicted and hanged at Nuremberg. Stange was dismissed from his university post; the Vikings retired to the fjords.

Lothar Malskat emerged from the war unemployed and broke. Discharged from the Wehrmacht, he attempted to survive as an artist, painting erotic pinups that he peddled on the streets of Hamburg. By the summer of 1945, his circumstances were dire. He sought out his old employer.

Fey seems to have been the only man in Germany unaffected by the war. Though his father had not survived, and the restoration trade was moribund, he still lived in much the same style as when Malskat first encountered him in 1936, wearing fine suits and smoking fancy cigarettes. He gave Malskat a room in his servants' quarters and put him back to work.

The new business was different, but familiar enough. Instead of faking restorations, Malskat forged old-master and modern paintings. Fey supplied him with yards of canvas and a list of desirable names: Rembrandt, Watteau, Munch, Corot, Chagall, Picasso. To keep up with orders from collectors in Frankfurt and Munich, Malskat had to work fast. "Sometimes I copied an old painting in a day," he later recalled. "It took me an hour to do a Picasso. But what I liked best was to do new paintings in the style of the French Impressionists." Among the seventy-odd artists he imitated over the next several years in some six hundred oils and watercolors were Renoir, Degas, van Gogh, Gauguin, and Utrillo.

As might be expected, given the scale and speed of production, the quality was uneven. One Frankfurt dealer made the mistake of showing a Malskat to Chagall, who was notoriously unable to detect counterfeits of his own work. For once, Chagall had no trouble perceiving the fraud and destroyed the forgery with his

own hands. The dealer just shrugged off the loss and never again sought Chagall's opinion.

There were plenty of buyers, enticed by economic conditions. With the fall of the Third Reich, the German economy was ruined, shifting most transactions to a black market. Wary of hyperinflation, people used cigarettes as currency and sought to protect their savings by purchasing commodities such as art.[5] The majority of new collectors were inexperienced, and since many of the most valuable paintings had been looted from foreign museums or seized from Jewish collectors during the Holocaust, asking questions about provenance was verboten. Leading people to believe they were beneficiaries of others' misfortune, Fey transferred attention from the artifact to the transaction. He made people complicit in his transgression. Because the purchase was illicit, they trusted that the artwork was authentic.

And for a brief period, it made no difference. Since nearly everyone accepted the paintings based on their attribution, they traded freely, a colorful surrogate for money. Those who were artistically savvy cynically suspended disbelief. The pious fraud was no longer political but had become economic.

The West German Currency Reform of 1948 effectively ended the black market. Supported by the Marshall Plan, the new deutsche mark superseded dubious old paintings, and even American cigarettes, as the medium of exchange. The deutsche mark was introduced in June. One month later, quick-witted Fey came to Malskat with a new proposition. In the heat of war, an old church had been

5. Almost all of this art was "degenerate" by the standards of the Third Reich. After the war, nobody was clamoring to own paintings by "official" artists such as Adolf Ziegler.

engulfed in flames, and the fire had revealed an unknown medieval mural. People deemed it a miracle and were calling for a conservator. On the strength of his success in Schleswig, Fey secured the contract to restore Marienkirche in Lübeck.

The selection was controversial. In a sealed report filed with the provincial Culture Ministry, the Schleswig-Holstein State Curator Peter Hirschfeld wrote that "the restoration of defective medieval mural paintings is, in the last analysis, a question of trust. Dietrich Fey will not guarantee that he has never done any overpainting in an unguarded moment. I therefore declare that I disassociate myself from the working methods of the restorer Dietrich Fey. I decline all further responsibility."

However, the church authorities were determined to hire Fey and to have his restoration bring the attention to Marienkirche that it had to St. Petri-Dom eighty miles away. "Paint out the church beautifully," advised the Lübeck bishop Dr. Johannes Pautke. Further encouragement to enhance the murals was given by the church superintendent and, most emphatically, the chief architect, Dr. Bruno Fendrich, who exhorted the restorers to "preserve the religious impression," reminding them that "we want no museum." According to Malskat, Fendrich's favorite refrain was "Immer Farbe druff!" *Lay on more paint!*[6]

Malskat laid on more paint than even Fendrich could have hoped. Scaffolding was erected to bar entry into the nave, and signs were posted warning of danger overhead. Fey instructed the masons to start hammering whenever anyone approached, warning Malskat and his assistant, Theo Dietrich-Dirschau, to conceal work in progress behind wooden panels. With those precautions in place, the two men scrubbed the walls and reprimed

6. Of course, none of these quotes can be taken at face value, since our only source is Malskat.

the brick. On the fresh surface, Malskat repainted apostles and saints that had previously been only faint and incomplete. He worked quickly with bold lines and bright colors, covering in days the square footage that would have taken a more conventional conservator months.

The speed with which he painted put the project ahead of schedule. By the summer of 1950, he'd re-created all the 14th-century murals in the nave. A year remained before the seven-hundredth anniversary festivities, so Fey had scaffolding erected in the choir and proposed that Malskat discover an additional cycle of murals.

Since the walls were blank, Malskat had no visual constraints. Within the limitations of the era he was faking, he was free to create. To an extent, he worked from books, in particular Morton H. Bernath's classic 1916 survey of painting in the Middle Ages, *Die Malerei des Mittelalters*. His murals also borrowed liberally from earlier periods, for instance a 9th-century depiction of a Coptic saint in Berlin's Kaiser Friedrich Museum. Nor did he forget his father, or Hansi Knoteck, both of whom once again were models in absentia, as was Grigory Rasputin, whom he cast as a bearded king. He painted in local laborers as monks. He portrayed himself as a patriarch. Within months, the walls of the choir were resplendent with art. Twenty-one Gothic figures stood ten feet in height, embellished with friezes of animals and flowers: The Marienkirche miracle had a surprise postwar sequel.

Amid all this secret activity, only one expert seems to have managed to ascend the seventy-foot scaffold uninvited, a doctoral student by the name of Johanna Kolbe. Though she didn't witness Malskat at work, she had a unique opportunity to scrutinize the paintings with a magnifying glass rather than binoculars. What she saw appalled her. She informed municipal authorities that the

paint was applied "much too thickly" and also noted a few oddities in the nave, such as the disappearance of Mary Magdalene's sandals. Fey accused her of defamation. She decided that her memory must have been faulty.

That left only acclaim. "Ideas hitherto current as to the original aspect of Gothic brick interiors will have to be revised in light of the merits of the works here recovered," wrote the Lübeck Museum director Hans Arnold Gräbke in a monograph on the murals, *Die Wandmalereien der Marienkirche zu Lübeck*. Noting stylistic similarities to the frescoes in Schleswig, he dated the choir murals to the 13th century, an assessment echoed by the art historian Hans Jürgen Hansen in a second treatise. "They exhibit a severe style, Byzantine-influenced and still almost Romanesque," Hansen observed, contrasting them with the 14th-century paintings in the nave, which he found "more animated, softer, entirely Gothic." Even the dour Peter Hirschfeld came around, calling the murals "the most important and extensive ever disclosed in Germany, in fact one of the finest intact frescoes of the thirteenth and fourteenth centuries extant throughout western Europe."

The seven-hundredth anniversary of Marienkirche was celebrated in that spirit. Chancellor Adenauer declared the murals "a valuable treasure and a fabulous discovery of lost masterpieces." Louis Ferdinand, Prince of Prussia (and grandson of the late Kaiser), offered his royal congratulations. Reproductions of the murals were printed on two million postage stamps, issued in ten- and twenty-pfennig denominations.[7] Articles were published in periodicals around the world, including *Time* magazine, which pronounced the paintings "a major artistic find," informing

7. Both were so-called welfare stamps, sold at a five-pfennig premium. The extra five pfennigs were donated to Marienkirche.

readers that "the interior of the Marienkirche looks more as its original decorators intended than it has for 500 years."

Das ist erhebend! Over the following months, 100,000 people visited the church, supporting Lübeck's faltering economy with revenue from tourism. The murals of Marienkirche were miraculous indeed, seemingly able to provide for the city's every need.

The only person who didn't find the miracle of Marienkirche uplifting was Lothar Malskat. While restoring the church, he often quarreled with Fey, who paid him a mere 110 marks a week out of the 88,000 deutsche mark budget. When Malskat protested that he was doing all the work, Fey reminded him that he was just an anonymous assistant; the Hanseatic City of Lübeck had hired Dietrich Fey, the acclaimed conservator of St. Petri-Dom, to restore Marienkirche.

More than he begrudged the low pay, Malskat resented the anonymity. As he worked in the nave and especially in the choir, he grew increasingly attached to the paintings, convinced that he was not their restorer—or even their forger—but their full-fledged creator. He inconspicuously marked some of the figures with his initials. At one point, he wrote, "ALL PAINTINGS IN THIS CHURCH ARE BY LOTHAR MALSKAT." Fey promptly had his words whitewashed.

The seven-hundredth-anniversary celebrations left no doubt as to Malskat's position. He watched Fey take full credit for the murals and receive all the accolades. Fey was publicly honored by Adenauer, granted an additional 150,000 marks in restoration money, and nominated for a prestigious university professorship in Bonn, while Malskat was left to drink bottled beer with the masons.[8]

8. Or so he later claimed. Though the substance of his complaints was accurate, he was perhaps being a bit melodramatic: A press photo from the anniversary celebrations shows him standing in front of the murals between Adenauer and Heinrich Lübke, the president of West Germany.

Malskat's resentment festered for eight full months, while he worked for Fey on smaller restoration projects in the Lübeck Rathaus. Repeatedly, he confided to Dietrich-Dirschau his intention to get even with his imperious boss and gain the recognition he craved. Each time he lost courage. Then on May 9, 1952, he abruptly entered the police station and announced that the Marienkirche murals were counterfeit. He'd faked the medieval paintings on Fey's orders, he said, and he was confessing because "that crook Fey" had treated him unfairly.

Nobody believed him. The cops labeled him a crackpot, a local newspaper proclaimed that "this is the lamentable case of a painter gone crazy," and the good people of Lübeck proposed to have him committed. They refused to examine the murals—to scrutinize their miracle—even after Malskat submitted photographs taken with his Leica documenting his creative progress from whitewashed walls to finished frescoes.

Malskat appealed to the national media. The unknown painter's sensational claims garnered him interviews on radio and television. He pointed out the figures based on Rasputin and Hansi Knoteck, and *Die Welt* printed photos of murals next to their purported sources, including the Coptic saint in the Kaiser Friedrich. To any unprejudiced observer, the resemblance was unmistakable. Lest open-mindedness prevail, the city of Lübeck issued an official statement: "Rumors and accusations against the renowned art expert Doctor Fey are of no consequence and purely malicious gossip." The walls of Marienkirche had been reclaimed from oblivion; now they needed to be protected against defamation.

Unable to get himself and Fey arrested for their fraudulent restoration of Marienkirche, Malskat returned to the Lübeck police station in August, confessing to their prewar forgery in the Schleswig *schwahl*. If anything, that admission only further damaged his credibility: The crackpot artist was now also deemed a

megalomaniac. Fendrich and his fellow Marienkirche officials went on record with a signed decree: "Any charges at present being leveled at the restorer Dietrich Fey are as yet insufficient to rouse our misgivings. The work of preservation will therefore continue under the restorer Dietrich Fey."

Malskat hired an attorney by the name of Willi Flottrong. He told the lawyer not only about the bogus restoration work but also about the phony Picassos and Rembrandts. Handing over a folder of evidence, he instructed Flottrong to file charges against Fey and himself, legally compelling the police to act. Flottrong submitted the portfolio to the prosecutor on October 7. Two days later, Fey was detained while police searched his house.

They found seven paintings and twenty-one drawings counterfeited by Malskat, including forgeries of Matisse, Degas, Chagall, and Beckmann. No longer could the conservator or his restorations be protected. A commission of experts was dispatched to examine the murals of Marienkirche. On October 20, they published a report. "The twenty-one figures in the choir are not Gothic, but painted freehand by Malskat," the committee wrote. "The painting described as old by the restorer, Fey, does not lie on the medieval layer [of mortar] but on a post-medieval layer, and cannot, if for this reason alone, be considered original." The report also confirmed that the murals in the nave had been repainted.

This time, the Lübeck bishop himself spoke up. Conceding that the murals were fake, Pautke asserted that "if the restorer Dietrich Fey has fraudulently succeeded in getting his work recognized as faithful restoration, this was possible only because of an extremely cunning deception which misled not only the church administration, as proprietor, but also curators and art experts."

However, nothing rankles quite like the fraudulently pious. In the face of such monumental betrayal of the public trust,

the courts were unwilling to accept as a foregone conclusion the innocence of anyone. Over the following ten months, the prosecutor amassed hundreds of hours of testimony. Embarrassing questions led the church superintendent to request early retirement and another high official to depart for East Germany. In the several-hundred-page indictment, Bruno Fendrich was named codefendant.

Thus, the trial of Malskat and Fey also became a trial of the institutions that had supported them. "The real defendants are not the forgers, but the experts and officials who failed to exercise proper care," editorialized a local newspaper. "They didn't mind being deceived. Had Malskat not photographed the empty church walls before he started painting his murals, the evidence would have been suppressed by the very people who employed him. They are as much to blame as the forgers themselves."

The case was too big for the Lübeck courthouse. To accommodate all the people clamoring to watch the trial, proceedings were held in the Saal des Atlantiks, a dance hall popular for its swinging music, fashionably known as *Stimmung und Schwung*. The bar was draped to lend sobriety to the hearing, and the number of spectators seated on the dance floor was limited to four hundred, though several hundred more paid the Atlantiks janitor twenty pfennig an hour for a chair in the garden, where they could hear the testimony on loudspeakers.

The trial began on August 10, 1954. Asked why he had confessed, Malskat told the tribunal and the people of Lübeck—as well as the nearly fifty reporters in the press box—that "everybody raved about my beautiful murals, yet Fey got all the credit. Nobody even knew my name." From that moment on, he was the center of attention.

He presented himself as the unacknowledged master he consi-
dered himself to be, speaking of the consummate ease with which
he'd decorated Marienkirche. ("I love to do thirteenth-century
painting," he quipped "Nothing to it.") At the same time (and
somewhat inconsistently), he disparaged the connoisseurs who'd
praised his forgeries. "One art critic raved about the 'prophet with
the magic eyes,'" he said. "It was modeled on my father. Another
gushed about the 'spiritual beauty of the splendid figure of Mary,
so far removed from our present-day image of womanhood.' For
that painting I used a photograph of Hansi Knoteck."

Of course, with this new knowledge, people could no longer see
these figures as the critics had in 1951, believing them to be ancient.
From the vantage of the trial, the forgery of Marienkirche was
unfathomable. "At a time when X-ray apparatus, quartz lamps, and
the most modern technical equipment seem to exclude the possi-
bility of large-scale art forgeries," asked the prosecutor, "how could
a second-rate painter have fooled the nation's leading experts?"

"People like to be fooled today," responded Malskat. "We just
gave them what they wanted."

What people did not enjoy was knowing that they'd been
tricked. On January 26, 1955, after more than five months of tes-
timony, the court reached a verdict. "Although the ascertainable
material damage done may not have been excessive, it seriously
endangered the restoration of Marienkirche as a whole," asserted
the presiding judge. "The dishonest behavior of those engaged
upon it undermined confidence in the proper execution of all the
reinstatement work." In other words, the offense was not funda-
mentally a crime of property damage. The infringement was
psychological: robbery of faith, theft of a miracle.[9] After Fendrich

9. Photographs taken before Fey was hired show that the unrestored murals were
in significantly better condition than he and Malskat later claimed or than the court
statement implied. But scholarship was clearly not what counted most in Lübeck.

and Dietrich-Dirschau had been sternly chastised, Fey was sentenced to twenty months in prison and Malskat to eighteen.

His reputation ruined, Fey never restored his career in conservation. Malskat fled to Sweden, where he attempted to capitalize on his celebrity, and to prove his artistic genius, by soliciting commissions. He decorated Stockholm's Tre Kroner Restaurant in the 14th-century Gothic style and recycled his Schleswig turkeys in ersatz murals for the Royal Tennis Court. Extradited to Germany in late 1956, he served his jail term and then faded into obscurity,[10] eking out a living as a self-styled expressionist for his remaining thirty-two years.[11]

However, the most punishing treatment was reserved for Marienkirche itself. With the verdict, Peter Hirschfeld turned with a vengeance on the murals he'd been led to admire several years before, stating that "the forgeries should first be plastered over so as to obtain a clear surface free from all theoretical preconception and thus enable careful plans to be laid for an ideal solution of the problem by substituting true works of art for forgery, honesty for insincerity, with consequent obliteration of the stain upon morality. It should be considered the duty of any truly Christian community to carry out this task."

In the choir, Hirschfeld had his way. Malskat's transgression was covered up by workers and by and large forgotten. In the nave, the opposite viewpoint prevailed. "The nave forgeries were

10. Obscurity, not anonymity. A couple of years before Malskat died, the German author Günter Grass (a Lübeck resident) revisited the Marienkirche scandal in a novel called *The Rat*. An icon of the "phony fifties" along with Adenauer, Malskat was made to represent the fraudulence of the morally corrupt postwar era.

11. Malskat's turn to expressionism was anticipated by critics, albeit unintentionally, when they noted the remarkable similarity of the Lübeck murals to the expressionist art of Ernst Barlach. One writer presciently called it "a six-hundred-year-old spiritual affinity."

deliberately left as they were," noted the restorer Sepp Schüller, conservator of the Suermondt-Museum in Aachen, writing about the scandal in his 1959 book, *Forgers, Dealers, Experts*. "They constituted a sort of warning to all concerned with art, either as amateurs or professionals."

The contradictory responses reflect our emotional ambivalence toward a betrayal of trust: whether to obliterate or to commemorate the offense. Yet whichever decision is made, the sting of injury will pass, and people will recover their belief. According to the Lübeck entry in *Rough Guide: Germany*—a Baedeker for the 21st century—"Gothic frescoes of Christ and saints add colour to otherwise plain walls [of Marienkirche]; the pastel images only resurfaced when a fire caused by the 1942 air raid licked away the coat of whitewash." Malskat is not mentioned, nor is his moral stain apparent in the church. For a new generation of tourists, the murals are again miraculous.

WHAT IS AUTHENTICITY?

Alceo Dossena
1878–1937

In the Duomo of Pisa stands an octagonal pulpit sculpted in marble by Giovanni Pisano. Amid vivid depictions of angels and prophets can be found a Latin inscription, chiseled in 1310, crediting Giovanni as an artist "skilled above all men in the art of pure sculpture, who carved, in fitting fashion, glorious works in stone and gilded wood." Though Giovanni's skill with stone is preserved in the pulpit itself—and can be seen in ecclesiastical statuary throughout Northern Italy—evidence of his glorious woodwork was nowhere to be found by the early 20th century, when the pulpit was discovered in church storage and restored, renewing interest in Pisano's early-Renaissance expressionism. The inscription posed a problem for art historians. Lacking examples of Giovanni's wood carving in Pisa and beyond, their scholarship seemed vexingly incomplete. So in 1924, a pair of enterprising Italian art dealers, Alfredo Fasoli and Romano Palesi, came up with an unsolicited fix. They commissioned a wooden Pisano statue of their own.

Of course, Giovanni was long gone, dead since circa 1315. Yet the tradition of craftsmanship to which he belonged—learned from his father and taught to his pupils—had not altogether perished. In the early 1920s, there was a man with the technical

skills, if not the fame, of a Renaissance master, working in the Lungotevere district of Rome. His name was Alceo Dossena.

Proposing an appropriate subject—a life-size polychrome Madonna and Child—Fasoli and Palesi supplied Dossena with the raw materials: an anonymous 17th-century wooden sculpture of approximately the right dimensions and some antique frames and reliefs from which to scavenge gold leaf and polychrome paint. After several months, they collected the finished statue and hauled it to a secluded convent chapel in the town of Montefiascone. Then they started spreading rumors about it.

Harold Parsons, Italian agent for the Cleveland Museum of Art, heard of the Madonna at a dinner party. Arrangements were made for him to view it in secrecy and to buy it—pungent with incense—for $18,000. By March 1925, the Madonna was safely in Ohio, and the discovery was triumphantly announced by curator William Milliken in the Cleveland Museum's *Bulletin*, which cited the Duomo pulpit's inscription and noted the long-standing gap in Pisano's oeuvre. "Certainly no exact attribution can be made," Milliken acknowledged, but careful stylistic comparison to Giovanni's marbles in Pisa, Siena, and Pistoia supported a bold conclusion. "It is no school piece," he wrote, "and at this moment there is no known artist to whom it could be logically ascribed if not to Giovanni."

Two years later, there was no known artist to whom it could be logically ascribed, Giovanni included. A series of X-rays taken in June 1927, prompted by the doubts of independent scholars, revealed that parts of the sculpture were internally joined with 20th-century nails. The Madonna was quietly returned to Europe, disappointment mitigated by an exciting new purchase from the Continent: For $120,000, the museum had just bought a life-size marble statue of Athena, excavated under enigmatic circumstances,

believed to have been produced in the Southern Italian territory of Magna Graecia in the 5th century BCE.

The curators were right that the statue didn't come from the Greek mainland, but they were two-and-a-half millennia off the mark on the date. Favorably compared to the famous *Apollo of Veii* in 1927, the Athena's origin was traced to Dossena's Lungotevere studio when the forger was publicly exposed in 1928.

Alceo Dossena has often been credited as the most versatile art forger in history. Shortly after the Athena scandal made worldwide headlines, amid revelations of several dozen more spurious attributions, the German documentary filmmaker Hans Cürlis sought to film him at work to grasp what scholars had missed. Dossena obliged, humming popular tunes as he sculpted clay and chiseled marble. "The abnormality of his work became so natural that it only later occurred to us that we had witnessed the reincarnation of a Renaissance master and an Attic sculptor," Cürlis observed in retrospect. "One of the fundamental laws governing our attitude to all art seems to have lost its meaning, the law according to which a work of art can only originate once, at the point where certain temporally determinate causes intersect."[1] For this challenge to art history, Dossena himself gave a simple explanation: "Even as a boy in the industrial art school at Cremona, I grew to be perfectly familiar with the various styles of the past," he said. "I could not assimilate them in any other way."

1. Cürlis was nearly as versatile a figure as Dossena. In the 1920s, he filmed some of the most radical artists of the era, from Wassily Kandinsky to George Grosz, for his epic fifteen-hour documentary, *The Creative Hand* (which also, significantly, included his footage of Dossena). A decade later—after almost all of those artists had fled Germany—he produced Nazi propaganda films with Leni Riefenstahl.

Though hardly the Accademia di San Luca in Rome, the trade school Dossena attended in Cremona, the Istituto Ala Ponzone Cimino, taught him the rudiments of painting and sculpture, exposing him to classical models he could copy while also emancipating him from the sort of book learning he abhorred. He trusted his own hands, placing more faith in his creative abilities than in his teachers' knowledge. According to a story told to BBC journalist David Sox by a relative of Dossena in the 1980s, young Alceo was so offended when an instructor criticized a Venus he'd sculpted that he broke off the arms and buried it. Local children soon found it and brought it to the school, where the statue was carefully cleaned and placed on exhibit as an ancient artifact. Dossena was expelled, the relative told Sox, when he gleefully exposed his own ruse.

The tale is perhaps too apt to be believed, given Dossena's later achievements, but his expulsion was real, and a school report scoffed that he had "all the characteristics of an *enfant terrible*." Instead of seeking formal education elsewhere, he went to work for art restorers in Cremona and Milan, fixing countless marble and wooden fittings in churches throughout Northern Italy. Those apprenticeships gave him practice in the traditional crafts, as well as a thorough knowledge of how to artificially age materials. Equally important, it put him in physical contact with the work of masters from Pisano to Mino da Fiesole to Simone Martini, all of whom would later be spuriously credited with Dossena's own creations.

Dossena never became a master restorer himself and seems not to have thought of conservation as his *métier*. It was a way to make a living, support his wife and young son, and pay for raw materials to sculpt in his free hours. Then the First World War intervened and offered him a break in the person of Fasoli.

By most accounts, they met in 1916 while Dossena was in Rome, a soldier on leave for Christmas, seeking some money for gifts. Carrying a small bas-relief of the Madonna and Child, which he'd sculpted in terra-cotta and patinated in an army urinal,[2] Dossena stopped for a drink at Vinoteca Frascati, or Caffè Felicetto, depending on who's telling the story, but by all accounts a dive bar in the underbelly of the Eternal City. He offered his artwork to the proprietor, who called for Fasoli, a neighbor with a small antique store. Fasoli liked what he saw. Reckoning that it had been pilfered from a church, he bought it for a hundred lire, worth approximately $12 in 1916. But Fasoli was not long deceived, nor was he disappointed to have been duped: While a thief might stock his shop once, a forger could supply him indefinitely. After the war was over, Fasoli set up a studio for Dossena and made arrangements with his well-connected colleague Romano Palesi—familiarly known as the wormwood king on account of his knack for artificial aging—to buy as much as Dossena could make.

And what did Dossena make of Palesi and Fasoli? The historical record, already undependable with respect to the Christmas story,[3] here falters completely. A decade later, Dossena would claim that he had no idea what the dealers were doing and that he was innocent of their crimes. He was at least ignorant of the size of their spoils—an estimated $2 million over ten years—that

2. Evidently the appearance of the Holy Family at the bottom of a latrine caused none of the consternation in 1916 that Andres Serrano's *Piss Christ* would in the 1980s.

3. There will most probably never be a definitive version of this story. Among the most widely repeated variations are those recorded by Sepp Schuller and Peter Arnau in 1959, Russell Lynes in 1968, and Lawrence Jeppson in 1970. David Sox's 1987 book about Dossena's forgeries, *Unmasking the Forger*, claims that the Christmas meeting is an outright fabrication and that Dossena met Fasoli after the war while peddling his wares in bars, but Sox presents no better evidence than the others. In all cases, as is so often the case, all that remains is hearsay.

they barely shared with him. The bas-relief was resold as a Donatello for a four- or five-figure sum. And for the $120,000 Athena, Dossena was probably paid about $7,500—a good wage for an accomplished stonemason.

Dossena the craftsman had plenty of work between 1918 and 1928. Commissions were regularly given to him by Fasoli, who, together with Palesi, decided in advance what might be marketable through their network of crooked and gullible middlemen. They benefited from the harsh economic conditions following World War I, which fostered a black market in genuine masterpieces illicitly sold by impoverished European institutions to the wealthy patrons of ambitious American museums. Rumors were rife and alluring. Even the Vatican was said to be furtively selling off hidden treasures.

In this environment, there was no reason that a wooden Madonna by Giovanni Pisano shouldn't appear for the first time in six hundred years. Indeed, it was hardly worth mentioning, compared to another Dossena masterpiece sold in 1924, a Simone Martini *Annunciation* that Helen Clay Frick purchased for $225,000.

Absolutely wonderful. Unbelievably rare. Those were the words with which Frick's European agents described it to her, proposing that she purchase it for her family's namesake museum. The agents were not exaggerating. A Sienese master of the early 14th century and a favorite of Petrarch, Simone was especially famous for an *Annunciation* in the Uffizi Gallery, which Czar Nicholas II had ordered copied by the painter Nicholas Lochoff. Following the Russian Revolution, Lochoff's copy was sold to Frick as a fine reproduction and hung at the entrance of Helen's museum in lieu of an original. Frick could scarcely have more visibly advertised

that she wanted a Simone Martini painting in her collection. Through a freelance scholar-dealer named Elia Volpi, her agents had discovered something even more spectacular.

Simone was known to have been influenced by French Gothic art, and the shapeliness of his figures suggested that he had especially learned from 12th- and 13th-century French statuary. Yet no sculptures by him were known, a fact noted in the 16th century by Giorgio Vasari, who lamented in his *Lives of Simone Martini and Lippo Memmi* that paintings "cannot have that eternal life which castings in bronze and works in marble give to sculpture." The unbelievable rarity Frick's agents had found was a pair of life-size marble statues strikingly similar to the Virgin and Angel in the Uffizi panel. Volpi proposed that Simone Martini had made them. Frick accepted his judgment and wired him the money. With unintended irony, the statues were placed across from the Lochoff copy in the Frick lobby, figures captured in mid-gesture waiting to be written into art history.

Tempting as it may be to take Frick for a fool, she wasn't one to spend her fortune indiscriminately. As early as 1921, she'd rejected another absolute wonder created by Dossena and peddled by Fasoli and Palesi: a complete marble sarcophagus said to have been sculpted by the 15th-century Tuscan master Mino da Fiesole for the aristocratic Savelli family.

The tomb was first shown to Volpi in a ruined Sienese church, where miraculously a receipt in Mino's hand was also preserved. When Volpi failed to interest Frick, Fasoli and Palesi had it moved to a cemetery in Florence, where they showed it to the Vienna Kunsthistorisches Museum curator Leo Planiscag. He also rejected it and convinced the Kunsthistorisches Hofmuseum in Vienna to return it when he learned that they'd acquired it. In 1924, finally, a dealer named Carlo Balboni bought it and sold it for $100,000 to the Museum of Fine Arts in Boston.

There were several obvious reasons to be skeptical of the tomb's authenticity. On the front of the sarcophagus, above the recumbent figure of a woman in low relief, were two identical Savelli coats of arms, an inexplicable redundancy. Even more non-sensical was the inscription chiseled beneath the body: *Obiit enim praefata Maria Catharina de Sabello anno Christi MCCCCXXX*. In Latin, the word *praefata* means "aforesaid," suggesting that the inscription had been copied verbatim from the last paragraph of a longer document. Most damning of all, in 1430, the year Maria Catharina died, Mino was just one year old.

Challenged on all these grounds and rattled by the exposure of Dossena (who gleefully claimed credit for it), the Boston museum removed the tomb from public view in 1928 but refused to acknowledge that it was new. The sarcophagus was still in basement purgatory in 1935, when George Edgell was made museum director and decided to put it back on view. Inconsistencies detected by laboratory examination were attributed to extensive restoration, a subject on which Edgell elaborated in the December 1937 issue of the museum's *Bulletin*. He proposed that a restorer "in rebuilding the tomb had used an old slab which did not belong to the original. Since this slab had the Savelli coat-of-arms, it might then have occurred to the restorer to repeat it for a dam-aged or missing slab on the other side, thus accounting for a second coat-of-arms on a slab of marble which microscopic inves-tigation revealed to be modern though artificially aged. Having the Savelli coat-of-arms, it would be necessary also to re-cut, or cut anew, the inscription so that it would apply to a member of the Savelli family. This could account for a modern inscription of inappropriate Latinity and a date which seemed too early for the style of the monument." Only after all these suppositions and justifications did he get to the point. "In any case," he wrote in third-person imperious, "the Director would like to emphasize in

conclusion the fact that the tomb is put on exhibition because it is a beautiful object."

That sentiment was echoed by other institutions more willing to acknowledge that they'd been duped. A 1928 article in the *New York Times* records the Cleveland Art Museum curators calling Dossena "among the greatest sculptors of the day." And in a 1931 interview with the *Times*, Frick trustee J. Horace Harding paid tribute to his "creative art," saying that "Dossena deserves to be recognized as one of the greatest sculptors the world has known. In my opinion, his sculptures which have found their way into American collections are treasures that are cheap at any price."

Naturally, there's a dose of retroactive self-justification in such assertions,[4] but the praise goes well beyond mere rationalization and helps to explain why experts and connoisseurs were willing to overlook the historical unlikelihood of sculpture by Martini or the manifold problems with the Savelli tomb. To early-20th-century viewers, these objects were almost preternaturally charismatic. For all Fasoli and Palesi's antics—often clever, sometimes ludicrous—what animated the artifacts was Dossena's mallet.

Dossena once told the art historian Walter Bombe that he had no formal training save for ten anatomy lessons. Though this claim conveniently overlooked his aborted trade school education and

4. Harding, for instance, was less gushing about Dossena before the Frick gave up on a Martini attribution for their *Annunciation*. On December 8, 1928, the *New York Times* ran the following item: "J. Horace Harding, treasurer of the Frick Collection, declares in a letter to the *New York Times* that the trustees of the collection have not purchased any sculptures by Alceo Dossena. 'Several sculptures were offered to the trustees, which time has developed were apparently works of Dossena,' Mr. Harding stated, 'but the articles were rejected by the trustees, and any reports to the effect that the Frick Collection has any of his works are untrue.'"

serial apprenticeships with restorers, it was essentially legitimate. Dossena's sculptures were without theoretical foundation. The anatomy lessons had taught him to begin with observation.

When Fasoli commissioned a sculpture, he supplied the artist with photographs that supplemented Dossena's direct experience of the masters' artwork in situ. In the case of Simone Martini, Dossena referred to pictures of the Uffizi *Annunciation*. For the Savelli sarcophagus, he was given photos of Mino da Fiesole's 1480 *Tomb of Francesco Tornabuoni* in Rome to inspire the architecture, and Bernardo Rossellino's 1451 *Tomb of the Beata Villana* in Florence to suggest the dead woman's recumbent pose. Dossena relied on these for historical facts such as period dress, as shown by another gaffe in the Mino sarcophagus: One of Maria Catharina's slippers lacks a sole because the sole of the Beata Villana's shoe was not visible in Dossena's photograph of Rossellino's tomb.

Yet the unintended omissions are the least of the differences. Dossena's Maria Catharina has a personality wholly distinct from the Beata Villana, more pampered, less devout. And the postures of his Virgin and Angel have the same center of gravity as those of Martini, but their gestures are dissimilar, their expressions altered, as if he and Simone had captured the same characters in different moods. Even if old-fashioned, Dossena wasn't wholly beholden to the past. He was also working from life.

"We watched Dossena modeling for a long time before we filmed him," Hans Cürlis later recalled of the documentary he made. "The figures were first thoroughly shaped in the nude from the living model, a pair of large wooden dividers being frequently used to measure length of limb, head, and distances on the model and transfer them to the clay figure. Then he draped the model and reproduced the robing in clay on his figures." Dossena's process was the same whether the subject belonged to the Renaissance

or ancient Greece. "We were naturally very keen to see Dossena at work on an ancient statue," noted Cürlis. "The goddess, too, was first modeled in the nude and then draped in her robe. The head took shape with equal fluency, and quite suddenly a smile dawned on the face of a woman to whom the Greeks had prayed two thousand five hundred years before."

Of course, female models, especially naked, weren't common in the 1400s, and the ancient Greeks left no record of their studio techniques. That didn't seem to bother Dossena and—from the standpoint of the artists he emulated—the remainder of his process was even more unorthodox. Immaculately finished statues were smashed with a hammer. In the case of archaic marble works, such as the Cleveland Museum's Athena, he sandblasted the fractures to emulate erosion. Then fragments were lowered by winch into an acid bath sunk in the studio floor and soaked as many as forty times, in between which the stone was blazed with a torch to crackle the surface. Other chemicals were intermittently applied to produce chalky deposits.[5]

Dossena declined to reveal his exact formula. "The patina is a secret of mine," he told the *Giornale d'Italia* in 1931, "and also a torment to me. If this light of mine gave luster to my creations it was never an end in itself. It was part of the amalgam that made of the object something worthy."

More broadly, Dossena was emphatic that he never intended to deceive people with his sculptures. Interviewed by *Art News* in 1929, he spoke with frustration of "the mistaken supposition that

5. The combined effect of these processes was remarkably convincing at the time. "It has been learned here that competent geologists declared that the apparent erosion of the fraudulent Greek works was the result of natural processes operating over twenty-four centuries," the *New York Times* reported on December 5, 1928. Of course, great care was taken to leave this meticulously wrought damage visible, by piecing the broken statues back together in as amateurish a way as possible.

I meant to make false representations. The truth is that I have never made any but original things, modeling them from nature in an antique character and style."

There are many reasons to doubt him, from his pretense of carving the Savelli coat of arms into the Boston sarcophagus to the troubles he took to make his patina penetrate beneath the surface of his Athena. There are also good grounds to believe Dossena, such as his predilection for working freely from life rather than focusing purely on antiquarian sources, to say nothing of his stonemason's wages. His undeniable fakery would seem to be incompatible with his evident sincerity. Following his exposure, people felt compelled to take one side or the other.

There is another option. Can it be that the issue of authenticity, foremost in experts' minds, didn't really matter to him?

"In the basement of the Metropolitan Museum of Art stands a little statue, smiling," reported the *New York Times* on December 5, 1928. "Perhaps it smiles because it slipped into America's greatest museum, past all the barriers raised to keep apocryphal works out. It was bought for the museum several years ago as a genuine piece of archaic Greek sculpture. Now it is known to be just another example of the work of that gifted imitator of ancient sculptural styles, Alceo Dossena of Rome."

The statue in the Metropolitan basement was a three-foot-tall kore, acquired in 1926 by the Met's European agent John Marshall as an artifact from the 6th century BCE. Marshall began to doubt the kore's legitimacy on stylistic grounds shortly after shipping it to the United States. He requested that it not be exhibited.

Several months later, Marshall was shown fragments of several more statues, including a standing Athena and an abducted maiden,

purportedly from the same illicit excavation.[6] These confirmed his suspicions of fraud. He partnered with a well-connected colleague, an Italian diplomat named Piero Tozzi, to discover the forger.

Fasoli must have been aware of the investigation—or must at least have heard rumors circulating in Rome about the recent spate of wholesale fakery—when Dossena approached him in May 1927 to collect several thousand dollars owed on a statue. Dossena needed the money urgently because his mistress had just died after months of illness, and he could not afford the medical bills or funeral expenses.[7] Evidently expecting that Dossena would soon be exposed and would no longer be of value, Fasoli refused to pay. Stunned by the betrayal of trust, Dossena sought the advice of a lawyer, who seems to have quickly reckoned the sort of money Fasoli and Palesi were making by selling Dossena's statues as antiques. Dossena sued his dealers.

Fasoli responded by reporting Dossena to the police as an enemy of the Fascist regime, accusing him of verbally slandering *Il Duce*. To lend authority to his groundless accusation, he hired the secretary of the Rome Fascist Federation, Aldo Vecchini, as his attorney. Not to be outdone, Dossena hired Roberto Farinacci, secretary of the National Fascist Party, second in command to Mussolini.[8] Charges against Dossena were summarily dropped,

6. With these statues, Dossena was just getting started. According to the December 5, 1928, *Times* article, "Not only were many of his works life size, but he even projected the completion of an entire pediment of an archaic Greek temple, with figures portraying the mythological battle of the gods and giants, known to archaeologists as giganotmachia."

7. Dossena seems to have left his wife, Emelia, back in Cremona but brought his son, Alcide, to Rome to work in his studio. With his Roman mistress, Teresa Lusetti, he had a second son, Walter, who joined Alcide in the workshop. Walter published the first brief biography of Dossena, *Alceo Dossena: Scultore*, in 1955.

8. Farinacci grew up in Cremona—and appointed himself mayor there before joining Mussolini in Rome—which may have made him receptive to Dossena. According to Lusetti's biography, Dossena was working on a bust of Mussolini at the time of Fasoli's accusation, which may also have helped him gain access to the powerful party secretary. Farinacci was enough of an admirer of Dossena that he accepted two small statues in payment for his representation, though the failure of his lawsuit left Dossena with little else to offer.

but Farinacci could not make Fasoli pay the money Dossena demanded, an ever-escalating sum stretching into the hundreds of thousands of dollars. After a court-appointed appraiser valued Dossena's sculptures at several thousand lire—the deliberate breakages being counted as damage—the case was abandoned.[9]

But the prominence of those involved and the sensational claims made Dossena famous by 1928, leaving no doubt about the origin of several dozen major Renaissance and Classical forgeries. In September, he was visited by Metropolitan curator Gisela Richter. With evident pride, he showed her his plaster model for the Metropolitan kore, studio photos of the Cleveland Athena, and numerous works in progress, including, her secretary noted, "a Mino da Fiesole relief of a Madonna, a Gothic baptismal font, a French seventeenth century helmeted head, tampered with acid perhaps, but certainly not yet fired, etcetera." He gave Richter a comprehensive tour of his studio. "All my own work," he told her. "None are copies, none are imitations, I created them all— paintings, sculpture, architecture, wood carvings."

He was equally forthcoming with others, including dealers such as Jakob Hirsch, who'd sold the Athena to the Cleveland Museum and was required to refund their money. For obvious reasons, Hirsch did not want to believe Dossena's claims and accused him of lying. Even after the sculptor showed him fingers broken off the Athena's hand, he insisted that Dossena was just a vainglorious restorer.

Certainly, Dossena wasn't modest. That much Hirsch got right. Shortly after the Fasoli trial, Dossena boasted to the

9. As in the case of Dossena's first meeting with Fasoli, there are many contradictory versions of these events, complicated by what Russell Lynes refers to as the "discovery sweepstakes" to claim credit for having caught him. This seems to be the most plausible reconstruction.

newspapers that his sculptures "really deserve to be prized as highly as those of Donatello, Verrocchio, Vecchietta or da Fiesole," all men he'd emulated in his half-century quest to assimilate his observations of the human figure with those of the artists he deemed masters.

He did not pretend that his work was theirs but imagined himself to be their peer and also a contemporary of the ancients. His falsifications—the hammer blows and acid baths—gave credence to this conviction.

Between 1929 and 1931, the notorious forger Dossena had exhibitions in Paris and Berlin and Vienna. His work was shown at the Victoria and Albert Museum in London. A full room was briefly devoted to his antiquities at the Metropolitan. His fakes were also put up for sale by dealers who'd been burned, as well as by Dossena himself. On March 9, 1933, National Art Galleries, Inc. organized a public auction in the ballroom of New York's Plaza Hotel. The catalogue was prefaced with an essay by the esteemed editor-in-chief of *Art News*, Alfred Frankfurter, who paid tribute to the "quality of sincerity in Dossena, the almost incredible ability of the man to have worked without affectation and without malevolence in the spirit of the dead past and its masters." In Frankfurter's opinion, that made his work "as valuable to the collector and museum for artistic achievement as for scientific documentation."

Buyers were warier. The thirty-nine pieces at the Plaza realized a mere $9,125. The highest price paid was $675, for a marble relief of the Madonna and Child in the style of Mino da Fiesole. Commentators were also growing increasingly disenchanted, particularly scorning new works executed under Dossena's own

signature.[10] "The faker Dossena is finished," wrote the critic Oscar Bie about Dossena's exhibit at the Berlin Hall of Art in 1930. "But the artist Dossena does not appear." Seven years later, the critic Adolph Donath was even more dismissive in his book *How Forgers Work*. "Dossena's work leaves us unmoved," he wrote.

That was the year Dossena died, following a stroke, on October 11, 1937. Posthumous judgment didn't improve his reputation. In the classic 1948 book *Fakes*, the art historian Otto Kurz derisively described Dossena's admirers as "those who expect historical sculptures to be very grand, but just the least bit stiff, a little boring, slightly empty, and above all not too outmoded." And when Perry Rathbone became director of the Museum of Fine Arts following George Edgell's death in 1954, he buried the Savelli tomb in storage.[11]

There is truth to Kurz's observation, apparent in retrospect. Maria Catharina's pretty face would have made her a good catch in the 1920s, and the figures in the *Annunciation* attributed to Martini are sweet enough to have been cast in the movies. Yet Frankfurter's 1933 tribute is equally compelling. If anything, the sculptures' sentimentality is testament to Dossena's sincerity. The slightly empty grandeur reflected his era and made his anachronistic art contemporary.

10. Dossena created religious statuary under his own name for churches, including the Chiesa del Gesù in Rome. He was also commissioned to portray fashionable aristocrats, including the Principessa Borghesi, in the Renaissance style.

11. Several years earlier, as director of the St. Louis Museum of Art, Rathbone had garnered praise in *Art News* for purchasing "the most important Etruscan revelation since the discovery of the famous *Apollo of Veii* in 1916," a terra-cotta statue of Diana the Huntress for which he paid $56,000. Several scholars questioned it on stylistic grounds. Then Walter Lusetti's 1955 book included several photographs of the sculpture being made in his father's studio. Rathbone was still insistent that it was authentic—albeit heavily restored—in the 1980s. No connoisseurship is without prejudice.

The schism in Dossena's reputation reflects the problem presented by his art, that it cannot adequately be categorized as true or false. Neither the praise he garnered in the 1920s nor the condemnation that followed does his work justice. He was an original and he was a copyist, and the compulsion to take sides merely reflects society's categorical literal-mindedness. Modern viewers deem authenticity a prerequisite for an artifact to be a work of art. Dossena presented people with an authentic paradox.

At least one anonymous functionary in the Italian government attempted to register what Dossena had achieved. Every sculpture bound for the 1933 National Art Galleries auction in New York needed to be documented for export. The bureaucrat issued a permit for each artwork, certifying that it was a genuine fake.

WHAT IS AUTHORITY?

Han van Meegeren
1889–1947

The first time Han van Meegeren exhibited his paintings, at a Hague art gallery called Pictura in 1917, the critics were ecstatic. "He shall find many admirers," predicted *De Nieuwe Courant*, one of the leading newspapers in Holland.

Five years later, the critics turned on him. "Pictorial gallivanting," pronounced the elite Dutch magazine *Elsevier*, asserting that van Meegeren's new biblical tableaux had "no profound meaning." Writing for the daily *Het Vaderland*, the influential art reviewer Just Havelaar was more explicit. "Whenever he set about to paint Christ," Havelaar wrote of van Meegeren's two-room show at the Hague's Kunstzaal Biesing, "he could not avoid the notion of something highly noble and exceedingly grievous to be represented, with the result that his Christ figures are often insipid and sweet, sometimes miserably forsaken, always weak and powerless." Though the gallery found buyers for van Meegeren's virtuoso depictions of the young Christ teaching in the Temple and the supper at Emmaus, his earnings could hardly compensate for the injury to his reputation.

Over the following decade and a half, van Meegeren redoubled his efforts, painting scenes of contemporary life fraught with symbolism, as well as commissioned portraits of rich patrons, but the critics appreciated none of it. "They resented his independence,"

the journalist Irving Wallace later related in the *Saturday Evening Post*. "When Dutch critics approached him with the routine promise of writing good reviews of his exhibits if he would pay them, van Meegeren indignantly refused. So the critics wrote bad reviews." No matter how fervently he protested, they would not relent. "At last, in 1936, when he could bear the criticism no more, van Meegeren determined to get even."

That autumn, working alone in a secret studio, van Meegeren created a new version of the supper at Emmaus. He painted on antique canvas with a badger-hair brush, using old-fashioned pigments including ultramarine and cinnabar. Setting the supper table with dishes and goblets from the 1600s, he embellished the scene with 17th-century stylistic touches such as pointelle. Then he signed it, not with his own name but with a monogram. In the upper left corner, he wrote the letters IV Meer.

One year later, a short article appeared in the *Burlington Magazine for Connoisseurs*. "It is a wonderful moment in the life of a lover of art when he finds himself suddenly confronted with a hitherto unknown painting by a great master, untouched, on the original canvas, and without any restoration, just as it left the painter's studio," wrote Abraham Bredius, former director of the Hague's Mauritshuis Museum. "And what a picture! We have here a—I am inclined to say *the*—masterpiece of Johannes Vermeer of Delft." Bredius found nothing to criticize and everything to praise. "Outstanding is the head of Christ, serene and sad...yet full of goodness," he eulogized. "In no other picture by the Great Master of Delft do we find such sentiment, such a profound understanding of the Bible story—a sentiment so nobly human expressed through the medium of the highest art." On the strength of that laudatory text, and the author's eminence, the Museum Boijmans in Rotterdam acquired the painting for 520,000 guilders—approximately $3.9 million today—and made

The Supper at Emmaus the centerpiece of a blockbuster exhibition on the Dutch golden age.

The art establishment was enraptured. "The discovery of *Emmaus* is the most important art historical event of this century," wrote the scholar Frithjof van Thienen in a 1939 monograph on the master of Delft. "The painting shows Vermeer at his best." Moreover, *Emmaus* established van Meegeren's visual language as Vermeer's own. Under the same legendary monogram, he avenged himself on the experts five more times between 1937 and 1943, before taking credit for creating Holland's most fêted paintings.

Rather than condemn his crime, the press embraced van Meegeren with a fervor to match the experts' erstwhile enthusiasm for *Emmaus*. In the Netherlands, his story was rapidly packaged as a novel and a comic book, and his saga spread globally through popular media, including *The Saturday Evening Post*. In Wallace's phrasing, van Meegeren's hoax stood to "vindicate his claims and blast the complacency of art criticism." The Dutch public concurred. A poll showed that van Meegeren was the second most popular man in Holland—bested only by the newly elected prime minister—and citizens petitioned to build a statue in his honor. After five years of German wartime occupation, during which the nation's powerful opportunistically collaborated with the enemy, van Meegeren symbolized the virtue of challenging authority.

Yet the unquestioning authority with which van Meegeren's saga was told had problems of its own. When he wasn't counterfeiting Vermeers, van Meegeren had spent the 1940s opportunistically painting Third Reich propaganda. And before the war? Han van Meegeren began his career as a counterfeiter in 1920, two years prior to the first murmuring about pictorial gallivanting. Van Meegeren's greatest forgery was his own life story.

The year of Han van Meegeren's debut at Kunstzaal Pictura is better known by art historians as the year Theo van Doesburg launched *De Stijl* in Leiden, less than fifteen miles northeast of the Hague. Aesthetically, the journal and the movement it spawned were a world apart from van Meegeren's quaint scenes of horse-drawn carriages and women with parasols, let alone his biblical tableaux. "The artist no longer needs a particular starting point in nature," *De Stijl* cofounder Piet Mondrian asserted in his 1919 treatise *Natural Reality and Abstract Reality*. "He spontaneously creates relationships in equilibrium—complete harmony—the goal of art."

For van Meegeren, the abandonment of nature was heretical. He was adamantly opposed to all manifestations of modernism and blamed the "fingerpainting" of Vincent van Gogh for the "spiritual sickness" that had corrupted the Netherlands. For van Meegeren, art was technique. And the traditional techniques that he'd learned as a boy in provincial Deventer were not to be questioned.

There were two avenues open to a man of his persuasion in early-20th-century Holland. The first was to make art for a contemporary public as alienated from the avant-garde as himself. The second was to retreat into the past. Van Meegeren successfully traveled both paths.

In the Hague, where opulence counted for more than ideas, van Meegeren's facile paintings found an eager audience. He was especially effective at infiltrating the elite precincts of the Liberal State Party, donating artwork for campaign posters in order to befriend members of parliament. Three years after he was lambasted in *Het Vaderland* by the critic Just Havelaar, Liberal State Party chairman H. C. Dresselhuys was quoted in the same newspaper claiming that van Meegeren was "one of our best contemporary artists." By then, he'd cornered the market on flattering

portraits of the upper crust. He had also found his way into middle-class homes with his saccharine drawing of a fawn—allegedly the pet of Princess Juliana—that decorated countless calendars and greeting cards.[1]

Van Meegeren was well compensated for this work, generating an income that many avant-garde artists would have envied. But in the early 20th century, no modern painter could command prices comparable to the old masters. Picasso earned approximately $5,000 for a major canvas in the '20s. By comparison, *The Laughing Cavalier* by Frans Hals sold for approximately three times that amount—and it was a counterfeit. The painter? Han van Meegeren.

Completed in 1922, the year of van Meegeren's biblical exhibition at Biesing, *The Laughing Cavalier* was one of his two earliest forgeries. The other, called *The Smoking Boy*, was also signed Hals and, like *The Laughing Cavalier*, was the product of technical innovation as much as stylistic imitation. Both were created by altering the chemistry of oil paint to mimic the effects of aging.

The crucial breakthrough was made by a conservator named Theo van Wijngaarden, whose restorations often included the discovery of signatures suggested by customers. Like all forgers, van Wijngaarden was bedeviled by the slow drying time of traditional paints made with linseed oil, which have a tendency to dissolve in alcohol when less than a hundred years old. By the early 20th century, the so-called alcohol test was routinely used to detect fraud. So van Wijngaarden shrewdly substituted the linseed for a glue made of gelatin. The only trouble was that he lacked artistic talent: By traditional standards, he couldn't paint.

1. As one of the animals in the Royal Menagerie, the fawn drawn by van Meegeren may technically have belonged to Juliana. As was so often the case in his work, attribution was a matter of opinion.

Then one day in 1920 he met van Meegeren through a mutual friend.

Even with a fast-drying medium, the forging of two oils by Frans Hals took time. The new paints needed to be perfected, the colors clarified, and the viscosity refined. A couple of period pictures by lesser artists had to be acquired. The original oil paint had to be scraped off the wooden panels, and the old images replaced with van Meegeren's inventions, evocative of Hals yet not recognizably derivative. Artificial aging was needed to make the paintings look like they'd survived three hundred years, unrecognized and carelessly kept, before being rediscovered and brought to an expert for authentication—a public unveiling that had to be meticulously planned in its own right.

The expert van Wijngaarden chose was Cornelis Hofstede de Groot, an independent art historian (and former Bredius protégé)[2] who made his living authenticating old master paintings. Hofstede de Groot's fees were based on a painting's value, with rates ranging from thirty to one thousand guilders. On payment, he'd fill out a preprinted form that, given his sound reputation, was practically as good as a check in the bank.

The financial arrangements naturally gave Hofstede de Groot an incentive to see the best in paintings.[3] Yet van Wijngaarden had also chosen him for another reason: The subject of *The Smoking Boy* had been selected especially for Hofstede de Groot, modeled on a painting in the Staatliches Museum Schwerin for which the expert had previously expressed admiration. Dating from 1626 to

2. By the 1920s, the two men were no longer on speaking terms, and even after Hofstede de Groot died, Bredius refused to enter the building housing his archives. Petty jealousies divided most of Holland's authorities, fostering an environment of distrust vulnerable to manipulation.

3. Charging a fee for authentication was customary and made experts such as Hofstede de Groot and Bredius wealthy enough to be serious collectors in their own right. It may be no coincidence that so many new paintings were discovered in this era.

1628, the Schwerin painting depicts a boy holding a flute, "evidently the same boy," Hofstede de Groot obligingly recognized, as the one in van Wijngaarden's find. Authenticating both of van Wijngaarden's paintings without hesitation, he bought *The Smoking Boy* for his own collection, deducting his 1,000-guilder fee from the 30,000-guilder invoice.

In August 1924, a brief article appeared in *The Burlington Magazine*, titled "Some Recently Discovered Works by Frans Hals," in which Hofstede de Groot took credit for reclaiming four of the old master's works from oblivion, including the two brought to him by van Wijngaarden. Theorizing that *The Smoking Boy* depicted "one of the sons of the painter" and dating it to 1625–1630, he wrote that "the picture has great attractiveness as a subject and marvellous handling of the brush, every stroke of which can be counted." *The Laughing Cavalier* received equal accolades— "magnificent in the contrast of colours and in a perfect state"— though he was obliged also to comment that "curiously the authenticity of this picture... was doubted, and a lawsuit is actually pending before the Court at The Hague."

The suit had been filed shortly after van Wijngaarden sold *The Laughing Cavalier* to a private collector through Frederik Muller & Co. in Amsterdam.[4] For unknown reasons, the collector had come to mistrust it and had it examined. The painting passed the alcohol test as expected but failed an even more basic diagnostic: Van Wijngaarden's miracle paint was soluble in tap water. Muller refunded the 50,000-guilder cost and accused van Wijngaarden of fraud.

Though he'd feigned professional disinterest in *The Burlington Magazine*, Hofstede de Groot was outraged. By his reckoning, the

4. Van Wijngaarden's codefendant was H. A. de Haas, an old school friend of van Meegeren they'd paid a commission to act as middleman.

allegations against van Wijngaarden were an indictment of his own judgment and thus a threat to his livelihood. Willingly led to believe that the sponginess of the paint was caused by van Wijngaarden's cleaning,[5] he declared war on anyone who questioned his attribution. That meant an assault on science, especially after additional examination of the painting uncovered pigments first used long after Hals was dead, including zinc white and cobalt blue.

"In the art of painting, the eye must be the benchmark, as in music it is the ear," Hofstede de Groot wrote in a pamphlet titled *Eye or Chemistry?* privately published to publicize his views. "Neither the tuning fork nor the test tube will do." He also took his case to the newspapers, including *Het Vaderland*, where van Meegeren's name appeared—yet again—this time following rumors he might have painted *The Laughing Cavalier*. "[He] should wish that [he] could paint that way," the connoisseur declared.

Still, van Meegeren and his partner were not rescued by Hofstede de Groot's arguments or influence, but rather by his pride. In 1926, he settled the lawsuit by paying Muller the full 50,000-guilder price for *The Laughing Cavalier*. The painting entered his private collection, joining *The Smoking Boy*. There it stayed, secure inside his limestone mansion where nobody could call his authority into question.

"To hear almost every year of a newly discovered Vermeer may cause suspicion," wrote Wilhelm Valentiner, director of the Detroit Institute of Art in the April 1928 issue of *Art in America*. "And indeed we can be sure that in the endeavor to discover unknown

5. Van Wijngaarden proved to Hofstede de Groot that the softness was caused by his cleaning chemicals by wetting another painting he claimed to have restored and showing that the paint became spongy in water. Naturally, the painting on which he demonstrated the authenticity of the Hals was also a forgery.

works by this rare master in recent times, paintings have often been associated with his name which cannot stand serious criticism. On the other hand it is still quite possible that for a number of years to come new Vermeers may now and then appear."

Valentiner's cautious optimism was shared by many early-20th-century scholars and curators, for whom Vermeer was as much an enigma as a revelation. Though admired by his contemporaries, who paid top guilder for his paintings, Vermeer was nearly forgotten by the early 18th century, when his name was omitted from Arnold Houbraken's standard encyclopedia of Dutch artists, *De Groote Schouburgh der Nederlantsche Konstschilders en Schilderessen*. Some of his paintings were lost. Others embellished the royal collections of the Duke of Brunswick and King George III, mistakenly attributed to more famous artists such as Pieter de Hooch and Rembrandt. Only in the 1860s was he rediscovered, brought to public attention in a series of articles by the French historian Théophile Thoré-Bürger.

Able to find almost no information on Vermeer's brief life, Thoré-Bürger dubbed him "the Sphinx of Delft" and intermittently referred to him as Van Der Meer. There was plenty to cause confusion, including the fact that in Vermeer's era there was a Johannes Van Der Meer working in Utrecht, as well as two Jan Van Der Meers in Haarlem. "This devil of an artist must no doubt have had several styles," he wrote. Nevertheless, he identified no fewer than seventy-two paintings by Jan Vermeer of Delft, on the basis of which he audaciously rated the painter "one of the foremost masters of the entire Dutch school," in the company of Rembrandt and Hals.

At first, the articles had little discernible impact. In 1881, a collector named A. A. des Tombe bought *The Girl with a Pearl Earring* for a mere 2.5 guilders at an auction in the Hague. Seven years later, the New York banker Henry Marquand bought *Woman*

with a Water Jug for $800—misinformed that the painting was by de Hooch—and donated it to the Metropolitan. Only with the turn of the century did Vermeer's name live up to Thoré-Bürger's promise. Bequeathed to the Mauritshuis Museum in 1902, *The Girl with a Pearl Earring* attracted crowds of admirers, enthusiasm matched at the Met when *Woman with a Water Jug* was included in a 1909 show on Dutch art. By 1916, Vermeer was in *Lady's Home Journal*, the most popular magazine in America, with two reproductions of his paintings provided for clipping out and framing.

Prices reflected the growing popularity. In 1901, the industrialist Henry Clay Frick paid $26,000 for *Girl Interrupted at Her Music*. In 1927, the dealer Joseph Duveen bought *The Lace Maker* and *The Smiling Girl* for £56,000, well over ten times Frick's expenditure and significantly less than Duveen charged the industrialist Andrew Mellon for them later that year.[6]

Those two paintings were the focus of Valentiner's article in *Art in America*. Though they'd already been authenticated by Wilhelm von Bode—director-general of the Prussian state museums and one of Valentiner's early mentors—he enlisted them to clarify some misconceptions about Vermeer dating back to Thoré-Bürger. In 1928, the Sphinx of Delft no longer seemed so mysterious. "After one knows a few works by the master, the others are much more easily recognized than is the case with almost any other great artist of the past," he wrote, noting that "newly discovered works by him frequently seem like puzzle pictures composed of pieces taken from different groupings in known paintings by him." Six decades of connoisseurship had honed

6. The precise amount of money paid by Mellon is unrecorded by the National Gallery of Art, which was created with his collection, and where *The Lace Maker* and *The Smiling Girl* can now be found.

Thoré-Bürger's job lot of seventy-two paintings to an oeuvre of just forty-one, including later additions such as those owned by Mellon.

However, Valentiner's prescription was more easily formulated than applied. Four years after his article was published, Abraham Bredius challenged the authenticity of six Vermeers, including one depicting "a very intriguing Vermeerish laughing girl," in *The Burlington Magazine*.[7] As Bredius explained, it was not surprising "that the 'fakers' have found in the brief and broken catalogue of his works a happy hunting-ground for their activities." Then he proceeded to show how real connoisseurship works.

The subject of his demonstration was a small painting called *Conversation Piece*, depicting a lady and a gentleman at a spinet, which he had recently authenticated based on careful comparison to known Vermeers. He noted that the gentleman was "leaning on the same musical instrument as may be seen in one of the National Gallery Vermeers" and that the lady wore "the large pear-drop pearl earrings which Vermeer loved to paint." He also recognized the curtain, which had the same pattern as the curtain in two other Vermeers, including the *Allegory of Faith*, a late religious painting that he himself had discovered back in 1899.

Of course, the curtain had been included for his benefit, much as the grin on *The Smiling Girl* had been painted with van Bode in mind—mimicking the smile on a Vermeer in the museum of von Bode's native Braunschweig—and much as the Hals *Smoking Boy* had been painted for the private pleasure of Hofstede de Groot. Moreover, they all had the same forger in common. Together with

7. When he wasn't attributing paintings to masters, Bredius busied himself questioning the attributions of others, including several of Thoré-Bürger's alleged Vermeers, regarding which Bredius's opinion prevailed.

Mellon's *Lace Maker* and a *Portrait of a Girl with a Blue Bow* authenticated by Valentiner, they were made by Han van Meegeren.

It's easy to look askance at these paintings today, to mock the experts' naïve arrogance, and to deride their blindness to quality. All four of these purported Vermeers appear improbably stilted, and the figures lack the liveliness of *The Girl with the Pearl Earring*. Yet similar criticisms could legitimately be leveled against *The Allegory of Faith*, Vermeer's overwrought depiction of a woman showing rapturous devotion to the crucified Christ with gesticulation befitting an opera diva. When Bredius discovered that painting in a Berlin art gallery, it bore the forged signature of the 17th-century portraitist Caspar Netscher and was believed by the dealer—not implausibly—to have actually been made by the history painter Eglon van der Neer. Bredius saw through both layers of misdirection and was not put off by the religious theme, at odds with all Vermeer's known paintings at the time. Even aesthetically, nothing recommended it to him. (He deemed it "large but unpleasant.") But he was confident enough in his attribution to buy it, and his confidence has survived more than a century of scrutiny.

In other words, the connoisseurship exploited by van Meegeren was the very basis of Vermeer's art historical resurrection. The authority he abused may have been venal and vainglorious—and jealously hostile to scientific verification—but there was no substitute for it. Gullibility was the underside of open-mindedness.

On July 10, 1935, the first full-scale Vermeer retrospective opened at the Boijmans Museum in Rotterdam. In addition to 15 paintings attributed to the Delft master—lent by museums including the Metropolitan and the Louvre—were an additional 115

canvases intended to put his work in context.[8] One room was devoted to Utrecht painters of the previous generation, including Gerrit van Honthorst and Hendrick Terbrugghen, who had traveled to Rome in the 1610s and been influenced by the work of Caravaggio. Inclusion of the Utrecht Caravaggisti, as they were known, was not as expected as the appearance of painters such as Rembrandt and Hals, but they'd been enlisted to make a point. "They are related to the early works of Vermeer," asserted the Boijmans director, Dirk Hannema, in an essay for the exhibition catalogue.

If not exactly obvious, the association of Vermeer with Caravaggio wasn't completely outlandish or totally unprecedented. As early as 1901, Abraham Bredius had speculated in the *Nieuwe Rotterdamsche Courant* that Vermeer was initially "influenced by the 17th Century Italian school." The occasion for Bredius's article was the attribution to Vermeer of two paintings even less likely than *The Allegory of Faith*. One was a mythical tableau called *Diana and Her Companions*. The other was biblical, titled *Christ in the House of Martha and Mary*. For the next several decades, these two ungainly Baroque paintings beguiled art historians such as Roger Fry, who argued in the July 1911 issue of *The Burlington Magazine* that "Vermeer began with the ambition of painting ideal scenes in the grand style and in accordance with Latin ideas of design, and that he gradually resigned himself to the narrower scope and smaller scale of typical Dutch genre."

The great game was to find works to fill the gap between this first phase and the period when Vermeer was painting more familiar works, such as *The Girl with the Pearl Earring*. In his 1911

8. Of the fifteen Vermeers, six were later attributed to other artists. Even at his apotheosis, the Sphinx eluded the experts.

article, Fry attempted to do so by attributing to Vermeer a large painting on the same mythical theme as the one attributed by Bredius, in this case showing Diana attended by a half dozen rather Dutch-looking nymphs. Hannema also had a candidate, which he included in his 1935 exhibition and catalogue. Titled *Mary Magdelaine under the Cross* and supported by the Christian iconography in two of the Bredius attributions, the painting was "attributed here, for the first time, to Vermeer." As in the case of Fry's *Diana*, though, the first time proved to be the last.

The Sphinx of Delft retained his secrets. Scholars were left to speculate about the impact of Caravaggio on Vermeer. "Perhaps tomorrow we will discover a thus far unknown painting, and next year another one, which will convincingly show this influence," wrote the critic Pieter Koomen in *Maandblad voor Beeldende Kunsten*. By the time his essay appeared, half a year after Hannema's exhibit opened, Han van Meegeren was working to ensure that happened.

Like the Caravaggisti, van Meegeren had traveled to Italy as a young man. Visiting Rome in 1921, he'd seen Caravaggio's *Supper at Emmaus* at the Palazzo Patrizi and subsequently painted his own version, much as Terbrugghen had done three centuries before him.[9] The existence of an *Emmaus* by Vermeer was plausible, and the production of one by van Meegeren was feasible, especially since he'd parted ways with Theo van Wijngaarden and independently formulated a new painting medium impervious to alcohol *and* water.

9. The *Emmaus* that van Meegeren saw, also seen by the Caravaggisti, was Caravaggio's second version, painted in 1606, now in the Pinacoteca di Brera. Multiple 17th-century Dutch versions have been attributed to Terbrugghen. Though none are now indisputably accepted as his own, during van Meegeren's lifetime several were, which may have influenced him. The 1921 version by van Meegeren was the one in his Kunstzaal Biesing exhibition.

Van Meegeren's paint was unlike anything Vermeer had ever seen. The secret elixir was Bakelite, a forerunner to modern plastic, made by heating a mixture of formaldehyde and carbolic acid. At the time, costume jewelry was often made with Bakelite because the material was durable and could be dyed bright colors—qualities that recommended it to van Meegeren—but adapting it to oil painting was by no means straightforward. To achieve the characteristic translucency of Vermeer's paints, van Meegeren dissolved the ingredients in turpentine, mixing in hand-ground pigments and volatile lilac or lavender oil.

It would not be inappropriate to call *The Supper at Emmaus* van Meegeren's masterpiece, for it took all that he'd learned from fifteen years of forgery, lifted to a new level of sophistication. There would be no obvious gaffes, as there had been with the anachronistic pigments in his Hals counterfeits. He started with a period painting depicting the raising of Lazarus—because it was cheap, not because he had a sense of irony—scraped down to the white underlayer, and painted over with a picture that adapted Caravaggio's composition to Vermeer's palette. The canvas was then cooked for two hours in a large oven, the paint gradually baked to hardness at a temperature of 250 degrees Fahrenheit. After applying a layer of varnish, van Meegeren pressed at the back of the canvas to bring through the natural craquelure preserved in the underlayer, accentuating the jagged pattern by rubbing india ink into the cracks. At last, van Meegeren added some artful damage, tearing the canvas and carelessly fixing the rip.

Abraham Bredius was eighty-two years old and living in Monaco when he first encountered the painting in the middle of 1937. The person who brought it to him was not van Meegeren but Gerard Boon, a Liberal State Party politician and former member of parliament of impeccable reputation. To explain the

sudden emergence of the unknown painting, Boon repeated a story van Meegeren had told him about an old Dutch family living in Fascist Italy. The painting had been on their walls for generations, but their opposition to Mussolini compelled them to emigrate, and naturally the family name couldn't be mentioned since sale of the canvas would require the utmost discretion. Though he didn't know much about art, the anti-Fascist Boon was determined to help them.

For his part, Bredius was more taken by the painting than by the politics. Enraptured by his latest discovery, he was afraid that *Emmaus* would be bought by an American, like so many other Vermeers. To keep it from the avaricious Duveen and save it for the Netherlands, he decided that his colleague Dirk Hannema had to acquire it for the Boijmans.[10]

Bredius's letters to Hannema were even more hyperbolic than his write-up for *The Burlington Magazine*. He insisted that *Emmaus* was "Vermeer's most important painting, *surely* his most beautiful work." The price was an astronomical 520,000 guilders, toward which Bredius sportingly contributed his 12,000-guilder authentication fee. For his part, Hannema went to work on Rotterdam's elite. He positioned the acquisition as a matter of civic pride. The biggest contribution—400,000 guilders—came from a socially ambitious shipping tycoon named Willem van der Vorm.

On June 25, 1938, Dirk Hannema unveiled *The Supper at Emmaus* as the centerpiece of a 450-painting survey of Dutch masterpieces from the 15th to the 19th century. Fully restored, the painting was magnificently framed and hung on a wall of silk brocade. Describing it as "the greatest attraction of all," *Time*

10. At least with regard to Duveen, he didn't need to worry. Offered the painting for 70,000 pounds sterling, Duveen's European agent Edward Fowles flatly turned it down.

Magazine reported that the museum's parquet floors had been specially carpeted to dampen the noise made by the constant crowds.

More quietly, scholars analyzed details such as the pointelle to decide whether the painting was among Vermeer's earliest, as Bredius claimed, or represented a later return to religion when the artist was fully mature. Careful consideration was also given to Caravaggio's *Emmaus*, with a thorough reappraisal by the art historian J. L. A. A. M. van Rijckvorsel published in the museum bulletin. "In contrast with Caravaggio's loud realism, we respectfully offer Vermeer's devout modesty," she wrote. "After a comparison of both works, the greatness and the individuality of the master of Delft is ever more apparent."

As the world prepared for war, connoisseurship was subsumed, and subverted, by nationalism. Bakelite was the least part of van Meegeren's formula for faking biblical Vermeers. The active ingredient was politics.

Less than two years after "Masterpieces of Four Centuries" opened at the Boijmans, Reichsmarshall Hermann Göring's Luftwaffe bombed Rotterdam. Nine hundred people were killed. The unprovoked attack was followed by an ultimatum: Surrender to Germany, or the blitzkrieg would be repeated in Utrecht. Holland capitulated.

Away from the city center, the Boijmans was unaffected by the bombings. If anything, the occupation improved the fortunes of Dirk Hannema, who accommodated the invaders to augment his power; his loyalty to Germany was rewarded with charge over Holland's state museum system. Yet few collaborators exploited the situation as unabashedly as Han van Meegeren. If he got even with the avant-garde, it was not in the guise of Vermeer. His comeback took form under his own name.

During the occupation, the foremost art authority in Holland was an administrator named Ed Gerdes. He ruled by fiat. Appointed by the Reich to run the occupation government's Department of Art and Propaganda, he was responsible for making Dutch art conform to the Nazi aesthetics espoused by Adolf Hitler. As in Germany, Dutch modernists were banished as degenerate. Anachronistic realism was endorsed and promoted to the extent that it reinforced National Socialist ideology.

Gerdes did not have to look far to find van Meegeren, who was his neighbor in the affluent village of Laren. Nor did he have to give the painter much direction, for van Meegeren shared Hitler's taste for cloying sentimentality, tinged with adolescent bombast or pubescent eroticism. Moreover, both men fetishized the past, perceiving the avant-garde as a betrayal of eternal principles by "madmen and swindlers" (as Hitler dubbed modern painters in *Mein Kampf*). Having failed to gain acceptance as an artist in turn-of-the-century Vienna, Hitler took special care to avenge himself as Führer. Van Meegeren's comeuppance on the avant-garde was the vengeance of a fellow traveler.

Praising van Meegeren for "understanding the new era," Gerdes awarded him prestigious commissions, including a painting for the entry hall of the Dutch Labor Front, the quasi-governmental agency that drafted Dutch men to toil in Germany. Under the title *Arbeid*—the Dutch word for "work"—van Meegeren showed laborers building a National Socialist future, girder by girder.[11] Given that van Meegeren's avant-garde rivals were forbidden to paint and could be conscripted at any moment, he could hardly have chosen a more loaded context in which to flaunt his success.

11. His symbolism is as overwrought as it is muddled. Inside the girders is a colossal Aryan head, which they appear to be imprisoning as it watches over them.

Gerdes also gave van Meegeren the high honor of exhibition in the Fatherland, where van Meegeren showed kitschy paintings on themes designed to appease the leadership. For instance, his 1942 canvas *Mealtime at the Farm* promoted the German cult of motherhood, showing a housewife surrounded by twelve children, her selfless bequest to the Aryan race. (Her husband was omitted, evidently having already been sacrificed on the battlefield.) Exhibited in five German cities, including Osnabrück and Stuttgart, as part of an exhibition of contemporary Dutch art, *Mealtime* helped to support the German delusion that their Dutch neighbors were their political allies and racial kinsmen. The painting was fraudulent without even being counterfeit.

Nevertheless, *Mealtime at the Farm* was technically more competent than another series of pictures van Meegeren was making around the same time. Painted in the style of *Supper at Emmaus*, they had almost the quality of forgeries of forgeries, each more slapdash than the last.

The first was a *Head of Christ*, painted with the same gaunt face, limp hair, and hooded eyes as Jesus in *Emmaus*. Purchased by Rotterdam shipping magnate Daniël van Beuningen—Willem van der Vorm's archrival—the *Head* was rumored to be a study for a lost *Last Supper* that was found as promptly as van Beuningen's 475,000-guilder payment cleared. On the advice of Hannema, he bought the larger painting as well, paying 1.6 million guilders and housing it in a specially built chapel. Van der Vorm in turn bought a painting depicting Isaac blessing Jacob. The resemblance of Isaac's face to Christ's is striking—hooded eyelids apparently running in the family—and the table over which Jacob bows his head is set with the same jug and platter as in *Emmaus*, evidently also inherited by Jesus from his holy ancestors.

By the time van Meegeren had Vermeer rendering Christ's feet being washed, the quality had fallen low enough to give even

Hannema pause. As usual, brought to market indirectly to protect van Meegeren's identity—this time through an old school friend—*The Footwashing* was fronted by the de Boer Gallery in Amsterdam, which offered it first to the great Vermeer admirer Adolf Hitler. Rebuffed by Führermuseum curator Hermann Voss, who had the rare gumption to question the attribution, de Boer approached the Rijksmuseum in Amsterdam, rousing interest by intimating that a sale to Hermann Göring was imminent. In short order, the museum raised 1.3 million guilders, 400,000 donated by van der Vorm.

The line about Göring wasn't quite a lie. Göring had been in the market for a Vermeer since 1938, when he coerced the Austrian branch of the noble Czernin family into selling *The Art of Painting* shortly after the Anschluss. The Austrian Monuments Office intervened before the Reichsmarshall could take possession—and gave the painting to Hitler. Göring was likewise blocked from acquiring *The Astronomer*, seized from the Rothschilds for the Führermuseum with the capture of France in 1940.

Göring redoubled his efforts with the occupation of the Netherlands. He took control of the Goudstikker Gallery in Amsterdam after the Jewish owners fled Holland. He installed his personal banker, Alois Miedl, as director and had Miedl send him the complete Goudstikker stock of 1,100 paintings. None were by the master of Delft. And then his fortunes changed in 1943, when the Goudstikker Gallery was offered a newly discovered painting titled *Christ and the Adulteress*. From the hooded eyelids to the wine jug—not to mention the monogram—the painting looked every inch a Vermeer.

A price of 1.6 million guilders was negotiated. The painting was freighted to Göring's estate, given pride of place. But he wouldn't pay until the seller revealed where the masterpiece had

come from.[12] Miedl queried the middleman, Petrus Rienstra van Stuyvesande, a director at his Amsterdam bank as beholden to him as he was to Göring. The line of authority could not have been clearer. Rienstra van Stuyvesande responded that he'd been asked to sell the Vermeer by a man he'd recently met through a real estate transaction, the Nazi painter Han van Meegeren.

Hermann Göring was arrested by American soldiers on May 8, 1945, the day of Germany's unconditional surrender to the Allies, as he fled his Brandenburg estate for the Austrian border. Among his personal possessions were six of the most valuable paintings in his collection, including *Christ and the Adulteress*.

By then, the Netherlands had been liberated, Alois Miedl had escaped to Fascist Spain, and a man named Joseph Pillar, a lieutenant in the Dutch Resistance, was investigating the Goudstikker Gallery, which he believed to be a front for a German espionage ring. Pillar did not have any evidence to support this claim, nor did he have an official mandate for his inquiry. In the postoccupation Netherlands, there was no clear line of command. Pillar had jurisdiction over Goudstikker because he'd been the first to get there.

As Pillar searched the Goudstikker records, he found references to Hermann Göring. He saw that the Reichsmarshall had purchased a Vermeer through Miedl and that the source was

12. Göring strongly suspected that the painting had been stolen. Some scholars believed that the Catholic convert Vermeer had been commissioned to paint his biblical series for a *schuilkerk*, a secret church—Catholicism was illegal in Protestant Holland when Vermeer was alive—and that the paintings still belonged to the hidden chapel. Though Göring surely didn't care who'd owned the painting before him—having already plundered half of Europe—his previous difficulties with Vermeer may have made him cautious that someone else was held responsible in case he was questioned.

Han van Meegeren. Though not exactly espionage, conducting business with the enemy had been expressly forbidden by the Dutch government in exile. Even trading cigarettes with soldiers counted as treason; van Meegeren had pawned the Dutch patrimony to the man who'd occupied Holland. On that basis, and Pillar's assumption that the painting must have been stolen from a church or museum, Pillar imprisoned van Meegeren on May 29.

Over the next several weeks, van Meegeren was questioned about the sale and the source of his Vermeer, but he would not speak. At last, Pillar lied that Miedl had been captured and planned to testify against him. Van Meegeren cracked. "You idiots!" he shrieked. "You fools! I sold no national treasure to the Germans! I sold no Vermeer! I sold a van Meegeren! I sold a Vermeer forged with my own hands!"

At least that was the outburst attributed to him in the *Saturday Evening Post*, published a year and a half later and repeated ever since in tales of van Meegeren's mistreatment and revenge. The true content of his confession to Pillar will never be known, except that it was enough to convert his worst enemy into his foremost ally: to make a man who risked his life fighting Nazis into the veritable ghostwriter of van Meegeren's hagiography.[13]

The transformation was all the more extraordinary, given that Pillar's investigation had already uncovered van Meegeren's friendships with the Dutch Nazi elite. Van Meegeren had even published a deluxe catalogue of his work with text written by the fanatical Nazi poet Martien Beversluis. On July 11, 1945, the

13. The scholar Jonathan Lopez persuasively argues in *The Man Who Made Vermeers* that the attraction was psychological, that van Meegeren vicariously gave Pillar the satisfaction of getting even with Göring. If so, Pillar was hardly alone in his psychological projection.

Dutch resistance newspaper *De Waarheid* revealed that a copy of his book, *Teekeningen 1*, had been found in Hitler's private library, inscribed "to my beloved Führer in grateful tribute, from H. van Meegeren." The following day, persuaded by van Meegeren that the dedication had been forged by an SS officer currying favor with Hitler, Pillar sought to neutralize the *Waarheid* article by publicly disclosing the astonishing story van Meegeren had confided in him. "Driven into a state of anxiety and depression due to the all-too-meager appreciation of my work," wrote van Meegeren in a sworn statement, "I decided, one fateful day, to revenge myself on the art critics and experts by doing something the likes of which the world had never seen before."

In trouble as he was just then, conning the Dutch museums might not have counted for much, but defrauding Göring reckoned as positively heroic. And van Meegeren's glory reflected on Pillar, lending authority to his self-appointed role as head of a *sui generis* paramilitary unit obscurely titled Field Security.

Yet van Meegeren's apotheosis was not instantaneous. Two different factions challenged his narrative. On the one hand, *De Waarheid* rejected his dubious explanation about the inscription in *Teekeningen 1*, which in any case unequivocally attributed to him Nazi-era paintings such as *Arbeid*; from the *Waarheid* perspective, he was a collaborator, regardless of whether he'd hoodwinked Göring. On the other hand, experts such as Hannema were unwilling to concede that they'd been tricked. Hannema based his case on *The Supper at Emmaus*, which most scholars concurred was by Vermeer and which clearly belonged to the same series as *Christ and the Adulteress*.

Of course, Hannema was a known collaborator who'd been stripped of his titles and shipped to an internment camp after the German surrender, whereas *De Waarheid* had unimpeachable moral authority in postwar Holland. Even a Resistance lieutenant

stood little chance of trumping them in their own sphere. So Pillar deflected attention from *Teekeningen* by focusing on *The Adulteress*.

Van Meegeren's forgery claims would have been easy enough to test. (He'd told Pillar that he had painted *The Adulteress* over a battle scene that he hadn't bothered to scrape away; his confession could have been verified with a single X-ray.) Instead, Pillar orchestrated a media spectacle worthy of Joseph Goebbels. Ordering an enormous canvas, he had his ward counterfeit a brand-new Vermeer in front of witnesses.

For two months in the Goudstikker Gallery attic, van Meegeren toiled on *The Young Christ Teaching in the Temple*, once more reprising a subject from his Biesing show, using the same visual and chemical formulae that he had on each painting since *Emmaus*. Journalists and photographers were invited to observe his progress, enticed by a story they found hard to resist. When the painting was completed, the *New York Times* ran a two-page spread with three pictures of van Meegeren painting, melodramatically writing that while he was at work, "it was said that he was 'painting for his life'; unable to produce this seventh 'Vermeer,' immediate sentence, perhaps death, would have been his fate." Of course, his artistic genius prevailed. "Experts have hailed the picture as magnificent in parts," reported the *Illustrated London News*, reassuring readers that van Meegeren had taken care to "prevent the picture from being taken for a Vermeer in the future" by including a Bible in the scene as an intentional anachronism.

Against this picaresque, *De Waarheid*'s earnest reporting didn't stand a chance. There were countless collaborators but only one Han van Meegeren. Though the ad hoc authority of Pillar's Field Security had provided van Meegeren's version of events with underlying legitimacy, endless repetition in the media and by the public made his story the accepted reality.

The first and only exhibition of van Meegeren's seven biblical Vermeers was in the Fourth Chamber of the District Assize Court in Amsterdam on October 29, 1947, when the artist was tried for forgery and fraud. The mini-retrospective—which the *New York Times* aptly noted "would have been the delight of any museum a few years ago"—was but one of the factors that made the trial unorthodox. The courtroom was overcrowded with spectators, and the combined sound of newsreel cameras in the press box was enough to remind one journalist of machine guns. Reporters climbed on chairs. People in the balcony laughed and cheered, overwhelming the presiding judge's efforts to maintain decorum. The trial completed what Joseph Pillar had started. The van Meegeren case emerged as theater.

The testimony especially has the scripted quality of stage dialogue. When a team of chemists presented data demonstrating that the paintings had been made with Bakelite, van Meegeren archly praised their work: "I find this research extraordinarily clever. Almost as clever as the painting of *Emmaus* itself." When the judge asked whether he admitted to selling his forgeries for high prices, he responded as if on cue: "I could hardly have done otherwise. Had I sold them for low prices, it would have been obvious they were fake."

Consistent with the comic tone was the farcical plot, that van Meegeren could prove his innocence only by establishing his guilt: Only conviction for forgery would acquit him of selling his national heritage to Göring. His work for Gerdes and his inscription to Hitler didn't suit the comedic tone and went unmentioned in the courtroom. Thus, his true collaboration with the enemy never entered the official record. Nor was his past with van Wijngaarden explored. That, too, would have distracted from the zany story line in the Fourth Chamber and detracted from its simple moral.

Lest the moral be missed, Irving Wallace laid it down for readers in the *Saturday Evening Post*: "The knowledge and integrity of many

experts, upon whose judgments museums and private collectors were dependent, and of some critics, upon whose opinion the layman was dependent, stood on trial," he wrote. Even if he'd committed fraud, van Meegeren was not perceived as the real culprit.

Nevertheless, he was charged and sentenced. That much was required. On November 12, the District Assize Court ruled that his wealth be confiscated to compensate the Dutch state and the two Rotterdam tycoons and that he serve the minimum allowable term of a year in jail. The term began in 1948, but not before van Meegeren delivered the final punch line: He died of heart failure on December 30, 1947.

For the experts and critics, the verdict and consequences were more ambiguous. Conveniently deceased before the trial, Abraham Bredius was universally condemned as a fool, while the few experts who had not been tricked took the opportunity to gloat. Most noisily, the Duveen agent Edward Fowles publicly released a telegram he'd secretly cabled to Joseph Duveen after seeing *Emmaus* in 1937: PICTURE A ROTTEN FAKE. When his story was picked up by the *New York Herald Tribune*, no mention was made of the suspect Vermeers that Duveen had sold Andrew Mellon.

On the other hand, Dirk Hannema refused to accept that *Emmaus* was a fake and spent the rest of his life trying to establish its authenticity with funding from Daniël van Beuningen. Though no credible scholars took Hannema's research seriously and he no longer had an official position at the museum, *The Supper at Emmaus* remained on exhibit at the Boijmans—with no mention of who'd painted it—until Hannema's death in 1984.

The unlabeled *Emmaus* was a fitting tribute for Han van Meegeren, who'd shattered the authority that made him without fostering alternatives.

WHAT IS HISTORY?

Eric Hebborn
1934–1996

Early in his career as an art dealer, Eric Hebborn acquired a drawing attributed to Jan Brueghel the Elder. The sketch depicted the ruined Temples of Venus and Diana on the Bay of Baia—the ancient Roman landscape lyrically rendered in flowing sepia—yet something appeared amiss to Hebborn's exacting gaze. The lines seemed sluggish, as if the pen had been hesitant, in conflict with the impromptu composition. Reckoning that he had a period copy, perhaps drawn by a printmaker preparing an etching, Hebborn resolved to replace it with the lost original.

That wasn't going to be easy, given that the year was 1963 and the original had probably been missing for three and a half centuries. But Hebborn had an original notion of originality. Sliding the sketch out of its old wooden frame, he taped it to a drawing board beside a sheet of blank paper from the same era and set out to rediscover Brueghel's lost drawing by copying the copy.

Hebborn was a fine draftsman, trained in classical techniques at the Royal Academy of Art. In fact, it was this education that sensitized him to the sluggishness of lines drawn by copyists, who typically must work more slowly than the original artist—suppressing spontaneity—in order to faithfully imitate an original composition. Experience with a pen also tipped Hebborn off to another,

subtler distinction: The lines in a copy are generally not drawn in the order they would be were the draftsman drawing from nature. Since the scene to be copied has been fully delineated in advance, there's no process of discovery. Embellishment can precede structure, like a tree sprouting leaves before branches.

Hebborn's task was a kind of reverse engineering, deconstructing the copy by considering the purpose of each mark in terms of the problems of drawing from life and then reconstructing the original on another sheet of paper as it would originally have been made. Or compare his feat to method acting. Loosening up with a tot of brandy, Hebborn revived momentarily Brueghel's encounter with the Temples of Venus and Diana. Then he sealed the rediscovered Brueghel in the antique frame, flushed the etcher's copy down the toilet, and sold his handiwork to the venerable Colnaghi Galleries on Bond Street, London.

The Temples of Venus and Diana on the Bay of Baia can now be found in the Metropolitan Museum of Art, albeit reattributed. The sketch is now said to have been made by Jan Brueghel the Younger.

The number of works by Eric Hebborn in public collections will never be certain. Between the early 1960s and his death in 1996, Hebborn created an estimated thousand drawings in the manner of various old masters, artfully mixed in with thousands more of legitimate origin that he handled as a dealer. Though dozens of the fakes have been detected by curators, and more were revealed by Hebborn himself in his notoriously mischievous 1991 autobiography, *Drawn to Trouble*, the vast majority remain in circulation under names other than his own.

The sheer variety of known Hebborn fakes has further complicated the task of finding his undisclosed forgeries. He drew con-

vincingly as Andrea Mantegna and Nicolas Poussin, Giovanni Battista Piranesi and Peter Paul Rubens, Thomas Gainsborough and Jean-Baptiste-Camille Corot. He could even limn the 20th century, illicitly expanding the oeuvres of Augustus John and David Hockney.[1] By the reckoning of former Met director and self-described "fakebuster" Thomas Hoving, Hebborn's range as a mimic is the broadest in the history of drawing.

The consequences of his activities were not only economic. Though the old masters market stumbled after Colnaghi revealed in 1978 that they'd unwittingly bought and sold dozens of his fakes, the financial damage was fleeting, as was the crisis in confidence of collectors and curators who'd been had. The more lasting impact, probably permanent, has been to corrupt art history itself. Writing for the journal *Aesthetics* shortly after Hebborn's death, the philosopher Dennis Dutton observed that "Hebborn's handiwork has altered our understanding of the history of graphic representation just as surely as a document forger's skill might alter our understanding of the history of ideas."

Dutton wrote those words in condemnation. Had Hebborn lived to read them, he'd have taken them as a compliment. And while Hebborn was a narcissist and braggart, he was also a bolder thinker than Dutton. Expressed through his forgeries, Hebborn's philosophy upset the idea that history is strictly past tense.

From the beginning, art was a form of rebellion for Eric Hebborn, his means of uncoupling the expected chain of events

1. In the case of Augustus John, Hebborn boasted of having also improved the artist's oeuvre. As he wrote in *Drawn to Trouble*, "the curious thing about the eighty or so drawings I have made over the years in this particular artist's manner is that they have proved more popular than the greater part of John's authentic works, and the collector is able to buy several genuine examples for the money they would now have to pay for a single 'John' of my own making."

in a working-class Englishman's life. He was born on March 20, 1934, into an oversize family struggling to get by on a green-grocer's wages, first in London and then in the dreary town of Romford, where he was enrolled in the Harold Wood Junior School. There he took his first art classes, supplemented by his own experiments in making drawings with the burned tips of spent matches. His creativity was not appreciated: Unjustly accused of arson and beaten for playing with fire, he avenged himself by committing the alleged crime, setting the school cloakroom on fire.

That stunt put him in reform school, followed by a series of foster homes in the seaside town of Maldon, where he joined a local art club under the tutelage of a landscape painter trained at the Royal College of Scotland. He learned to paint. No longer was he deemed a juvenile delinquent. The town newspaper praised him as "a keen and promising artist."

The article also noted his admission to the Chelmsford Art School. He studied there for several years, the start of a traditional education in drawing, painting, and printmaking culminating in his graduation from the Royal Academy of Art. Distinguished by the Hacker Prize[2] and the Silver Medal in Painting, he competed for the Rome Prize, which he won in 1959. At the age of twenty-five, the greengrocer's son had establishment credentials that were impeccable—and that would have ensured him a sterling career a century earlier, before modernism supplanted academic acumen with avant-garde innovation.

Yet old-fashioned acumen was not wholly a thing of the past. Or rather, there were still precincts where the past had not been overtaken by the present. While at the Royal Academy, Hebborn

2. Augustus John was the jurist for the Hacker Portrait Prize, though the prize was not awarded for one of Hebborn's forgeries.

discovered that his skills with pen and brush were still valued by art restorers. According to his autobiography, he worked for one in his free hours, a man named George Aczel who kept a studio in Haunch of Venison Yard. In Aczel's shop, Hebborn was given the task of filling in gaps. Often these were areas where the canvas had been damaged beyond repair and had to be patched, in which case he might paint in a stretch of sky or a fold of flesh. Sometimes the gaps were more speculative. Customers requested that desirable signatures be found or, more fancifully, the addition of horses and hot air balloons. As Hebborn improved at his job, adding new details that Aczel artificially aged, the gaps grew increasingly gaping until, as he dryly wrote in *Drawn to Trouble*, "I would one day be able to 'restore' a whole painting— from nothing at all."

That day came when a dealer brought in a blank 17th-century canvas on which Hebborn was instructed to "find" a seascape by the Dutch artist Willem van de Velde the Younger. The dealer had come prepared to help Hebborn discover the desired image, showing him photographs of more easily visible van de Velde paintings, pointing out the sort of ship he expected to be found, and indicating anticipated details from rigging to sea currents. Aczel prepared the canvas. He filled in the cracked ground with a jelly that could be extracted, when Hebborn's work was complete, to instantly enhance the antique seascape with three centuries of craquelure. He also prepared period paints, thinned with benzene to accelerate drying. And to add a final touch of authenticity, he had Hebborn cover the counterfeit van de Velde signature with that of Jan Brueghel, the sort of petty fakery you might expect to find on a genuinely old painting.

What became of the van de Velde remains unknown. The dealer deliberately requested a minor work "for the small collector" to bypass the expertise of museums. Most likely it adorns the wall

of a private house, a handsome thing as genuinely decorative as a real van de Velde painting.

The gap Hebborn filled was the one left by van de Velde's death. He took a commission that the 17th-century Dutchman couldn't. In a sense, the two artists traded places. Hebborn dropped into the past to carry van de Velde into the present.

George Aczel asked Hebborn to join the restoration business. Hebborn declined and sought instead to become a professional artist. He made wood engravings and watercolors and ink drawings. Ignored by the contemporary art establishment, his landscapes and studies of the human figure were favorably received by antiquarian connoisseurs, who assumed they'd been made years before Hebborn was born. One painting was mistaken by a collector for the work of classical landscapist David Cox. Another was bought by an unscrupulous dealer who added the signature of Impressionist Walter Sickert.[3]

An artist more mature than Hebborn might have taken these misattributions as compliments that confirmed the refinement of his technique, or interpreted them as a critique of his contemporary relevance. Instead, Hebborn responded with blame—experts were fools, dealers were knaves, modern art was a talentless sham—and set out to prove his case by defrauding everyone. With his lover, Graham Smith, he established Pannini Galleries in London and later in Rome. Some of their merchandise was acquired in junk shops and at auction. At least as much was Hebborn's own production.

3. Sickert himself might have appreciated the dealer's duplicity. According to Osbert Sitwell, who edited Sickert's writings on art, Sickert was once asked whether some canvases of dubious authenticity had truly been painted by him. "No," he responded, "but none the worse for that."

Hebborn distinguished his operation from one blatantly out to make money by subscribing to a "moral code": "Never sell to a person who was not a recognized expert, or acting on expert advice," he vowed. "Never make a description or attribution unless a recognized expert has been consulted; in which case the description or attribution would in reality be the expert's." Hebborn's job was to create artwork that would silently telegraph the attribution he intended. To succeed, he needed to absorb not only the nuances of how the master drew or painted but also the intricacies of how the connoisseur reasoned.

Hebborn construed his endeavor as a sort of competition against all specialists, a game he referred to as "delightful duality," and he'd develop his strategy by outlining how he believed his opponent would authenticate the artworks if the opponent used sound reasoning. Preparing to forge a preparatory drawing for Corot's famous *Portrait of Louis Robert*, for instance, he reckoned that the Colnaghi specialist he hoped to trick would be familiar with the original painting in the Louvre and a related drawing in the Fogg Art Museum and recognize their family resemblance to his effort, while also appreciating that his sketch did not directly copy any known drawing. "It is inconceivable," Hebborn imagined the expert thinking, "that an imitator could have so thoroughly assimilated Corot's personal 'handwriting' as to draw freely in it while remaining faithful to the formal content of the picture."

A further challenge—which in Hebborn's case was an enticement—was that Corot had already been so often faked. According to one famous quip, attributed to the French writer René Huyghe, "Corot painted three thousand canvases, ten thousand of which have been sold in America." In this respect, Hebborn's case was likely helped by the want of a signature and his reticence on the matter of authorship. (He played up his ignorance, and presumptive innocence, by pretending to think the

artist might be Degas.) Over the course of two weeks' research, the expert convinced himself that the drawing was genuine, that Corot was the artist, and that Colnaghi should buy it. "I was banking on the man's knowledge, intelligence, and sensibility to quality," reflected Hebborn in *Drawn to Trouble*. "He could not possibly have known it, but he was playing a game which, ironically, he could only win by making a false move."

And yet the greater irony is that, by the same reasoning, Hebborn lost by winning. By his logic, his success as a forger paradoxically attested to the experts' expertise. The game itself turned on a false assumption, suggesting a deeper fault in the system. The fundamental issue at stake with Hebborn's forgeries was not a problem with art dealers and historians but the trouble with art history.

Eric Hebborn occasionally alluded to a book he intended to write on the "serious grammar" of drawing. The book was to be an extension of a paper he prepared as a student, which argued that the draftsmanship of artists as diverse as Leonardo da Vinci and Vincent van Gogh drew on the same "universal source." Hebborn had further advanced this idea in discussions with art historians such as his friend Sir Anthony Blunt, with whom he'd become acquainted at the Royal Academy of Art. The art historians were notably unimpressed.[4] Their work was to make stylistic distinctions, revealing the individuating character of an artist or a period. Toward that end, even the most antiquarian among them implicitly accepted the avant-garde notion of progress. Though they did

4. Nevertheless, Blunt recognized Hebborn's own ability to contort history. In his memoir, *Celebration*, Graham Smith even claims that Blunt put Hebborn on the path to forgery. Early in their friendship, Blunt advised Hebborn that if he made his drawings on old paper, "they would easily pass as originals." Not only was Blunt right but also he was occasionally duped.

not necessarily equate progress with improvement, their evolutionary conception of history was distinctly modern.

Hebborn intended his grammar to reveal the universal source that art historians obscured with their spurious classifications. And when he wasn't ranting against experts and dealers—or cheating them to fund his increasingly *dolce vita*—he conceived of forgery as empirical research and considered his fakes to be experiments. "If they got through," he argued, "then I would know for certain that my theories about drawing were right, that is, it is possible to escape the influence of period, place, and one's own personal mannerisms, and enter mentally into the timeless world of art from which the best artists draw their inspiration."

One of the most acclaimed of Hebborn's escapades was a drawing attributed to Piranesi, bought by the National Gallery of Denmark, that curators only reluctantly conceded was Hebborn's when he claimed it as his own on a BBC television program. The drawing was inspired by an engraving that Hebborn believed Piranesi had flubbed. Descriptively titled *Part of a Large Magnificent Port Used by the Ancient Romans*, the print seemed to him unusually cramped and illogical in perspective, as if Piranesi had tried to fit his scene on too small a copper plate. As in the case of the Metropolitan's Brueghel, Hebborn resolved to discover the original, only in this case he envisioned a grander composition than was preserved in the print. The drawing he made refracted Piranesi's content and style through his own imagination to realize what might have been. Deceiving the experts, he not only showed his conjecture to be convincing but also demonstrated that his 20th-century hand could draw without the least taint of his own era.

Still, it was a peculiar strategy, paradoxical in its own right, to argue that historical context was irrelevant by enticing historians to identify his fakes as authentic products of the past and to ascribe to them specific names and dates. The success of Hebborn's

forgeries didn't prove that the grammar of art is universal but implied that the history of art may be permeable, the cultural continuum as elastic as an accordion file. Hebborn's deceit let him get past the professional prejudice of historians to show that an accomplished artist can compellingly engage us by taking up the stylistic concerns of any other artist or era. Art does not progress, Hebborn's work suggested. It just grows more diverse.

On March 10, 1978, Colnaghi & Co. published a statement in the *Times* of London: "About eighteen months ago, it came to our attention that the authenticity of a group of Old Master drawings which were purchased by two former directors of this gallery between eight to ten years ago, from one source and over a number of years, is now doubted. The present directors of Colnaghi's therefore decided to contact all the present owners of these drawings bought from this company and recall them for examination." Assuring the public that purchasers had been offered a refund "in accordance with long standing custom," Colnaghi sought to impart innocence and gentlemanly comportment. Their failure to mention the source of the suspect drawings was likewise pragmatic. Though they knew the bogus drawings had come from Eric Hebborn, they could not forensically prove his fakery since his paper and ink were genuinely antique. Pure connoisseurship was unlikely to be decisive in court, and unless Colnaghi successfully pressed charges against him, their public accusation of Hebborn would expose them to a libel suit.[5]

5. Hebborn was also helped by the fact that he had not misrepresented the work, instead allowing the work to misrepresent itself. As much as this may have been motivated by the rules of delightful duality, he was also aware of the legal benefits. He was even careful not to put old master prices on his forgeries, allowing the dealer or auction house to determine their worth. And to would-be forgers, he had this legal advice: *Do not be greedy.*

Hebborn never went to jail. He never stood trial. Even attempts to privately blackball him had scant effect, since he could always approach dealers and auctioneers through mercenary intermediaries. All that the experts could do was look out for faults in his forgeries: similarities between drawings or passages of less-than-masterly draftsmanship.

The Colnaghi debacle had been precipitated by instances of both. Konrad Oberhuber, curator of drawings at the National Gallery of Art in Washington, D.C., observed what he believed to be stylistic overlaps while studying two drawings acquired from Colnaghi, one by the Renaissance painter Francesco del Cossa and the other by Cossa's near-contemporary Sperandio Savelli. He additionally deemed both drawings to be muddled in places—beneath the artists' talent—a fault he also found with a second Cossa drawing acquired from Colnaghi by the Pierpont Morgan Library in New York. The Morgan curator, Felice Stampfle, was inclined to agree. They approached Colnaghi. All three drawings were found to have Hebborn as their source. Colnaghi called in approximately a dozen more drawings sold to them by Hebborn, including works allegedly by Tiepolo and Rubens and Augustus John, which they'd placed in private and museum collections. Cast into the shadow of doubt, all began to look suspect.[6]

Deleterious resemblances were found, including an overabundance of crosshatching and overly curly hair. More perversely, the drawings were all deemed to have a "washed out" look, as if the genuinely old paper had been artificially aged.[7] A compendium of

6. "They will all claim to have had their doubts," Hebborn tartly commented in an interview with the *Daily Mail* years later, when he published his autobiography, "but writing out cheques seems a curious way of expressing them."

7. Hebborn harvested much of his antique paper from old books, which had the advantage of documenting the paper's precise age by the publication date. Slicing out the blank endsheets with a razor, he then selected an artist to forge based on when and where the paper was made.

shortcomings came to define the forger. Some of the presumed faults were spurious; some of the condemned drawings were genuine.

Hebborn delighted in the confusion—which he believed corroborated his thesis that the experts were dunces—and yet was upset by their failure to recognize his skill as a forger. Contradictions in his character, perhaps exacerbated by the paradoxes of his work, made him increasingly ambivalent about his reputation. Visited in Rome by the *Times* correspondent Geraldine Norman, who hoped to elicit a confession, he played the perfect host, pouring bottles of wine late into the evening and feigning innocence. "It was clear he knew I didn't believe him," Norman wrote nearly two decades later in an obituary published by the *Independent*, "and he didn't mind that at all." On the other hand, when his work was not included in *Fake?*—the landmark 1990 British Museum survey of forgery throughout history—he wrote an irate letter to the curators, chiding them for omitting his work. "The British Museum need not have looked far, since there are a few of my works in its drawings collection already—notably the Van Dyck *Crowning with Thorns.*"

One year after this incident, and likely motivated by the slight, Hebborn published *Drawn to Trouble*. He exposed dozens of other fakes in public collections, including the Piranesi and the Brueghel. He also named all the experts and dealers he'd duped, including numerous directors of Colnaghi and specialists at Christie's and Sotheby's. Yet for all the damage done by the content of his book, readers were exasperated most by the style. As Holland Cotter fumed in the *New York Times*, "The book isn't a 'confession,' as the subtitle promises, but a self-vindication."

Cotter's description was essentially accurate. Hebborn expressed no regret, insisted he'd always been in the right, and justified himself with reasoning as opportunistic as it was

inconsistent: The experts deserved to be cheated because they were idiots, yet his forgeries were incomparably brilliant, and by the way there's no such thing as a fake drawing, only a false attribution. Hebborn also revealed that he'd sold five hundred more forgeries since the Colnaghi affair—all of which he declined to identify—and claimed in addition to have put numerous red herrings on the market, self-consciously inept imitations of his earlier works designed to make experts believe they'd caught on to his personal style.

The book made him infamous, garnering him the name recognition he'd once sought for art signed *E. Hebborn*, if not the critical acclaim he desired. He attempted to capitalize on his celebrity, showing innocuous watercolors at London's Julian Hartnoll Gallery.[8] More profitably, he accepted commissions from dealers to make fakes on demand as he'd once done in Haunch of Venison Yard. The most profound effect of his book, though, was to reveal the extent of his subterfuge, the degree to which he'd inserted his work into the past.

Drawn to Trouble publicly announced that he'd sabotaged the historical record. The drawings in museums were no longer sacrosanct as historical documents, since almost any of them might be modern. If they were to be appreciated, they'd have to stand on their own merits. And if a Hebborn forgery should merit museum standing, then there was one more drawing in the world for people to relish.

Eric Hebborn was killed by a hammer blow to the back of his head, inflicted on the night of January 11, 1996, in the

8. In truth, he had never stopped producing work under his own name, shown in galleries from London to Hamburg. His landscapes were perfectly generic, like templates waiting to be imprinted with the personality of an artist.

Trastevere district of Rome. He was walking home from a bar when he was struck. The murderer was never caught, nor was the motive ever ascertained. The police scarcely bothered to investigate. There were too many people who wanted him dead, for too many reasons. As the newspaper *Il Messaggero* noted, "His talent and taste for fraud had made him an enfant terrible for the world of art."

Yet Hebborn's death did not end his assault on the history of art. Weeks before his murder, the Italian publisher Neri Pozza released *Il Manuale del Falsario*, which Hebborn wrote in Italian. It was translated into English and published a year later as *The Art Forger's Handbook*. Providing practical guidance—from recipes for making bistre to techniques for tinting paper—the book was deemed in a review by Thomas Hoving to be "delightful and thoroughly dangerous." At last, anybody could learn to make art forensically indistinguishable from the work of previous centuries. *The Art Forger's Handbook* opened the temporal accordion file to everybody.

At the same time, Hebborn's own contributions to the accordion file were becoming increasingly uncertain. Nobody could find the preparatory drawing for Corot's *Portrait of Louis Robert* that he'd described in his autobiography. Graham Smith, who split with Hebborn in 1968, claimed in *Art & Auction* that the Brueghel in the Metropolitan was genuine and Hebborn's story was made up: There never was an engraver's copy that Hebborn cribbed and flushed down the toilet.[9] Though unprov-

9. Even if Hebborn did copy it and flush it down the toilet, was it an engraver's copy? When the estimable 20th-century art dealer Joseph Duveen was young, his uncle supposedly tested his connoisseurship by setting some antique porcelains in front of him, mingled with several fakes, and instructing him to smash the forgeries with a walking stick. In this act of bravura, Duveen was Hebborn's purported model. Yet even Duveen was hardly infallible, later falling victim to the forger Han van Meegeren.

able, Smith's allegation was supported by Geraldine Norman, who told a *New York Times* reporter that Hebborn was unreliable. "When she once confronted Mr. Hebborn over his forgery claims," the *Times* reported, "'He smiled across the table and said, "I like to spread a little confusion."'" If Hebborn was lying, then *The Temples of Venus and Diana on the Bay of Baia* in the Met could well be by Jan Brueghel the Younger. Or Jan's father.

Truly Hebborn's capacity for mayhem was boundless. Maybe there'd been no George Aczel, or there'd been several, any one of whom may or may not have had Hebborn fabricate a van de Velde. At various times, Hebborn had both claimed and denied forging paintings by Annibale Carracci and Rogier van der Weyden. During the filming of a 1991 BBC documentary, he confided off camera to the reporter Ben Gooder that he'd redrawn Leonardo's chalk cartoon depicting the Virgin and Child with St. Anne and John the Baptist in London's National Gallery. He explained that the original had been irreparably damaged while he was a student at the Royal Academy—where the drawing was then stored—and that he'd been called in secretly to re-create it, in compensation for which the academy had awarded him the Rome Prize. Gooder had dutifully spread the rumor, aided by denials from the Royal Academy: "Astonished," they proclaimed in a public statement, "that anyone could fall for such an unlikely story from someone who made a living out of being a fake."

Of course, his reputation as a fraud was what gave his confabulation credibility. He didn't need to make five hundred forgeries after the Colnaghi affair; simply claiming to have done so was enough to throw art history into turmoil. In fact, faking his fakery may have been his master stroke, since no amount of sleuthing could detect forgeries that never existed.

We can imagine that any drawing lacking certain provenance is by Eric Hebborn, or by the school of Hebborn established with the publication of his *Art Forger's Handbook*. By extension, we can see all art of any age as contemporary, eternally current, and perpetually relevant. Historians may fret, and philosophers may quibble. But for the artists who made the work, whoever they may be, forgery is immortality.

WHAT IS IDENTITY?

Elmyr de Hory
1906(?)–1976

On the Mediterranean island of Ibiza, where celebrities vacationed in the 1960s, nobody was more visible than Elmyr Dory-Boutin, nor was anyone more enigmatic. High above the coastline in his cliffside villa, the Hungarian expatriate hosted the most extravagant parties south of Barcelona. Guests included movie stars such as Ursula Andress and Marlene Dietrich, yet the center of attention was Dory-Boutin himself. Besotted by his polyglot conversation and golden monocle, some friends speculated that he was royalty in exile, a theory he didn't contradict. Others wondered whether—given the inexhaustible collection of School of Paris masterpieces that funded his entertainments—he just might be responsible for the decade's biggest art scandal: the sale of nearly fifty dubious paintings by Matisse and Modigliani and Picasso to the Texas oil mogul Algur Hurtle Meadows.

In the spring of 1967, he finally confided in a neighbor. He admitted that his real name was Elmyr de Hory, that he was the only son of landed gentry from Lake Balaton, and that his whole inheritance had been lost in the Second World War. His precious post-Impressionist masterpieces were fakes, forged by his own hand, more than a thousand of which had gone to public museums and private collections, including Meadows's Dallas mansion.

To de Hory's neighbor, a struggling novelist named Clifford Irving, the confession had the sound of a best seller. Irving estimated that a biography might net as much as a million dollars and offered the forger a 50 percent stake in the venture. Given that the Meadows scandal had seriously hampered Elmyr's painting sales and that Spanish extradition laws protected him from standing trial, the decision was easy. De Hory told all. Playing for maximum impact, Irving titled his book *Fake: The Story of Elmyr de Hory, the Greatest Art Forger of Our Time*, and McGraw-Hill commissioned Milton Glaser to design the dust jacket.[1] Seven of de Hory's Modiglianis decorated the front cover. As many false Matisses graced the back.

EXPOSED—A MAN WHO HOLDS THE ART WORLD TO RANSOM, ran a headline in the *London Daily Express* on March 12, 1970, just in time for a black-tie book-release party in de Hory's cliffside villa. The global attention gratified Elmyr, who took sly pride in his new image, showing the newspaper to guests and quoting from it in English and French.

His biographer let him hoard the credit. If Irving was envious, nobody on Ibiza noticed. Nor did Irving hint at his plans for a new book, a project known to only a few McGraw-Hill executives. On January 3, 1971, he'd shown his editor a flattering letter about *Fake* from the billionaire recluse Howard Hughes. "It seems to me that you have portrayed your man with great consideration and sympathy, when it would have been tempting to do otherwise," read the handwritten note. "For reasons you may readily understand, this has impressed me." Within several months, Irving had secured a $750,000 contract to ghost Hughes's memoirs.

1. At the time, Glaser was well-known as the cofounder and design director of *New York Magazine*. Several years later, in 1973, he designed the iconic *I ♥ NY* logo.

A year later, with publication imminent, Hughes made his first contact with reporters in nearly a decade and a half. Ever wary of undue exposure, he declined to appear in person, holding a press conference by speakerphone. "I don't know him," Hughes said when a reporter mentioned Irving's name. "I have never even heard of him until a matter of a few days ago when this thing first came to my attention." The book totally flummoxed him. "I mean this episode is so fantastic that it taxes your imagination that a thing like that can happen," he said. "I only wish I were still in the movie business."

Time Magazine dubbed Irving *Con Man of the Year*, his portrait painted for the front cover—with "just a touch of Modigliani"—by the notorious Elmyr. The accompanying article marveled at the manuscript's "undeniable smack of authenticity," noting that some of the most knowledgeable editors in the industry had "found it convincing in its tone and above all its remarkable wealth of detail about Hughes' complex life." With the exception of some notably bizarre passages and arbitrarily altered details, Irving's ersatz *Autobiography of Howard Hughes* was remarkably accurate, far more so than his account of his neighbor on Ibiza—who didn't come from Lake Balaton or descend from landed gentry, let alone have the birth name Elmyr de Hory.

Von Houry. Raynal. Herzog. Cassou. Dory-Boutin. These are a few of Elmyr de Hory's documented aliases, yet his true name has never been determined. One faction led by the art historian Johannes Rød claims that he was born Elemer Horthy and that he was the son of a middle-class Calvinist tailor. Another faction, led by de Hory's executor, Mark Forgy, argues that his birth name was Elemer Albert Hoffmann, and he was the son of a bourgeois Jewish merchant.

Both names have been matched to birth certificates—Horthy was born in 1905 and Hoffmann in 1906—and each identity is supported by circumstantial evidence, in neither case decisive. Horthy's name can be found in 1922 enrollment records for the Budapest art academy where Elmyr's training probably began, and a man claiming to know de Hory during the war later informed Irving that the forger's childhood had been lower middle class. As for Hoffmann, the name was among de Hory's known aliases, and after he died, Forgy found a portrait believed to depict Elmyr and his brother Stephen, painted around 1912 by the fashionable Hungarian artist Philip de László, a luxury affordable to a bourgeois merchant, perhaps, but probably not a tailor.

De Hory mentioned such a portrait in *Fake*, albeit retouched. Most notably, his brother was absent, replaced by a mother he described as an heiress to a Jewish banking fortune who "went to all the greatest Paris fashion houses for her clothes and furs" while his father was busy serving as Hungarian ambassador to Turkey. "The portrait disappeared during the Second World War," he told Irving. "But how I would love to see it again."

The war was Elmyr's alibi. Anything that had come before seemed plausible in its aftermath. He claimed that he'd studied painting in Munich and then Paris, where his teacher was Fernand Léger and he was friendly with Matisse and Picasso, as well as Maurice de Vlaminck, Kees van Dongen, and André Derain. "I was sitting with them night after night at the Café du Dôme, or the Rotonde, for years," he told Irving, vividly depicting the life of a young aristocrat struggling to succeed as an artist.[2] His reminiscences could not have been completely make-believe: Even when he wasn't faking the work of his Montparnasse neighbors, his technique forever bore the indelible mark of 1930s School of Paris.

2. All statements by de Hory quoted by Irving come from *Fake*.

The influence of other painters was all-encompassing. Elmyr had no aesthetic imagination, no artistic personality. Attracted to his shallow pretenses, people saw what they wanted to see. One day in 1946, he was visited in his Montparnasse studio by Lady Malcolm Campbell. As they were chatting, she noticed an unsigned drawing pinned to his wall. The drawing depicted a young girl's head with such simplicity and certitude she decided it was an early Picasso. When she said so, de Hory coyly asked how she knew. She averred that she was a connoisseur and recollected Elmyr's stories about his friendship with Picasso before the war. She wished to buy it. "Well, why not," he said, and accepted £40 payment. Just before the last of it was spent, Elmyr ran into Lady Campbell at a cocktail party, where she took him aside to say she was feeling "a bit odd." Short of cash, she'd taken the drawing to a dealer. He'd bought it on the spot—for four times her cost.

Elmyr took the hint. He went directly home and consulted a few catalogues on Picasso. Then he picked up a pen and attempted to do on purpose what he'd already done by accident. He drew six classical female heads as Picasso had drawn them in the 1920s. He asked a friend to disrobe so that he could draw her in the nude. The next day, he took two of the heads and the nude to a Left Bank gallery. He told the dealer that Picasso was an old acquaintance, that the drawings had been a gift, and that he was forced to sell them on account of wartime misfortune. The dealer paid him nearly five thousand francs. "And suddenly I realized that I can sell something absolutely unexpectedly for quite a great deal of money in a time when I was unable, but absolutely unable, to sell any of my paintings," he told the French filmmaker François Reichenbach in a 1970 BBC documentary. "I would like to see the poor Hungarian refugee who would have resisted that temptation."

De Hory insisted that standards of morality had changed with the war and that desperation justified activities that had been

unthinkable before. His confession cast him as victim, an identity he never abandoned, even when his aliases and aristocratic pretenses failed him. Whether this tale of original sin was literally true, Lady Campbell never corroborated. However, Elmyr believed it absolutely, and from that moment forward, he acted accordingly.

The first certainty about Elmyr de Hory dates to 1948, when he was forty-two years old, or forty-three, or thirty-seven by his own reckoning. In a January blizzard, the Lilienfeld Galleries opened his debut exhibition in New York City. De Hory was in the United States illegally, lacking a passport and a nationality and making up for it by attaching titles such as *baron* to his name and keeping the company of people like Lana Turner and Anita Loos, America's answer to aristocracy.

Karl Lilienfeld had a respectable stable of artists. The gallery showed post-Impressionist stalwarts including Vlaminck and Derain, as well as Raoul Dufy, Georges Braque, and Marc Chagall, all of whose work de Hory would eventually fake. At the time, though, Elmyr was still trying to distinguish himself from them, without much success. A review in *Art News* was typical: "His lively realism, reckless paint and lush colors strike the well-known chord of the School of Paris, as do his subjects—French ports, harlequins and facile portraits." Only Elmyr's sitters differed from the typical French fare, since the people he depicted were those he hoped would buy his wares.

Loos deemed his depiction of her so appalling that she took it as a gift only so that she could have her maid throw it out. His portrait of Zsa Zsa Gabor was a source of greater contention. He claimed that she commissioned him to paint her in the nude with a guitar by her side. Asked by Irving for verification, she declared that "all Hungarians are liars" and said the truth was that Elmyr

had sold her two fake Dufys for $5,000. ("Two Dufys?" he countered. "On the face of it, that's absurd. Can you imagine Zsa Zsa buying even *one* Dufy?") Though listed in the Lilienfeld inventory, his "Portrait of Zsa Zsa" vanished when the exhibition ended. Only one painting sold, leaving him $375 in Lilienfeld's debt. The debit confirmed his sense of victimhood and established a convenient culprit: the art market.

He remembered his old friend Picasso. In the used bookshops along Fourth Avenue, he found dusty albums, dating from the 1920s, with titles such as *Views of Paris*. He cut out the blank endpapers, on which he drew Picasso figures in pen, coloring some with gouache. Perhaps attracted to the symbolism of sacrifice, he was especially fond of Picasso's 1943 sculpture *L'Homme à l'Agneau*, for which he drew anachronistic studies in Picasso's classical prewar style. He brought his first to the prestigious Perls Gallery, just down the block from Lilienfeld, explaining that misfortune forced him to sell. After examining it over the weekend, Klaus Perls offered the aristocratic Hungarian $750.[3]

What worked in New York was successful in cities across the United States, and by moving around often—and frequently changing his name—Elmyr deflected suspicion that one refugee could have such an extensive collection. Sometimes he presented himself as Baron Herzog, taking the surname of one of Hungary's wealthiest Jewish families. (They lost their world-class painting collection to Nazi plundering, followed by Hungarian nationalization, so the sight of a baron peddling $500 works on paper was plausible, and the notion that the drawings might be fake was almost unthinkable.) Elmyr also liked to call himself Louis Raynal

3. Multiple versions of this drawing were in circulation through the 1960s. Perls later saw one in the apartment of a fellow dealer bearing the inscription, "A mon ami Elmyr de Hory. Picasso."

and to mention that the French art historian Maurice Raynal was a cousin. (Maurice was one of the foremost supporters of Cubism and an intimate friend of many School of Paris painters, making *Raynal* an eminently reputable name. Nobody seems to have inquired how Maurice's cousin became Hungarian.)

Even more than the plundered names, purloined gossip was his stock in trade. In Paris, he'd picked up details about artists' private lives that could be casually dropped in conversation. The anecdotal knowledge quietly confirmed the impression made by his distinguished physical appearance: The drawings had been given to him in friendship—and appreciation for his patronage— before he'd lost his inheritance and had to sell these precious souvenirs of Paris.

The friendships swiftly multiplied, and the souvenirs grew more abundant. By 1949, he counted Matisse and Renoir and Modigliani as old intimates. As in all acquaintances, he had his favorites (especially Modigliani, with whom he felt "an affinity," as he told Irving), and he also had his quibbles (especially with Matisse, whose lines, he informed Reichenbach, "were never as sure as mine"). Of course, he kept his reservations private. When he stepped into a gallery with his portfolio, he expressed nothing but admiration for the artists, and they collectively testified to his connoisseurship.

Until they didn't. His first trouble was in 1952, at the Beverly Hills gallery of Klaus Perls's brother Frank. Presenting himself as Louis Raynal, Elmyr showed the dealer a selection of approximately ten drawings attributed to Matisse, Modigliani, Picasso, and Renoir. Perls was impressed by the quality of the Picassos and especially the Renoirs, yet he was taken aback when he looked at a Modigliani portrait of the painter Chaim Soutine, which uncannily reminded him of the Renoir drawings he'd just seen. Reexamining the whole stack, he recognized that all had brilliant

draftsmanship but that the brilliance was always alike. He surmised that they'd all been made by the same hand and concluded that the hand belonged to Louis Raynal. There was no doubt in his mind. As impulsively as he'd decided the drawings were fraudulent, he evicted Raynal from his gallery and—as he later recalled—threatened to call the police if Raynal didn't leave town.

Elmyr went, but the problem followed him even as his market expanded. In Miami, he set up a sort of mail-order business, offering his works on paper to museums and galleries by writing to curators and dealers. His inventory swelled to include drawings and watercolors by Georges Braque, André Derain, Maurice de Vlaminck, Raoul Dufy, Pierre Bonnard, Edgar Degas, and Marie Laurencin. More or less any artist working in Paris between the wars could count on his friendship.

The scheme worked remarkably well when he submitted just one or two works by the same artist. For instance, in early 1955, he posted a handwritten letter to Boston's Fogg Art Museum, offering to send a couple Matisse drawings "if you would be interested in examining them for eventual purchase."[4] Garnering an affirmative response from the curator Agnes Mongan, he rolled them in a tube and sent them via Railway Express.

"I have delayed writing you until Harvard Commencement was over," Mongan wrote to him months later, in early summer. "I had hoped that some Harvard man would turn up as they occasionally do who would offer to buy the drawings for me. I think the drawings are beautiful and I should be happy to have both of them, but unfortunately we haven't the funds for both. In that case, might I have one for $525?"

4. At the time, Elmyr was using stationary printed with his Miami address but without any name, a money-saving measure for a man with multiple aliases. On his letter to the Fogg, he simply added *Raynal* by hand.

The work she bought was given the descriptive title *Young Woman with Flowers and Pomegranate* and put on exhibit. Postcards were printed. Everyone was satisfied until several months later, when Elmyr sent some more drawings for Mongan to consider: a couple of Modiglianis and a Renoir. Like Frank Perls, she reacted instinctively to what she saw, and instinct told her the whole group was wrong. The Modiglianis and Renoir were quietly returned. Though nothing could be proven, the Matisse was put in storage and the postcards shredded. Lest he sue for defamation, Elmyr was never told what happened.

Only decades later, after Mongan was dead, did Rød gain access to her records while filming a documentary about Elmyr with the director Knut Jorfald. Reviewing the original correspondence, they tried to ascertain how *Young Woman with Flowers and Pomegranate* passed initial inspection. They sought an explanation from William Robinson, the new drawings curator. Regurgitating the connoisseurial cliché that a forgery is convincing for only one generation, he said Elmyr's drawing had "the stylistic characteristics of the 1950s," which he described as "emphasis on the decorative and superficial."

The drawing is undeniably pretty, a characteristic shared by all Elmyr's known work, yet the same could fairly be said of the art he was emulating. The period to which de Hory was attracted and the city where he received his training emphasized the decorative and superficial, if not exclusively, then at least to a greater extent than any place or time since François Boucher reached his Rococo prime. Elmyr's fault was to perceive too clearly this quality his friends had in common and that he shared with them, allowing it to predominate. In other words, he captured something true of each artist's line, but the truth he captured was always the same. Individually, the drawings reflected the

intended artists. Collectively, they identified their common source by betraying his perspective.

The largest collection of Elmyrs ever assembled was acquired in the 1960s by Algur Hurtle Meadows. By 1966, the oil tycoon owned fifteen Elmyr Dufys, eight Elmyr Derains, seven Elmyr Modiglianis, five Elmyr de Vlamincks, three Elmyr Matisses, two Elmyr Bonnards, and individual examples by Elmyr Gauguin, Elmyr Degas, Elmyr Marquet, Elmyr Laurencin, Elmyr Picasso, and Elmyr Chagall. Some were rendered in watercolor or gouache, but the majority were oils.

Oil was de Hory's ideal medium. "An oil, you know, taking into mind the possibilities of texture and color, is theoretically much more complicated," he told Irving, comparing paintings to works on paper. "You have the chance to do a major masterpiece." Though there were fewer technical challenges to a line drawing— which required only india ink and paper of plausible age—the complex physical characteristics of paintings on canvas disguised underlying similarities in style that stood out in stark black and white.

Of course, paintings were also more valuable, meaning that de Hory didn't have to sell them by the hundred and risk having their family resemblance detected, but the higher prices attracted closer scrutiny of each individual piece. Shortly after moving to Miami, de Hory had a battered old painting shipped from Paris, which he brought to a local carpenter with instructions to copy the French stretcher in assorted sizes. He then artificially aged the counterfeit supports with dirty linseed oil, a treatment he also applied to the back of his new canvas. Buyers were reassured by the patina, as well as the correctness of obscure details, such as the joinery

work. The canvas told a story that corroborated the one told by the brushwork and signature and by de Hory himself as gentleman collector.

His paintings could be remarkably convincing. *Figure with Flowers*, allegedly by Matisse, acquired by M. Knoedler & Co. in New York, was deemed so important by the gallery that a full-page ad was placed in the 1958 *Art News Annual*. Even after the picture was condemned by Matisse's daughter, Marguerite Duthuit—who'd been granted the legal right to authenticate her deceased father's work—Knoedler president E. Coe Kerr held it in the highest esteem. "It was a great painting, just great," he later recalled. "You could never dream it was a fake."

Yet Duthuit's undisputed authority bespoke a greater change in the market, as paintings by 20th-century artists escalated in price. Increasingly, collectors and gallerists deferred connoisseurship to experts and judged paintings on the basis of certificates. Letters of authentication signed by art historians were considered dependable, but the most coveted certificates came from family members or—best of all—the artists themselves. Intended to thwart forgery, the system made Elmyr's job easier: A certificate was far simpler to fake than a painting.[5]

He started at the top. For instance, he authenticated a *Still Life with Jug* by writing *"Cette peinture est de moi"* on a sheet of paper in Picasso's script. The scrawled note was persuasive partly because of the handwriting but primarily because the offhand quality was in keeping with Picasso's impulsive character. Like most convincing forgeries, it was the product of impersonation.

5. The prevalence of certificates and the prominence of experts were already well established in the old masters market. Naturally, the system was exploited by forgers, most notably Han van Meegeren.

If only Elmyr's personal manner were as fluid as his identity on canvas and paper, he might have sold fraudulently authenticated fakes indefinitely. But his insistence on passing for a Hungarian aristocrat, so useful at first, increasingly made him an easy mark, especially in the United States. Each time he got caught, his prospects narrowed. It made little difference how often he changed his name. Dealers had only to look out for the golden monocle. To hold the art world at ransom and become the greatest art forger of his time required that he meet someone who could sell as duplicitously as he could paint. Beginning in 1958, two men vied for the role as partners and rivals: Fernand Legros and Réal Lessard.

Neither had a proper background in art. Introduced to Elmyr through a mutual friend, Legros was a French-speaking Egyptian with an American passport who claimed to have danced in the Monte Carlo ballet. Ten years younger, Lessard was his lover, a French Canadian beach bum with a sixth-grade education. Their first qualification was that nobody in the art world recognized them. Their second qualification was that, after a little priming from Elmyr and a trip to his tailor, they were able to act as if they were experienced dealers. And so they became within a few years.

By then, Elmyr had moved to Ibiza, where his aristocratic shtick went unquestioned by fellow expats, and nobody ever knew he was an artist. When he wasn't throwing lavish parties, he made paintings to order for Legros and Lessard, scraping down antique canvases they brought him, following their requests as to artist and subject, and improvising the specifics.[6] The subjects were

6. To facilitate this work, Elmyr kept an extensive art library, supplemented with high-quality transparencies that allowed him to study crucial details such as the texturing of brushstrokes. In the margins of books, he made technical notes in Hungarian, which he reckoned would be indecipherable to snoops.

often inspired by the titles of paintings in obscure old catalogues, where paintings were reproduced on loosely tipped-in plates. When Elmyr's version of a Matisse *Woman with Vase* or a Dufy *Reception at Elysee Palace* was complete, Legros would have it photographed and printed on the same glossy paper as the original catalogue plate, and the two pictures would be switched, giving the forgery instant provenance.

Legros and Lessard were even more industrious when it came to authentication. They bribed the experts or had their official stamps counterfeited. When the artists were still alive, the duo gambled on poor memory and failing eyesight, a ruse known to have worked at least once on an eighty-nine-year-old Kees van Dongen, who authenticated an Elmyr ostensibly painted when van Dongen was in his forties.[7]

The extensive documentation allowed Legros and Lessard to circumvent galleries, retailing directly to the nouveau riche of Europe and the United States. Texas oil tycoons were at the top of their list, and at the tip of the top was Algur Hurtle Meadows. He was a self-made millionaire in a hurry to validate his financial success with cultural clout and had already made a fool of himself by trying to buy a Prado for Dallas, filling the museum of Southern Methodist University with misattributed Spanish masterpieces. He'd been misled in Spain because he saw art as a commodity and was focused on price rather than quality. He drove a hard bargain and bought at a steep discount, concessions that Legros and Lessard were more than happy to give him.

They let him bargain down the asking price on an Elmyr Modigliani from $100,000 to $45,000. For just $41,000, they let

7. According to Lessard, authenticating the painting brought van Dongen great pleasure. Recognizing the model, the old man rhapsodized about how many times he'd made love to her.

him have an Elmyr Chagall, an Elmyr Derain, and an Elmyr Bonnard. At various times and in different moods, Meadows claimed that he'd paid between $375,000 and $600,000 for a collection independently appraised at $1,362,750. The appraiser was recommended to him by Legros.

The tycoon was pleased by the high appraisal, and his wife was content with the colorful paintings, which decorated their Dallas mansion and impressed their friends. In fact, Meadows grew suspicious only in 1966, two years after Legros and Lessard began selling to him, when Lessard had Legros jailed for stealing a briefcase stuffed with Lessard's private business. It was the first time their jealous enmity—plague of conmen—was revealed to a client.

Their mistrust for each other was contagious. Together with Elmyr, they'd created an alternate world in which some of the century's foremost artists had created dozens of works they never actually painted. That alternate world was their joint fiction, and the characters who populated it were their shared identity, conjured by their coordinated effort. As their relationship fractured, Elmyr Matisse, Elmyr Modigliani, and their brethren were orphaned.

"I've had a bellyful of this mess," Meadows told *Time Magazine* in June 1967. "I'm fed up to the top of my head." His ire was not directed at Legros and Lessard so much as at the five experts who'd viewed his collection and told him that forty-six of his fifty-eight modern masterpieces were fake. The select group of American dealers—including the two Perls brothers—had visited at his invitation, with the hope that they would soothe his doubts. Instead, they'd denounced his cultural trophies with such rapid certainty that his suspicion turned on them. He handed over all

fifty-eight works to Wildenstein & Co., the French gallery that represented many of the foremost School of Paris artists. Wildenstein came to a different conclusion, deeming eight of the alleged fakes to be authentic.

The confusion was understandable as the paintings lost their veneer of provenance. Identified with Legros and Lessard, who had always salted their business in fakes with authentic works, the paintings now had to be judged based on visual characteristics, and the verdict reached depended on experts' opinions of Modigliani and Matisse as much as on their assessment of Elmyr's handiwork. Uncertainty about which paintings were faked revealed uncertainties about the artists forged, differences of opinion about their characters, their strengths, and their faults.

The single point of consensus was that the fakery had been achieved by more than one person, quite possibly a whole secret factory, given differences in style and quality. The same consortium was believed to be behind several bad lots placed in French auctions by Legros around the same time. In the Paris suburb of Pontoise, an alleged turn-of-the-century Vlaminck was found to still have wet paint. At the Hotel Rameau in Versailles, a watercolor painted with one of Raoul Dufy's familiar promenade scenes was improbably signed with his brother Jean's name. As Elmyr later confided to Irving, the signature had been switched because the job he'd done was below Raoul's standards. Jean was a lesser talent, so the fake was foisted on him.

Elmyr blamed his inconsistency on the instability of his life, entirely dependent on Legros and Lessard. They'd always been careful to keep him in a state of financial dependence, providing him with a house and sports car but keeping most of the earnings for themselves. His precarious situation may have helped keep his paintings varied, but as the Legros-Lessard venture imploded

with the French auction scandals and a lawsuit from Meadows, he no longer had the finances to survive, let alone pose as a baron.

It was in this state of duress—with Legros and Lessard on the run—that he confided his story to Irving. The narrative he told was the one he wanted to believe, full of aristocratic privilege and artistic promise withering into pathetic victimhood. Irving's book recorded these delusions amid candid accounts of his fakery, frequently confirmed by outside sources.[8] The lies that counted most to him—concerning his own identity—were neatly tipped in, much as his fake School of Paris paintings were tipped into genuinely old art catalogues.

And the revelations were so astonishing that nobody gave much thought to the names of landed gentry on Lake Balaton or former Hungarian ambassadors to Turkey. "I have noticed in this most curious world that anything is possible, and that what seems highly improbable is currently beyond the reach of one's imagination," wrote Irving in his preface. The fraud disclosed in *Fake* stretched the imagination's reach, paradoxically priming readers to believe practically anything.

Fake was published in the United States in the fall of 1969 and in England the following spring. The consequences for de Hory were hardly as he expected. Selling a mere 30,000 copies, the book failed to make him a millionaire. However, his paintings, signed with a cursive *Elmyr*, became desirable as never before. To own one was to identify with the trickster as opposed to the tricked, to be on the right side of the credibility gap.

8. Not everyone accepted Irving's account. "Mr. Legros denied that he was a business associate of Mr. De Hory and also that he ever 'knowingly' sold a collection...which had been painted by Mr. De Hory," reported the *New York Times* on September 18, 1970. Legros sued Irving in New York State Court for $55 million in damages and increased the sum to $205 million the following year. The court dismissed the case for want of jurisdiction.

"Ladies and Gentlemen, by way of introduction, this is a film about trickery, about fraud, about lies," intoned Orson Welles at the beginning of his final film, *F for Fake*. "Tell it by the fireside, in a marketplace or in a movie, almost any story is almost certainly some kind of lie."

The focus of Welles's movie was intended to be Elmyr de Hory. Appropriating scenes from Reichenbach's 1970 BBC documentary and mingling in footage of his own sleight of hand, Welles set out to create a cinematic essay on a topic with which he'd been associated since at least 1938, when he incited panic with his mock news broadcast about a Martian invasion, *The War of the Worlds*. But as he remixed Reichenbach's footage of Clifford Irving describing Elmyr's trickery, news of Irving's own fraud and lies hit the airwaves, remixing everything. In Welles's phrasing, he'd stumbled into "a storyline rotten with coincidence... that the author of *Fake*, a book about a faker, was himself a faker and the author of a fake to end all fakes that he must have been cooking up while we were filming him.... He's nudging the Martians a bit for the championship title."

The Autobiography of Howard Hughes did indeed rival *The War of the Worlds* as the century's foremost hoax, yet the connection to Elmyr's fakery can hardly be called coincidence. "Elmyr's become a modern folk hero for the rest of us," Irving told Reichenbach. Identifying with de Hory, disdaining the complacency of expertise, Irving recapitulated his painting in writing.[9]

9. Welles also was an enemy of experts, especially film critics. François Truffaut went so far as to claim that Welles made *F for Fake* to avenge a *New Yorker* article by Pauline Kael, in which she alleged that he'd stolen credit for *Citizen Kane* from the screenwriter Herman Mankiewicz. Welles didn't directly reference Kael in *F for Fake*, but he did devote an entire monologue to eviscerating expertise: "Experts are the new oracles. While greatly pretentious, they speak to us with the absolute authority of the computer.... They're god's own gift to the faker." Regardless of whether Truffaut was right, Welles clearly identified with Irving and de Hory and gave their scorn for expertise cinematic flair. The critics responded by eviscerating *F for Fake*.

According to Irving's postmortem account of the hoax, *What Really Happened*, the direct inspiration for his "gorgeous literary caper" was a story in the December 21, 1970, issue of *Newsweek*, "The Case of the Invisible Billionaire." The article described Hughes's total seclusion and his stubborn refusal to communicate with the media, the government, and even his own employees for the past decade and a half, despite his dominance of industries from aviation to gambling. The billionaire's reclusiveness only encouraged public interest in his private life. An authorized biography was a guaranteed best seller. If it were fraudulent, Irving surmised, "Hughes would never be able to surface to deny it, or else he wouldn't bother."

To write the book, Irving teamed up with Richard Suskind, a hack biographer with a knack for research. Together, they compiled everything that had ever been published about Hughes and a few things that hadn't been, most notably the rough-draft memoirs of Hughes's estranged lieutenant, Noah Dietrich.[10] From this, they fabricated more than one hundred hours of interviews. "We'd sit there with a tape recorder and a mountain of notes and documents," Irving recalled in a 2007 interview with *The Telegraph*. "And literally, I would say, do you want to be me today or do you want to be Howard? And then we'd start recording, going back and forth."

The transcript was so compelling that Irving and his publisher decided the story should be told in Hughes's own voice. What made it convincing was the combination of well-known facts with unfamiliar details that conformed to people's perception of the

10. At the time, Dietrich was seeking an editor and circulating the manuscript among acquaintances, one of whom Irving happened to know. Recognizing many of the stories but not knowing that he was the source, Dietrich later vouched for the authenticity of Irving's book.

eccentric tycoon. Some of these details were found buried in archives. (For instance, in the Academy of Motion Picture Arts and Sciences, Irving and Suskind discovered a three-page memo from Hughes to one of his studio executives applying engineering expertise to the problem of cantilevering Jane Russell's breasts.) Other details were totally fabricated, albeit always involving people already dead. (For example, Irving and Suskind confabulated that Hughes had flown to Africa under an assumed name for a secret meeting with Albert Schweitzer and that he'd gone to the Ganges disguised as a beggar.) The pastiche quality of the autobiography, and especially the overlay of free invention refreshing familiar themes, was akin to the visual formula for de Hory's paintings.

The Hughes hoax also enlarged on Elmyr's fraud in another crucial respect: Scrutiny was deflected from the work by drawing attention to provenance. For the whole time he and Suskind were writing the book, Irving kept McGraw-Hill distracted with tales of his meetings with Hughes, supplemented with forged documents written in Hughes's slapdash script.[11] The settings of his alleged interviews were always appropriately outlandish—such as atop a mountain overlooking Oaxaca, Mexico—where Hughes inevitably arrived wearing false beards and other disguises. Irving took care to call his editors from Oaxaca, as well as destinations including the Bahamas, Puerto Rico, and Miami, claiming another meeting with Hughes anywhere his extramarital affair with Baroness Nina van Pallandt took him.

McGraw-Hill was so completely convinced that even after Hughes learned of the hoax and held his disembodied press conference, they deemed him an impostor. Irving encouraged this

11. Whenever Irving needed an alibi or excuse, he produced a letter from Hughes. In one of these forged letters, the paranoid billionaire ordered Irving not to turn over his taped interviews to McGraw-Hill. Irving thus dodged the insurmountable problem of faking Hughes's distinctive voice.

belief. He insisted that he and Hughes were victims of a sinister cover-up by people afraid of the truth, hinting that the conspiracy might perhaps even have originated within Hughes's own corporation. On *60 Minutes*, he declared, "There's a James Bond setup here that's out of the worst possible detective novel you could ever read." Asked if anyone had ever seen him with Hughes, he mentioned Suskind, describing a scene in which Hughes offered Suskind a prune from a bag in his pocket. "We still disagree," Irving told *60 Minutes* reporter Mike Wallace. "I say it was a cellophane bag. Suskind says it was a paper bag." His uncertainty about such a meaningless detail made the big lie more believable because it telegraphed his commitment to truth even with respect to the most trivial specifics. He gamed people's assumptions, like a conjurer who scrupulously shows there's nothing up his sleeve before making a grown woman disappear. As Welles admitted in *F for Fake*, Irving "is a much better magician than I am."

Hughes was not Irving's undoing. Even some of the journalists who interviewed the billionaire remained convinced of Irving's integrity, especially after Irving passed a polygraph test and handwriting experts vouched for the letters Hughes allegedly sent him. As of early 1972, one of the most powerful industrialists in the world had lost his identity to a small-time novelist on Ibiza and could not reclaim it because Irving was the better of the two at playing Howard Hughes. The situation recalls a story related in *Fake* about the French art expert André Pacitti, who was so often fooled by de Hory's forgeries that he ended up rejecting a couple of genuine Dufys. "He had become so used to seeing Elmyr's 'hand' that it was 'right' for him," Irving observed, "and the hand of poor dead Dufy looked suspect." De Hory's Dufys were more convincing than the real thing because they were more cohesive and consistent. The same held true for Irving's impersonations of Hughes.

What Irving could not completely control was his own life. His story collapsed when van Pallandt revealed their affair to *Life Magazine*, saying that in Oaxaca he never mentioned an interview with Hughes, let alone left her for the mountains. He was betrayed by an alibi he didn't even need. Abetted by a racy photograph of van Pallandt splashed across the cover of *Life*, the Irving saga swiftly overtook public interest in Howard Hughes. Inevitably, Irving's Ibiza neighbor was implicated in the fraud, accused of having forged Hughes's handwriting.[12]

"The whole thing is ridiculous," Elmyr fumed to reporters from the *Sunday Times*, still incensed that *Fake* hadn't earned him the money Irving had promised. "Would I be likely to take part in such an operation of forging documents for a man who had proved himself untrustworthy?" Of course, the denials made him appear more guilty, and the portrait of Irving he painted for the cover of *Time* was widely perceived as his confession. It was a good story, far more plausible than the truth: that Irving had simply done the handwriting himself and that the checks issued to Hughes by McGraw-Hill had been endorsed by his wife.[13]

12. The quality of forgery was good enough to have tricked the experts at Osborn, Osborn, and Osborn, handwriting specialists hired by McGraw-Hill to look over all the Hughes letters when their authenticity came into question. According to the firm's official report, "Both the specimen and questioned documents reveal great speed and fluency of writing. Yet the questioned documents reflect in every detail the genuine forms and habit variations thereof which make up the basic handwriting identity of the author of the specimen documents.... These basic factors, we believe, make it impossible as a practical matter, based on our years of experience in the field of questioned handwriting and signatures, that anyone other than the writer of the specimens could have written the questioned signatures and continuous writing."

13. Irving based his forgeries on a letter handwritten by Hughes to two subordinates, replicated in *Life*. Irving claimed that he happened to have the same penmanship as Hughes, and he may even have convinced himself, since retrospective handwriting analysis has revealed errors concealed by sheer bravado: Unlike most would-be forgers, he wrote fast. He taught his wife, Edith, to do the same and had her pose as Helga R. Hughes—H. R. Hughes—at the Swiss bank where they cashed McGraw-Hill's checks. For this fraud, they both served brief prison terms.

So what *did* Elmyr fake? The answer is at least as elusive as his real name.

In 1976, de Hory committed suicide with a cocktail of sleeping pills and cognac to avoid extradition to France, where he was to be tried for fraud in the long-drawn-out Meadows case. Three years later, Fernand Legros published an autobiography, *Fausses Histoires d'un Faux Marchand de Tableaux*, in which he capriciously accused "Hoffni-Hoffmann" of being a *faux faussaire*—a false forger—whose claim to having faked the masters was a hoax. In his 1989 memoirs, *L'Amour de Faux*, Réal Lessard was more brazen, asserting that he actually painted the forgeries he and Legros sold and that Elmyr had only occasionally been permitted to add signatures. His plagiarism of Elmyr's reputation was all-encompassing, including de Hory's best-known forgeries, such as the portrait van Dongen mistook for his own work, described by Irving and illustrated in *Fake*.[14]

But if Legros and Lessard were not to be trusted, neither was Elmyr. Interviewed by *Life* in 1970, he estimated the market value of his fakes to be $60 million and cavalierly gave examples of his undetected masterpieces, such as a Matisse *Portrait of Mademoiselle Roudenko* at the Fogg Art Museum. There was just one problem: The Fogg was bequeathed that portrait by the financier Maurice Wertheim, who'd bought it directly from Matisse. "With an ego like that," *Life* summed up, "someday De Hory is liable to claim that smiling lady in the Louvre."

Elmyr's plagiarism of authentic works only served to obfuscate, confounding the identification of work he really faked. In the catalogue for a 2010 de Hory retrospective at the Hillstrom Art Museum, Irving estimated that up to 90 percent of Elmyr's

14. By the time Lessard's memoirs were published, he was making a living painting in the style of the masters. Plagiarism of de Hory's reputation was good marketing.

forgeries remained undetected. "Elmyr's illegitimate master-pieces in public and private collections under the names of a number of the great Modernists may continue resting undis-turbed, perhaps forever," mused museum director Donald Myers, inadvertently echoing de Hory. ("If you hang them in a museum and if they hang long enough," said Elmyr in *F for Fake*, "then they become real.")

All but one of the seventy-two works in the Hillstrom exhibi-tion were signed by Elmyr, postdating the publication of *Fake*, when he was earning his living selling work by the masters under his own name.[15] After his death, the values escalated. In the 1980s, paintings sold for thousands of pounds at Sotheby's and Christie's. As the prices went up, so did the amount of available work. The quality became less consistent, and the look grew more diverse. Especially peculiar were a large number of post-Impressionist paintings depicting women with Asiatic features. In 1991, a selec-tion of these unprecedented Elmyrs were reproduced in *Enigma! The New Story of Elmyr de Hory, the Greatest Art Forger of Our Time* by Ken Talbot. Aside from those color plates and the author's name, the story was not new at all. *Enigma* was just a reprint of *Fake*.

Talbot had bought the rights to *Fake* from Irving, and he also owned four hundred works supposedly acquired directly from de Hory. Shown some examples by Johannes Rød, people who'd known Elmyr on Ibiza said they looked nothing like his work, leading Rød to conclude that they were "fake fakes" cheaply produced in Asia and made to look legitimate by the inclusion of

15. The signed works were all lent by his executor, Mark Forgy, who served as a private secretary during the final years of Elmyr's life. In an unpublished memoir, Forgy claims that de Hory continued to make and sell fakes even after appearing to go legit.

several in *Enigma*. If Rød is correct, then Talbot pulled off a ruse Elmyr once planned with Lessard—only in their case the biography was going to be about van Dongen, with Elmyr's forgeries as illustrations.

Or would the illustrations have been painted by Lessard? In the abyss between forgery and plagiarism, Elmyr disappears.

WHAT IS CULTURE?

Tom Keating
1917–1984

One sunny morning in 1983, a model named Amanda slipped on an antique French blouse, swept back her long auburn hair, and turned toward the painter Tom Keating, pouting her lips as young girls did for Renoir. Though Amanda knew that the potbellied Cockney artist had counterfeited more than two thousand paintings by masters ranging from Rembrandt to Edvard Munch in his sixty-six years—and that many had fraudulently sold at auction—her face radiated childlike innocence as he loaded his palette with viridian and vermilion and alizarin crimson, colors Renoir had favored a century before.

Keating had inferred Renoir's techniques by studying the Frenchman's paintings at London's National Gallery and the Tate. He'd also read the standard textbooks from Renoir's era and had handled Impressionist paintings as a restorer. Most important, he'd assimilated Renoir's creative process, reducing knowledge to habit. In his old-fashioned smock and full white beard, taking up a stub of sanguine chalk, Keating was as much in character as his model.

He began by drawing her figure on the canvas with a few fluid gestures. Taking up his palette, he then brushed in the pale sunlight pouring across her face. He described her contours in shadow

with broad strokes of dark green background and filled in her coif as a swath of burnt sienna. His underwork looked nothing like the Renoirs in museums. Periodically, the figure lost even the basic appearance of a woman, only to gain greater semblance to his model several brushstrokes later. For him, the fickle procedure was "like love," he said, "and this is the beauty of it."

Gradually, the model's visage took shape on the canvas. Keating conveyed a sense of depth by outlining Amanda's figure in cobalt blue. He used the same hue to define the bone of her cheeks, gently blended into the warmth of her skin. Then he disfigured her again with stabs of pure color. He built up the pigment into a thick mask of impasto, fusing the colors by blotting the paint with sheets of newspaper. He repeated these steps over and over. By degrees, Amanda's features blurred into the anonymously sweet hues of a typical Renoir girl.

Yet even had her face remained as identifiable as in a mug shot, Amanda need hardly have worried about a visit from Scotland Yard. This subterfuge was no secret. The studio in which she posed belonged to Channel Four, where Keating's acts of artistic imposture were filmed for British national television. Starting in 1982, weekday episodes of *Tom Keating on Painters*— aired at 6:30 P.M. to attract a family audience—revealed the working methods of Titian and Rembrandt and Monet and Constable. In thirty-minute sessions, the potbellied Cockney demonstrated how to paint Turner's ships and van Gogh's sunflowers. Viewers adored him. As the British TV personality Magnus Magnusson later noted in an elegiac essay, Keating's popularity was "almost on a par with art historian Kenneth Clark and his pioneering 1969 BBC television series *Civilisation*."

The comparable status of *Civilisation* and *Tom Keating on Painters* was as revealing as it was surprising. Two men could not have come to prominence by paths more different. Heir to a

Scottish textile fortune, Lord Clark was former Surveyor of the King's Pictures, director of the National Gallery, and Slade Professor of Fine Art at Oxford. Keating was a former house-painter from the bleak Forest Hill district of south London, whose "Sexton Blakes"—Cockney rhyming slang for *fakes*[1]—made a mockery of institutionalized erudition. Their perspectives on art were as disparate as their backgrounds. "Although Renoir's first impulse to paint came from an almost naïve sensuous delight," Clark wrote in *The Burlington Magazine*, "he never imagined that the mere representation of agreeable objects was the end of painting." Keating begged to differ. "He loved young girls," Keating told TV viewers. "Don't we all?"

Of course, ratings on television counted for nothing in the ranks of scholarship. Keating didn't express his opinions in learned language. His ideas scarcely registered with the guardians of culture. Certainly, his byline never appeared in august journals such as *The Burlington Magazine* or in monographs on the likes of Renoir and Constable. His handiwork did, though—albeit bearing signatures other than his own.

The greatest disappointment in Tom Keating's life came at the age of fourteen, when he was turned away from St. Dunstan's College in London. Overcoming the poor education available in Forest Hill, he'd passed an entrance exam to the respectable public school, only to be told by the headmaster that his family would

1. Rhyming slang is a sort of street code in which a word is disguised by rhyming it with the end of an unrelated phrase (e.g., *wife* is rhymed with *trouble-and-strife*), often further concealed by lopping off all but the beginning of the proxy (here, *trouble*). Famous names are also used, such as *Gregory Peck* for *neck*. In the case of pulp detective Sexton Blake, the name is usually rhyming slang for *cake*, but Keating playfully reassigned it to *fake*.

have to cover the fourteen-pound expense of books and clothes. "He might just as well have asked for fourteen thousand," Keating recalled in his picaresque 1977 autobiography, *The Fake's Progress*.[2] His father's shilling-and-sixpence hourly wage as a housepainter could scarcely feed the overcrowded Keating household. So young Tom got a job. He worked as a delivery boy, a lather boy, a lift boy, and a bellboy before entering the housepainting trade, mastering the crafts of graining and marbling just in time to be enlisted as a boiler stoker in the Second World War.

The sole benefit of military service was eligibility for a two-year rehabilitation course, on the basis of which Keating was admitted to Goldsmiths' College, University of London. Entering the art program, he tried (as he later phrased it) "to get a bit of taste." Instead, he discovered the cultural chasm separating him from his higher class peers. The rift could be humiliating, as when they'd mocked him for praising the anti-Modernist painter Pietro Annigoni, whose academic realism could appeal only to a ple-beian.[3] Lack of refinement may even have undercut Keating's efforts to earn a diploma: While he got high marks for painterly technique, his composition was deemed insufficiently original. He left Goldsmiths' as he'd entered, an artisan.

Only indirectly did Goldsmiths' offer an escape from the shilling-and-sixpence life. In his two years, Keating had picked up a complementary set of skills by working evenings and weekends

2. The full title is *The Fake's Progress, Being the Cautionary History of the Master Painter & Simulator Mr. Tom Keating as Recounted with the Utmost Candour without Fear or Favour to Mr. Frank Norman.* As the title suggests, the book was dictated by Keating and edited by Norman with Keating's collaboration. All quotes from Keating in this chapter are taken from this source unless noted.

3. At the time, Keating's own drawings bore a close resemblance to Annigoni's art—so close, he claimed in *The Fake's Progress*, that Wildenstein Gallery director Jack Beddington offered to exhibit the drawings together with Annigoni's paintings, an offer Keating declined only because he couldn't afford the framing.

for art restorers. At the esteemed Hahn Brothers in Mayfair, he learned the painstaking craft of filling in cracks—mixing paints just light enough that they'd match the original color under a darkening coat of varnish—but he was soon lured away by a more vigorous restorer, less burdened by ethics, a man he dubbed Fred Roberts in *The Fake's Progress.*

At Roberts's small shop, Keating was given jobs that thoroughly exercised his technical skills and appeased his painterly ambitions. His first big task was to fill in a hole torn through a large landscape by the 19th-century Royal Academician Thomas Sidney Cooper. The canvas had been ripped by shrapnel during the Blitz. Roberts relined it—laid it down on new cloth—physically stabilizing the painting but leaving a conspicuous gap in Cooper's grazing herd of cattle. In place of the livestock, he proposed that Keating enliven the pasture with children encircling a maypole. "It was a naughty thing to do," Keating later admitted, "but the alternative was filling in cracks. More than anything else in the world I wanted to paint and I didn't care what it was that I painted."

And so it was that the fake progressed. Among the many canvases passing through Roberts's shop was a quaint winter scene by Frank Moss Bennett, an early-20th-century British genre painter whose works were widely reproduced on cigarette cards and calendars. Sounding the tone of his fellow Goldsmiths' students, Keating made some snide remarks about the picture and was challenged by Roberts to show he could match it. His first attempts were essentially replicas, carefully duplicating a horse-drawn coach departing a country inn. His third effort was more ambitious. "I felt that I knew so much about the artist that I could do one out of my own head," he recollected. He visited the National Maritime Museum, where he could sketch mannequins attired in period costumes. From these drawings, he painted a pastiche that played on

Bennett's obsession with seafaring in the age of Sir Francis Drake. "It took me exactly two weeks to complete, and when it was finished I was so proud of it I signed it with my own name."

The signature was the only detail that Roberts saw fit to correct. Without consulting Keating, he had it autographed *F.M. Bennett 1937* and consigned it to a West End gallery that also fronted some of the more outlandish restorations. Keating learned about the scam only when he saw one of his ersatz Bennetts in the gallery windows. "I was astonished to discover, as I looked around, that hanging on the walls were quite a number of the paintings that I'd prettied up with boating scenes, little girls with ribbons in their hair and other additions to make them more saleable," claimed Keating in retrospect. "I wondered, as I stood there, how many other dealers in the West End went in for this kind of deception."

As hard as it is to believe that Keating was wholly oblivious to this fraud—what other purpose could even his first maypole have served?—witnessing it in a gallery does seem to have made his relationship with forgery more complicated. No longer was the art market an abstraction to him, distant and anonymous. Instead, it became his focus, giving him a rationale for adopting the style of other painters and earning some money in their name. "It seemed disgraceful to me how many of them had died in poverty," he asserted in *The Fake's Progress*. "All their lives they had been exploited by unscrupulous dealers and then, as if to dishonor their memory, these same dealers continued to exploit them in death." The time had come for the commercial art establishment to learn a lesson, by his reckoning, and the poverty he shared with past generations qualified him for the job. "I was determined to do what I could to avenge my brothers and it was to this end that I decided to turn my hand to Sexton Blaking."

By the early 1950s, Keating had a wife and two children. They lived together in a decrepit Forest Hill flat, devoid of furniture, that doubled as his studio. What the neighborhood lacked in luxuries it made up for in junk shops, where broken old paintings of no artistic merit could be bought for mere shillings. Unable to afford fresh art supplies as a student at Goldsmiths', Keating was already accustomed to refurbishing used canvases. He began to see their dilapidation as an advantage: Anything he painted on them inherited the patina of past centuries.

He was not particular about matching the canvas to his picture. At first, he favored genre painting—"ice-skating scenes, ladies reading letters at spinnets, tavern interiors"—pastiche subjects that lent themselves to pastiche treatment. He cribbed imagery from books and postcards. Older supports got variations on Peter de Hoogh, Adriaen Brouwer, and Gabriel Metsu. Newer canvases were usually made to resemble the work of Cornelius Krieghoff, whose pictures Keating first encountered in Fred Roberts's shop.[4]

Given the sheer number of mid-19th-century canvases moldering in south London junk shops, Krieghoff got by far the biggest posthumous boost. He scarcely needed Keating's assistance. A Dutch artist working in Quebec City in the 1850s, Krieghoff produced thousands of diminutive farm and tavern scenes, many of which were bought as souvenirs by British soldiers. Historians came to value them for their detailed documentation of Canadian customs. Collectors coveted them for their decorative charm. Dealers delighted in their escalating prices,

4. The two small Krieghoffs that Keating encountered in Roberts's shop were the only ones he ever saw in person. His primary source of imagery was Marius Barbeau's classic *Cornelius Krieghoff: Pioneer Painter of North America*, supplemented by auction catalogues and several large color photographs he requested from museums in Canada.

reaching into the thousands of pounds by the 1950s. Keating appreciated them for Krieghoff's skillful depiction of "jolly little Brueghelesque figures" and for the fact that Krieghoff "did so many versions of the same picture"—to which hundreds more could and would be added over the following decade.

Keating took seriously the work of mastering an artist's style, teaching himself all he could learn on his own, but this care with technique was intentionally offset by his recklessness with materials. Rather than scraping down the old potboilers he bought in junk shops, he simply cleaned them with alcohol and reprimed them with a layer of rabbit-skin glue. He painted directly onto this surface, often in acrylics, sometimes brushing on a layer of darkening varnish before the paint cured. The results were predictably catastrophic. Even if his synthetic pigments were never detected by scientific testing, the paint would start to peel in a few decades, betraying his ruse. Ultimately, all that would remain was the original potboiler, more often than not the portrait of a grim British grandmother.[5]

Even more anarchic than his method of creation was his mode of distribution. Keating sold his first Sextons in the Forest Hill junk shops where he bought his canvases, seldom calling attention to the signatures, charging as little as five pounds apiece, rarely more than fifty. By 1956, he'd left his family for itinerant work in Scotland—restoring the trifling art collections of minor Highlands castles—a job that unaccountably inspired him to take up French Impressionism. He tossed his Sisley landscapes and Renoir girls into country auctions together with the Dutch genre pictures. It was a buyer's market. "Sometimes a farmer might write to me and enclose a fiver for a Krieghoff that hadn't attracted any bidders

5. "I have always felt," Keating wrote, "that it would be quite wrong of me to obliterate the work of a fellow artist no matter how poor his paintings may be."

at a cattle auction," he recalled. "His wife liked it and was a fiver all right?" Another time, a Krieghoff hammered at a pig auction for eighteen pence.

However, the vast majority of fakes were just given away, along with sketches drawn in imitation of Rembrandt—penned with homemade seagull quills—and watercolors painted in the styles of J. M. W. Turner and Thomas Girtin. In the Highlands and then back in London, Keating gave pictures to friends and neighbors, acquaintances at the corner pub, the man who read his gas meter.[6] In some cases, he regarded fakery as a means of helping people in need, while also bringing chaos to the art market when the forgeries were cashed in at auction. At least several Sexton Krieghoffs sold at major houses such as Sotheby's and Phillips, though generally at junk shop prices since the catalogue entries were shrewdly vague.[7] Rumors about forgery had the desired effect, depressing all Krieghoff prices and curbing dealers' profits.

"I've been a socialist all my life," Keating declared in his autobiography. Yet he was onto something more subversive than merely unhinging the market. With his Sexton de Hooghs and Sexton Renoirs, Keating made the masters widely available and broadly affordable—even if only in ersatz form—allowing practically anyone to live with a magisterial collection. In a country as

6. The haphazard distribution of Sexton Blakes later prevented even Keating himself from accounting for all that he'd done, though he worked on a sort of catalogue raisonné with the journalist Geraldine Norman. Few of the drawings and watercolors were ever recovered. "I cannot even indicate whether the reason for this is that they were so good that no one even questioned their authenticity, or so bad that no one gave any serious credence to them," wrote Norman.

7. Like Cockneys, auctioneers have a code of their own. When an artwork is catalogued under the full name of the artist, the house is signaling high confidence in the attribution. If only the last name is given—as in the case of Keating's Krieghoffs—the buyer had better bid with caution.

stratified as mid-century England, where culture was interchangeable with status, his Sexton Blakes afforded a sort of cut-rate cultivation.

Tom Keating deemed himself a successor to Edgar Degas because Degas mentored the British artist Walter Sickert, who'd mentored one of Keating's early mentors. It was a tenuous connection, reinforced in Keating's mind by a Degas self-portrait he counterfeited in 1962. As he told the story, he'd no recollection of making the pastel. "It sounds ridiculous, I know, but Degas really did draw that picture through me and many others besides," he claimed. "I woke up one morning and found it on the easel, in place of the scratchy, silly daub that I'd been working on the day before."

The drawing impressed a couple of Keating's friends, siblings who were junk dealers in Kew. In *The Fake's Progress*, he dubbed the pair Roger and Anne and said they began pestering him for paintings to sell after Anne showed the pastel to a Paris gallery and was offered two thousand pounds. Keating's response was characteristically impulsive. First, he ripped up his drawing. Then, he went into business with them.

Roger and Anne supplied the canvases and the clients. Keating prepared the inventory. The artists he chose to Sexton—the German Expressionists—he deemed the opposite of Degas. "It may be unfair, but I have never liked them all that much," he later explained. "You only have to look at the self-portraits of Karl Schmidt-Rottluff with his barbaric fizzogg and monocle, to see how arrogant they were." But the Expressionists were in vogue with collectors, and Keating found them easy to mimic. Cribbing from "a little paperback that cost a few bob," he turned out twenty-one paintings in a weekend under bankable names, including

Kirchner, Nolde, and Pechstein.[8] To save money, he simulated passages of thick impasto by mixing poster colors with housepainter's emulsion. He rendered everything else in acrylic. As usual, the canvases were old potboilers, sealed with rabbit-skin glue, and sometimes underpainted with assorted rude words. For those, he used lead white, a traditional oil pigment he reckoned would show up in an X-ray due to the heavy metal content.

It was a peculiar business strategy, to say the least, as if Keating sought to sabotage himself (and his partners) for straying too far into capitalism. Roger hawked a couple of dozen of the paintings to the tony Redfern Gallery in Mayfair, where he was received by the gallery's senior director, Harry Tatlock Miller. As Miller later recalled, the junk dealer claimed to know nothing about art, and to have acquired the works blindly from the estate of an old German émigré. In terms of provenance, the story was worthless. The amount Miller offered was negligible. Then Redfern singled out twelve of the paintings they believed to be authentic and sold five of them in a summer exhibition.

If Keating heard about this, it didn't make him more entrepreneurial. Instead, he found himself possessed by Francisco de Goya. As Degas had done, Goya enlisted him to create a self-portrait. "Never before or since have I felt so strongly the presence of a master," he recollected. "The old boy was standing there right next to me and he was guiding my hand so firmly that I felt I had no control over what was taking shape on the canvas." In the end, Keating found himself staring at an image of Goya as he looked in old age—similar to Goya's famous self-portrait of 1815—albeit

8. Keating's notion of German Expressionism was rather vague. He included several variations of Edvard Munch's *Scream* in the first batch.

rendered atop a Scottish potboiler in a careless mix of oils and acrylics. Keating embellished the picture with an inscription: *Death comes to us all.* (Because he knew no Spanish, he had the proprietor of a local coffee shop translate his English. "La muerte viene para todos," the bemused Spaniard scribbled on his bill for egg and chips.) Keating hung the portrait on his studio wall. He made no effort to sell it. For him, it vindicated a slight quite different from the grudge he held on behalf of his brother Impressionists. Goya had not been wronged by the art market, in his opinion, but by the museum establishment that destroyed old masters' work by overrestoration. This painting was a replacement, and the museums were not fit to own it.[9]

That Goya had chosen him did not surprise Keating any more than he was amazed to have been enlisted by Degas. Evidently, he believed past masters recognized themselves in him as he saw himself in them. His creation of their self-portraits showed their shared sympathies across time and nationality: Painters belonged to the same culture and could understand each other in ways that museum professionals and peddlers could never comprehend. Yet Keating was not condoning an alternate elite. He considered the culture open to anyone willing to wield a brush.

If Keating had a regret about not graduating from Goldsmiths', it was that a diploma would have qualified him for an art school professorship. In 1963, at the age of forty-six, he made up for it by teaching drawing to half a dozen teenagers he met in the Kew railway station. They were all school friends, happy to take his free Saturday morning lessons. They brought him small gifts in exchange: an ounce of tobacco, an art book found in a junk shop.

9. Nevertheless, he did not hesitate to give it to a friend as a going-away present when his friend left London for the Canary Islands—where presumably death soon came to the chemically unstable overpainting.

One sixteen-year-old girl grew especially attached to the graying Cockney and convinced her parents to give Keating a pound per day for full-time instruction. Her name was Jane Kelly.

He taught her all he knew as an artist and restorer. They spent practically every day together. In spite of their age difference, or because of it, they became intimate. "I think any artist who has learnt on a one-to-one basis from a master must love the master," Kelly explained to the *Toronto Star* in 1979. "It's absolute falling in love with the person and all they stand for, in the same way that one falls in love with Rembrandt." Four years after they met, they began a life together and started a restoration business in Cornwall.

Keating made the most of the countryside. One of the volumes Jane's friends had given him was a monograph by Geoffrey Grigson called *Samuel Palmer's Valley of Vision*. The book impressed him deeply. Palmer was a 19th-century English painter, largely self-taught, whose early landscapes were touched with a visionary quality influenced by William Blake. Palmer himself described them best when he said that they had "a curiousness in their beauty—a salt on their tails by which the imagination catches hold on them." Completed between 1826 and 1835, when Palmer was living in the Kent village of Shoreham, the watercolors and drawings from this period are exceedingly rare, numbering fewer than one hundred. (One of the finest was owned by Kenneth Clark, who considered Palmer to be the British van Gogh.)[10] Palmer's son Herbert has sometimes been accused of destroying the rest after his father's death, perhaps to accentuate Palmer's

10. Clark acquired his Palmer watercolor—*Cornfield by Moonlight with the Evening Star*—in 1929, just three years after Palmer was "rediscovered" in a seminal exhibition at the Victoria and Albert Museum. Beginning in 1931, Clark served for four years as Keeper of Fine Arts at the Ashmolean Museum, which was to become the preeminent repository of Shoreham-period Palmers under his successor, Karl Parker.

more conventional later paintings. Whatever the reason for their scarcity, Keating couldn't tolerate the loss of work he deemed comparable to Turner's finest, created by a man he considered "gentle, lovely, meek, generous, devout and humorous." He sought to undo Herbert's damage, "to replenish the stock as a kind of vendetta."

While still in Kew, Keating Blaked the first Shoreham Sextons. Drawn offhand, most were casually given away or used as Christmas cards. Moving with Kelly to rural Cornwall was effectively moving backward in time, toward Palmer's pastoral ideal. Yet it was a second move several years later—into a Tudor manor house in the Suffolk village of Wattisfield—that finally enticed Palmer to visit the faker in person.

By then, Keating had collected a thick stack of old paper, including blank pages from 19th-century diaries and ledgers, as well as cardboard from Victorian photo albums. He'd also learned to imitate the preternatural luminosity Palmer achieved by mixing his watercolors with glutinous tree gum and coating the pictures in thick coats of varnish. (With characteristic pragmatism, Keating substituted cooking gelatin for the gum.) Taking up these materials one weekend while Kelly was visiting her family in London, Keating produced sixteen Sexton Palmers in rapid succession.

They kept coming all through the next year. "God's honor, I have never drawn a sheep from life," he wrote in *The Fake's Progress*, "but Palmer's sheep would begin to appear on the paper tick, tick, tick, and there they would be in the guv'nor's 'valley of vision' watched over by the good shepherd in the shadow of Shoreham church." Other artists also availed themselves of Keating's materials: "Gainsborough, Wilson, Turner, Girtin, Constable, all the boys." However, no one was as close to him as Palmer, with whom he was on a first-name basis: "With Sam's permission I sometimes signed

[drawings] with his own name, but they were his work and not mine." As it transpired, Keating was not the only one to be bamboozled.

In early 1970, the *Times of London* saleroom correspondent Geraldine Norman received a catalogue from a small Suffolk auction house called Arnott & Calver. To attract her attention, the auctioneer included a photograph of a rare Shoreham period Palmer drawing titled *Sepham Barn*. Following the sale—which was held in a local church—Norman learned that the Palmer had been acquired by Leger Galleries of Old Bond Street, London, for £9,400. The imposing price, combined with the rarity of the work, was enough to merit mention in her daily column, and the glossy photo provided a good illustration.

Several days later, the *Times* received a letter from an art dealer named David Gould. The photograph of *Sepham Barn* "showed sufficient detail to make one wonder if this was a pastiche," he wrote. "The drawing has all the ingredients apart from the somewhat unusual bats ('borrowed' from the 1824 sketchbook?) of a Shoreham period drawing of 1831. But to my eye it lacks the idiosyncrasy which infused Palmer's work with an inimitable poetry." Because Gould was an eminent connoisseur, the letter was published. Because he was a notorious gadfly, nobody paid it much attention, least of all Leger. If anything, their confidence was bolstered once they had a chance to examine the drawing outside the dusty old frame and found a small signature hidden under a mount. They put it on the cover of their autumn catalogue, priced at £15,000.

The next time Norman saw *Sepham Barn* was in November 1971, in a Leger watercolor exhibition with two more Shoreham-era Palmers. The catalogue laid out their provenance. All three had been

given by the artist to the Reverend John Farr of Gillingham, Norfolk, and inherited by his son Thomas, who moved to Ceylon circa 1868. Thomas left them to his daughter May Elizabeth, who married Douglas Kelly, "and thence," concluded the catalogue entry, "by descent to a member of the family." Norman asked Gould what he thought. He responded that the whole batch was likely fake and periodically let her know about others he believed came from the same source. At last, in March 1976, she decided to investigate.

With Gould's assistance, she collected photographs of thirteen suspect Palmers, which she showed to experts, including Geoffrey Grigson. The majority—Grigson included—rejected them on connoisseurial grounds. Norman submitted one, borrowed from a Leger client named C.V. Green to scientific testing. The drawing had been made sturdy by gluing together layers of paper and cardboard, as was Palmer's habit. On the back, an old hand had written the Reverend Farr's name in antiquated ink—but several intermediate layers tested chemically modern. Asked for a reaction, Leger Gallery director David Posnett provided the complete Farr-Kelly family tree and argued that the drawings couldn't have been faked since they'd been in Ceylon since the 1860s, long before Palmer's Shoreham work became collectible. In case that wasn't persuasive, Leger also threatened to sue the *Times* for libel.

Norman's article was published on July 16, 1976. Carefully weighing the evidence, she concluded that all thirteen Palmers were counterfeit, including the three at Leger and another acquired by the Cecil Higgins Museum and illustrated in *The Burlington Magazine*.[11] "Somewhere there is a talented painter at work," she summed up, "and I would love to meet him."

11. The journey from Keating's drawing board to the Cecil Higgins Museum is characteristically circuitous. In the early 1960s, while Keating was still living in Kew, two Sexton Palmers were sold together in a Bonhams auction for £30. One disappeared, but the other was brought by the purchaser to the highly reputable Colnaghi Gallery on Old Bond Street. Convinced that it was authentic, the gallery purchased it for £200

Readers were eager to assist. One told her about a Suffolk restorer named Jane Kelly who lived with a bearded old painter. Another had more concrete information. Insisting on anonymity, he demanded £7,000 to reveal the forger's name and to provide photographs of the man painting Palmers and Constables and Krieghoffs. Norman bargained him down to £150. In exchange, he told her all about Keating. What the man did not mention was that he was Jane Kelly's brother.

Keating was living alone in a ramshackle cottage on the edge of Dedham, a small town in Essex, when the reporter from the *Times* drove up in her Morris 1100. He invited her inside, poured her a cup of coffee, and gamely told her about his life as a restorer and artist, omitting only the bit about his Sexton Blakery. He was also vague about Jane, who'd left him and moved to Canada with another man the previous winter. He preferred to rant about his struggle against the art establishment as a working-class socialist.

Norman wrote about him on August 10. Ten days later, the *Times* published his riposte. "I do not deny these allegations," he wrote. "In fact, I openly confess to having done them." Alluding to the full scope of his forgery, he declared that money was not his incentive. "I flooded the market with the 'work' of Palmer and many others, not for gain (I hope I am no materialist) but simply as a protest against the merchants who make capital out of those I am proud to call my brother artists, both living and dead." Lest he be doubted, he claimed that he always left obvious traces of

with an agreement to share profits on resale. Colnaghi then offered it to the Cecil Higgins for £2,500. After consulting with the British Museum expert Edward Croft-Murray, the Cecil Higgins acquired it and put it on exhibit in 1965, titled *The Barn at Shoreham*. When Norman's exposé ran in the *Times*, Colnaghi offered to refund the purchase price, but the revelation made the watercolor far more popular than it had been when it was considered authentic, and the Cecil Higgins kept it.

fakery, such as his use of anachronistic paper. "Quite frankly, and with, I trust, due modesty, I cannot imagine how anyone could begin to believe that the crude daubs being marketed as Samuel Palmers were authentic," he wrote. "Anyone with a true love of this kindly, generous and devout artist (who was unable to afford a pinch of snuff in his declining years) will know that he could not possibly have done this work, even on an off day."

Keating's confession-cum-indictment circulated worldwide via Reuters and the Associated Press. Reporters converged on Dedham, but they could not find him because he'd departed for London. He'd gone to see Geraldine Norman.

Though Norman had exposed him, he deemed her a sympathetic figure, respectful of his radical politics and appreciative of him as an artist. He connected even more deeply with her husband, Frank, a petty-thief-turned-playwright most famous for his Cockney comedy *Fings Ain't Wot They Used T'be*. The two old rogues started swapping stories. Within a few hours, Frank had agreed to ghost Tom's autobiography.

The book was announced on August 27. More than one hundred journalists and photographers crowded into the ornately gilded boardroom of the London publisher Hutchinson & Company. Awaiting them was a painting resembling John Constable's *Hay Wain*, except that behind the wain Constable himself could be seen standing at his easel, his back to the buildings that had been behind him when he composed the original. Stepping in front of the pastiche—cameras flashing—Keating opened his palms and started laughing.

The working press was delighted by his irreverence toward everything and everyone, including himself. A tabloid ran the headline MY OLD MASTERS ARE OLD RUBBISH. *Time Magazine* quoted him saying that "anyone who sees my work, and thinks it genuine, must be around the bend." *The Burlington Magazine* was

rather less amused. "There is something peculiarly distasteful about the whole affair," sniffed the editors. "One would assume from the coverage in the press that a new Raphael had come to light in the National Gallery, or a Rembrandt in the Wallace Collection.... Nothing of this kind ever hits the headlines for longer than a day. The Keating affair has been going on uninterruptedly week by week, ever since July 16th, 1976, and shows no signs of abating."

Geraldine Norman responded with a letter, duly published, in which she observed that the media always went in for sensationalism, no matter what was at issue. "The truth of the matter is that a deep and genuine appreciation of art is a pleasure enjoyed by the few," she wrote. "It is, and always has been, an élitist activity." To her, this was just the way of the world, a concession for which Keating had no sympathy. Elitism was what prevented art from being enjoyed by everybody—and the sensationalist media coverage of his outing was proving more damaging to the embarrassed elite than his actual Sexton Blaking.

First to file a complaint with the police was the Redfern Gallery, followed by Leger.[12] However, neither was as damning as Keating himself. *The Fake's Progress*, published in the summer of 1977, provided an over-the-top account of how he'd made his Krieghoffs and Palmers and almost everything else. The book was released in tandem with *The Tom Keating Catalogue*, a slick volume comprising

12. At the time, Leger was under investigation by the British Antique Dealers' Association for being less than forthcoming when doubts about their Palmers were raised. (Rather than refund Green's money, they'd agreed only to give him several objets d'art of equal value, in exchange for which he was made to promise never to discuss the deal.) After several months of cursory questioning, the trade association concluded that Leger had acted with "the utmost propriety."

more than one hundred pages of illustrations. He periodically added to this count by pointing out forgeries published elsewhere, such as his five Sexton Constables in Harold Day's 1975 monograph, *Constable Drawings*.

Keating's trial at the Old Bailey courthouse provided an even greater opportunity for him to wreak havoc. Both he and Kelly were charged with conspiracy to defraud and with obtaining by deception payments amounting to £21,416.[13] Extradited from Canada in early 1979, Kelly pleaded guilty in order to testify against her former lover, who she claimed had exercised a "Svengali-like" control over her. On account of that influence, she said, she'd been driven to place several of his Sexton Palmers in local auctions. Learning that *Sepham Barn* had been bought by Leger and featured on the autumn catalogue cover, he'd sent her to the gallery with several more of his Palmer fakes, appropriating her family history as provenance.

Keating pleaded innocent. Maintaining that he'd never intended to defraud or deceive, he spoke of his simple desire to paint in the spirit of the masters—under their guidance—and his struggle on their behalf against the corrupt art market. He'd been mortified to learn how much *Sepham Barn* had realized at Arnott & Calver and how much money Kelly had received for his Palmers at Leger. Of course, these justifications were not legally viable, nor were they logically consistent. (Were he really under the influence of the masters, why would he produce rubbish? If his paintings were really all daubs, how could they so effectively have penetrated the market? Were the Sextons satirical or were they paranormal?) But even if his explanations wouldn't hold at the Old

13. Not all of this money came from the sale of Sexton Palmers. The case also included a Sexton Krieghoff and a Sexton Constable, the latter retailed by Lionel Evans, an Essex antique dealer who was a codefendant.

Bailey, they were perfectly pitched for Fleet Street, where he wasn't perceived as a Svengali figure but as a trickster—not exactly innocent but obviously benevolent—with an uncanny resemblance to Father Christmas. Even if he *had* deceived and defrauded Leger, they'd blithely retailed his work on Old Bond Street even after they'd been advised by experts that the work could not be authentic, as Posnett was made to admit during the trial.[14] Every day for three weeks, a public that couldn't have cared less whether a new Raphael came to light in the National Gallery, or a Rembrandt in the Wallace Collection, paid keen attention to the mischief caused by Keating. In the melodrama *Art News* dubbed *watercolorgate*, connoisseurship was popular entertainment.

And then the trial took an unexpected turn. Hospitalized after a motorcycle accident, Keating contracted bronchitis, exacerbated by pulmonary disease and a heart ailment. Doctors didn't expect him to live. Declaring nolle prosequi, the prosecutor dropped the case. "As the trial ended," the Associated Press dryly reported, "Keating copies of the English landscape painter John Constable were on sale in a gallery across the street at $120 each."

Signed with the faker's name, they were valuable not as Constables but as Keatings.[15] As he recovered from his ailments and found broad interest in his work, Keating took full possession of his Sexton Blakes. His *Hay Wain in Reverse* was a model. "I seem to be able to walk right into pictures, turn around in them, and even make contact with the masters who made them," he

14. One of the experts was Karl Parker of the Ashmolean.
15. The monetary value of Keating's Sextons rapidly escalated with his growing celebrity. The first auction dedicated to his work, held at Christie's on December 12, 1983, drew a crowd of 800 people who bought all 137 lots for a total of £72,000. He intended to use the money to buy a cottage but died before he had a chance. Naturally, his death made the paintings only more collectible. A second Christie's sale of 202 works from his studio realized £274,000, twenty times the estimate, on September 10, 1984.

explained. Literally applying this skill, he began exploring the internal space of other masterpieces. For instance, he re-created Turner's *Fighting Temeraire*, depicting the old British warship as if he were standing inside the Thames River looking toward the shore from which Turner first sketched it.

This was the canvas with which *Tom Keating on Painters* debuted in 1982. As he painted it, he explained Turner's techniques, often in the second person as step-by-step instructions. His plain-spoken language demystified the art. (Painting impasto clouds "comes from years of buttering bread," he advised. "In my case bread and margarine.") Crucially, he condescended to neither the artist nor his audience. Painting as the master might have done—not merely imitating a picture, but inventing a new composition—informed Keating's admiration, and he presented it as a hands-on self-education open to everyone. Each of the twelve episodes Keating completed before succumbing to heart failure in 1984 urged viewers to pick up a brush and explore: not to accept Lord Clark's word, let alone *The Burlington Magazine*'s authority, but to make contact with the masters and become a part of the fraternity.

How many did? The numbers will never be known. Unlike formal education, the acculturation proffered by Keating was strictly personal. "Diplomas don't make painters," he wrote in *The Fake's Progress*, and the same could be said for connoisseurs. The real Sexton Blakes were the pedigreed elite.

PART THREE

FORGING A NEW ART

I.

In the first few months of 1963, the Mona Lisa was seen by nearly two million people in New York and Washington, D.C. Shipped to the United States on a diplomatic mission—escorted by the French culture minister and received by President John F. Kennedy—the painting did little to assuage Franco-American tension about NATO and nuclear proliferation, but the visit certified Lisa del Giocondo's status as the smiling face of high art, as iconic as any modern movie star.

Several months earlier, an up-and-coming Pop artist named Andy Warhol, notorious for painting consumer goods, turned his attention to celebrities, including Elvis Presley and Marilyn Monroe. Instead of painting their portraits by hand, he adapted a technique from commercial printing, in which a photographic image could be transferred to canvas by pushing paint through a mechanically produced silk-screen template. Any photo could be replicated, including those in newspapers, favorite sources for Warhol since they reinforced the relationship of his paintings

to mass media. The newspapers might even give him ideas, suggesting popular subjects. And in the winter of 1963, few subjects were more popular than the touring Mona Lisa.

Nobody would mistake Warhol's Mona Lisas for the Renaissance original. Leonardo da Vinci finessed La Gioconda's visage with multiple layers of translucent pigment, applied over months with fine sable-hair brushes. Warhol could produce her likeness in mere minutes, a silhouette instantly recognizable as a smear of black paint. He made multiple versions in various sizes. Several were diptychs. His most ambitious was a five-by-six grid called *Thirty Are Better Than One*.

The title was as sly as his painting was cunning. Thirty *are* better than one, at least in Warhol's handling of Leonardo's portrait. Recognizing that the Mona Lisa had become a celebrity akin to Marilyn Monroe, he proposed that fame was a commodity and that the endless replication of a celebrity's face made it so. His industrial process mimicked the mechanism by which people become products, and the end result revealed the degree to which consumers are active participants, mentally filling in enough details to identify Warhol's raw silk screen with Leonardo's sfumato portrait. In *Thirty Are Better Than One*, the Mona Lisa is reduced to a pattern, like paisley or toile de Jouy: perfectly flat, potentially infinite.

Warhol gave Marilyn Monroe the same treatment, screening her face repeatedly from edge to edge of his canvas, yet his repetitions of the Mona Lisa were the most provocative expression of his disquieting vision. Unlike Monroe, whose messy life was extensively chronicled, Lisa del Giocondo was known only by her appearance. A single image was the entire basis of her fame. All surface, no substance, the Mona Lisa was the model celebrity—and an ideal model for deconstructing celebrity in the 1960s.

In art historical terms, Warhol's copies fall under the category of appropriation, a subgenre as old as the 20th century, in which legitimate artists technically come closest to forgery. Though not produced under false pretenses, works of appropriation art are fundamentally derivative. Like forgeries, they trade on borrowed status. Their significance emanates from an absent original.[1]

In other words, appropriation artists appropriate the forger's modus operandi for artistic purposes. And almost always, as in the case of Warhol, those purposes are subversive. Appropriation is a form of critique, a mode of questioning. Yet Warhol was nearly unique in his ability to question more than merely the work he appropriated.

Thirty Are Better Than One is not really about the Mona Lisa or even about art, but rather concerns the tortuous relationship between culture and media, a relationship beginning to play out in his own life as he became the first metacelebrity. In a sense, the Mona Lisas and Marilyns and all the paintings that followed were mere props in that lifelong performance, just as counterfeited canvases are only the physical manifestation of a forger's swindle. Fame was Warhol's true medium, which he subverted by insisting that he was just like everybody else. "I think it would be so great if more people took up silkscreens so that no one would know whether my picture was mine or someone else's," he said in a November 1963 *ARTnews* interview. And by 1968, he was predicting a future in which everyone would be famous for fifteen

1. Appropriation should be distinguished from even the strongest cases of artistic influence. Though Édouard Manet's *Olympia* was obviously inspired by Titian's *Venus of Urbano*, and his substitution of a prostitute for a goddess is clearly meaningful, his reference was to the *content* of Titian's famous painting, achieved by echoing the composition. He provocatively inserted his *Olympia* into a tradition including not only the *Venus of Urbano* but also Giorgione's earlier *Sleeping Venus*. His painting turns on that tradition, rather than being a painting about a painting.

minutes, a nightmare hybrid of democracy and individualism he personally set out to realize by casting anyone he met, regardless of talent, in his unscripted movies. Like the greatest of conmen, Warhol manipulated people's desires and beliefs, but unlike Elmyr de Hory or Han van Meegeren, he did it all out in the open, for everyone to see.

Warhol proved that legitimate art could be as powerful as the counterfeit. He showed the extent to which the forger's art can be appropriated, the mantle of anxiety reclaimed. Yet his achievement also exposes the opportunities squandered by other serious artists, who could potentially have gamed the system but never even tried, preferring instead to produce angst-ridden baubles to be risklessly ogled in museums.

Art has a lot to learn from forgery. If artistic activity online and in the street are any indication, radical contemporary artists perceive the failings of previous generations. Some are attempting to make up for past indolence. One of the most notorious, known only by the pseudonym Banksy, has puckishly taken up where Warhol left off. "In the future, everyone will be anonymous for 15 minutes," he wrote in 2006—spraypainting the words on an obsolete TV set—while tauntingly keeping his identity masked.

To this day, Banksy remains known only by his exploits, including his own Mona Lisa appropriation, La Gioconda wearing a yellow smiley face: centuries of Western art distilled to a perfect cliché. In 2004, Banksy smuggled his painting into the Louvre, illicitly attaching it to the wall with double-sided tape. Within minutes it was found and hustled from view by museum staff. However, the anxieties it elicited cannot so easily be effaced. Where does culture belong? What can art express?

II.

In the fall of 1919, nearly half a century before Andy Warhol made his Mona Lisa silk screens, Marcel Duchamp bought a postcard photograph of La Gioconda from a Parisian street vendor on the rue de Rivoli. Adding a beard and mustache as well as his own signature, he brought the card to New York as a gift for his patron Walter Arensberg, one of the first people in the world to appreciate the *readymade*, his revolutionary new art form.

Duchamp had begun producing readymades in 1913—a year after he painted his notorious *Nude Descending a Staircase*—when he had the "happy idea" of attaching a bicycle wheel to a kitchen stool. His delight in this undisguised combination of common objects led him to more outlandish productions, most famously an upturned urinal that he signed with the pseudonym R. Mutt and submitted to the 1917 Society of Independent Artists exhibit in Manhattan. Simply titled *Fountain*, the work was rejected, despite the fact that the show was unjuried and open to anyone who paid a $6 entry fee. In retaliation, Duchamp and a couple of collaborators published an unsigned editorial in a little magazine called *The Blind Man*. "Whether Mr. Mutt with his own hands made the fountain or not has no importance," they wrote. "He CHOSE it. He took an ordinary article of life, placed it so that its useful significance disappeared under the new title and point of view—created a new thought for that object."

Fountain redefined art, rejecting craftsmanship and sanctifying curation. The artist's job, as envisioned by Duchamp, was to provide a context in which an object functioned as an idea. And the idea of *Fountain* was to enact that redefinition.

Duchamp purposely constrained his selection of readymades, recognizing that the limiting factor was viewers' attention. In that

respect, *Fountain* was an ideal choice. Even the word *urinal* was considered indecent in 1917; public display of the porcelain bathroom fixture would have been nearly pornographic.[2] Choosing the Mona Lisa was also impertinent, especially given the means by which he "rectified" this readymade: In addition to the roughly drawn mustache and beard, he captioned the postcard with the letters L.H.O.O.Q., which can be phonetically read as *elle a chaud au cul*, French slang for "she has a hot ass." The vulgarity was juvenile but not gratuitous. Defiling La Gioconda, Duchamp desanctified Leonardo's masterpiece in order to resanctify it as his own. He finished the thought first broached by *Fountain*, that authorship was entirely a matter of proclamation and that even the most famous of images could be appropriated as a new artwork because the act of appropriating it would give it new meaning.

If *Fountain* challenged the conventional notion of art, *L.H.O.O.Q.* questioned the nature of creativity. And almost immediately, the opportunity suggested by Duchamp was seized by his friend Francis Picabia, who decided to print the rectified readymade in his journal *391*. Since *391* was printed in Paris, and Duchamp and his postcard were already in New York, Picabia simply bought another reproduction of La Gioconda and drew in the mustache himself. He forgot the goatee. "That made the difference," Duchamp told the art historian Pierre Cabanne in a 1966 interview, but the greater distinction was in the captioning. *Tableau Dada par Marcel Duchamp*, Picabia called it, appropriating Duchamp's appropriation (and also Duchamp's name) for the antiart crusade that Dada represented.

2. Given that Duchamp was a cofounder of the Society of Independent Artists and knew the other personalities involved, he must have anticipated the hostile reception his pseudonymous submission would receive and even hoped for the rejection. Exclusion from the context of exhibition contributed to the context of rebellion.

As antiart, *L.H.O.O.Q.* made a strong statement—visualizing the nihilist defeat of civilization—but Duchamp was no Dadaist. His readymades upset tradition to find a way forward. The way he found was so open-ended that his readymade art could be readily remade to support any message, even those he might be inclined to oppose.

That open-endedness has made Duchamp irresistible to artists ever since. His influence is ubiquitous, evident in Surrealist objects such as Salvador Dali's lobster telephone and Pop paintings from Warhol's soup cans to Jasper Johns's American flags. "He has changed the condition of being here," Johns wrote in a posthumous appreciation. For the appropriation artist, he might even be said to have *created* those conditions.

III.

In 1964, as Andy Warhol turned his attention from the Mona Lisa to Day-Glo hibiscus flowers, a young artist named Elaine Sturtevant asked to borrow some of his silk-screen templates so that she could take up his process and make paintings identical to his. Warhol was happy to oblige.[3]

Sturtevant had her first solo show the following year. At the Bianchini Gallery in Manhattan, she exhibited several *Flowers* remakes, as well as her reiterations of paintings by artists including Jasper Johns and Frank Stella. All were remarkably similar to the

3. Not everybody was so generous. In the same year, Warhol himself was sued for copyright infringement by the photographer Patricia Caulfield, whose magazine picture of hibiscus flowers he'd blown up and recolored in his silk screens. Though her case was tenuous, given how completely he transformed the image, he chose to settle out of court with a cash payment. He had no interest in interrogating intellectual property law and, whenever possible, made future silk screens from his own photos.

originals; in each case, she'd carefully reenacted the painter's method of working. "Ask Elaine," Warhol would say whenever art historians pestered him with technical questions.

Sturtevant's appropriations were taken in stride by critics, who regarded her as more Pop than the Pop artists she mimicked. She objected to their assessment, arguing that Pop dealt only with surfaces. "I started asking questions about what lay beneath the surface," she claimed. "What is the understructure of art?"[4]

The postmodern art critic Douglas Crimp was similarly motivated in 1977, when he curated *Pictures* at Artists Space in Manhattan, the first exhibition to explicitly present appropriation art as a movement. "Needless to say, we are not in search of sources or origins, but of structures of signification," he wrote in the journal *October*. "Underneath each picture there is always another picture."

At Artists Space, Crimp's position was most clearly illustrated in the work of Troy Brauntuch, who reproduced a group of banal architectural sketches originally drawn by the failed-artist-turned-Führer Adolf Hitler. The images' power was wholly on account of the absent author: Brauntuch revealed how much the understructure of art could conceal. Yet the *Pictures* artist who was most inspired by the exhibition and who most exhaustively examined the implications of appropriation was Sherrie Levine.

In 1979, Levine rephotographed a couple of dozen photographs originally taken by Walker Evans in 1936. Documenting a family of sharecroppers in rural Alabama, the images were some of Evans's most widely recognized pictures, first published in the 1941 best seller *Let Us Now Praise Famous Men* and reproduced

4. Sturtevant made these comments to the painter Peter Halley in a September 2005 *Index Magazine* interview, sounding the same argument she had been making for four decades. During that time, she never stopped appropriating.

again in the 1978 book *First and Last*. Levine's pictures were pho-
tographs of pages from the 1978 catalogue. The only thing that
distinguished them from Evans's originals was that she retitled
them *After Walker Evans*.

Since the rephotography was completely mechanical, her
entire creative role was the act of appropriation. "The work is in a
dialectical relationship to the notion of originality," she told *Arts
Magazine* in 1985. "A picture of a picture is a strange thing and it
brings up lots of contradictions."

Levine concurrently pursued contradictions in other media.
For a 1985 Hunter College exhibition on the theme of repetition,
she redrew a drawing by the Russian Suprematist Kasimir
Malevich, copying it six times with such precision that each of her
derivative originals could not be distinguished from the others. In
1991, she began casting urinals in bronze—the preferred material
of high art—and setting them on pedestals with titles such as
Fountain (after Marcel Duchamp).

Again and again, Sherrie Levine has entered into dialectics
with art of the past, questioning conventional assumptions about
originality and creativity and interrogating the meaning of art.
Often subtle, always smart, they elaborate Duchampian riddles
more imaginatively than the work of Brauntuch or Sturtevant.
Yet ultimately they fall into the same rut.

Duchamp made art about art to question what art was about.
Even in 1917, a decade after the advent of Cubism, art was severely
constrained by tradition, which limited the creative potential of
artists. *Fountain* represented a mode of creation that had never
even been considered in academies, alerting artists to strategies
they'd not conceived before and exposing audiences to unor-
thodox artistic practices. Readymades were instruments of free-
dom, and to a remarkable degree, they emancipated artists and
liberated institutions. By the 1960s, an artwork could be an

environment, a happening, or even a concept. Yet all too often, the environment, happening, or concept would be about art.[5] This avant-garde tendency to ponder and parse what it means to be free, rather than acting on that freedom in any new way, is ubiquitous. Appropriation is the epitome.

In 2001, an artist named Michael Mandiberg launched the Web site AfterSherrieLevine.com, offering downloadable digital scans of *After Walker Evans*, together with printable certificates of authenticity. "A lot of conceptual art is an inside joke, and a lot of these jokes are one-liners," he confessed in an artist's statement. "This site (like Sherrie Levine's work itself) is no different." Art about art spawns art about art about art. The readymade has liberated artists to incarcerate themselves in their own hall of mirrors.

The realm of self-reflexive art is an insular space, comfortably detached from broader society. Both artists and society may appreciate that safety, but it denies everyone the subversive function that art ought to have in our culture. The readymade has been counterproductive.

"Duchamp is not viable," Sturtevant admitted to the critic Hans Ulrich Obrist in a 2008 interview for the journal *032c*, and Levine's *Fountain* embodies that disillusionment in a physical object: The most radical artwork of the century is cast as just

5. At its best, the game could at least be played with a sense of irony. For instance, in 1971, John Baldessari made a half-hour video of himself writing the words "I will not make any more boring art" over and over again. More typical is Joseph Beuys's 1965 performance *How to Explain Pictures to a Dead Hare*, in which he walked around a locked gallery with a dead hare on his arm and whispered into its ear while standing in front of assorted artworks. "The idea of explaining to an animal conveys a sense of the secrecy of the world and of existence that appeals to the imagination," he later informed his acolytes with stultifying seriousness. "Even a dead animal preserves more powers of intuition than some human beings with their stubborn rationality."

another bronze statue: not a rupture with the past but a bona fide piece of art history.

Publicly withdrawing from art to play chess in the 1920s, Duchamp may have been tacitly acknowledging the readymade stalemate. Or his retirement—which was hardly permanent—can be read as a new gambit. To rejuvenate art, people had to stop behaving like artists.

IV.

The Bank of England didn't believe that J. S. G. Boggs was behaving like an artist when they learned that he was making money. On October 31, 1986, three inspectors from Scotland Yard raided an exhibition of his currency at the Young Unknowns Gallery in London and placed him under arrest. Though his banknotes were drawn by hand, bearing his own signature as chief cashier, the British government pressed charges under Section 18 of the Forgery and Counterfeiting Act, threatening to end his career with a forty-year prison sentence.

Eventually, Boggs was acquitted. His lawyers persuaded the jury that even "a moron in a hurry" would never mistake his drawings for pounds sterling. In truth, the threat posed by his art had nothing to do with counterfeiting. If the Bank of England had reason to be anxious, it was because people *knowingly* accepted Boggs's bills in lieu of banknotes.

Boggs's project began with a simple exchange. At a Chicago diner one day, he ordered a doughnut and coffee. On his napkin, he distractedly wrote the number one, gradually embellishing it until he found himself looking at an abstract $1 bill. The waitress noticed, too, and liked it so much she wanted to buy it. Instead of

selling it, he offered it in exchange for his 90¢ snack. She accepted, and as he got up to leave, she gave him a dime in change.

That became the model for every transaction that followed. Wherever Boggs was, he drew the local currency by hand, and whenever he wanted to buy something, he offered his drawing at face value. In this way, he paid for food and clothing and transportation. However, he would not retail drawings to collectors. If collectors wanted to buy, he'd sell them the change and receipt from a transaction, leaving them to locate his drawing and negotiate with the merchant who'd accepted it instead of cash. In that way, he created an alternate economy based on an equivalence between money and art: the inherent uselessness of both that makes the value of each arbitrary.

This correspondence could easily have been tendered as a critique of the art market, and it had been in the past. For instance, in the early 1970s, the conceptual artist Ed Kienholz stenciled ever-increasing sums of money on sheets of paper, each of which he sold successively for the indicated amount, starting at $1 and eventually reaching $10,000. What makes Boggs so compelling is that he reversed the equation. He doesn't tell us that art is absurd but breaks out of the museum-gallery complex, leveraging the absurdity of art to question the sanity of finance.

Ditching the museum-gallery complex has boundless advantages, most conspicuously exploited by street artists such as Banksy.[6] The bane of law-and-order fanatics, their misbehavior blasts through barriers of money and power, even when those partitions cannot literally be breached: On a concrete wall built by Israeli security to blockade Palestinian territory, Banksy has

6. Not that street artists ditch the establishment completely. All too many (including Banksy) ape their own graffiti in innocuous paintings and prints retailed by galleries on the basis of street cred.

illicitly stenciled pictures of small girls frisking armed soldiers and of masked insurgents hurling bouquets of flowers. Violating military regulations to spread messages of peace in a universal visual language, Banksy animates painting as both image and action.

Art behaves in unexpected ways when accepted practices are abandoned. When Shepard Fairey was a student at the Rhode Island School of Design in the late 1980s, a friend asked him how to make a stencil. To demonstrate, he tore a promotional photo of professional wrestler Andre the Giant from a newspaper, sliced away background and shadows with an X-Acto, and teasingly added the line "Andre the Giant Has a Posse," before using the stencil to make stickers that he pasted up around town. Within days, Fairey overheard people speculating about the message. Was the posse a skate-punk group? A political movement? A cult? The irreducible ambiguity left all options open. A vast diversity of people gravitated toward the image, identified with it, and started making their own stencils and posters of Andre.

Over the next couple of decades, image and message were simplified into a blunt black-and-white icon of a brutal face with the words OBEY GIANT emblazoned beneath. Those modifications, wrought by consensus without any organization, have rendered the project more ominous with time, enlarging and entrenching the giant's sphere of influence. Whenever Los Angeles or Berlin or Tokyo is hit, spectators and participants alike are impelled to assign meaning to a campaign without any purpose except self-sustenance.

The power of street art, like forgery, is that it cannot be avoided. Spraypaint puts self-expression in the hands of the disenfranchised, who overwrite their neighborhoods with their own text and images. Wheat paste tweaks company billboards into anticorporate agitprop. (An Apple ad is defaced to make the "Think

Different" tagline next to a photo of the Dalai Lama read "Think Disillusioned.") All of this activity provokes pertinent questions: Who owns a city's visual space, the corporations who can buy it or the public who lives in it? How can the space be disrupted to make us less complacent?

The operational strategy of street art, where social structures are challenged on their own turf, is often referred to as culture jamming.[7] And as our culture has increasingly moved online, jamming has increasingly followed suit.

One of the first such hacks was perpetrated on December 10, 1998, when the net artists Franco and Eva Mattes launched www.vaticano.org, a near-perfect double of the official Vatican Web site. The fake online Vatican thrived because few people knew that the Vatican had its own top-level domain—www.vatican.va—and search engines amplified people's mistake.[8] As a result, untold thousands browsed papal encyclicals that had been lightly modified to promote free sex and drug legalization. Hundreds took advantage of the special offer to have their sins absolved by e-mail.

Franco and Eva Mattes have distinguished their work from appropriation art by referring to it as *attribution art*, a term that aptly aligns them more closely with forgers such as Tom Keating than with straight artists such as Sherrie Levine. At least initially,

7. It may be tempting to see culture jamming as a sort of latter-day Situationism. Like the Situationists in mid-century France, contemporary street artists eschew institutionalized spectacle to confront people directly, and much of their work is politically motivated. However, the Situationist International was a movement—built on theoretical precepts and organized with party discipline—whereas graffiti is a sort of folk art, and street artists are anarchic. Situationism was a political tactic. Culture jamming is an emergent phenomenon. For that reason, culture jamming is far more resilient and far more suited to artistic practice.

8. The more traffic that search engines directed to the site, the more credible the site appeared to search engine algorithms, which directed more traffic to the site, ad infinitum.

such work depends on anonymity. On first viewing, *Vaticano.org* was essentially utopian, subversively foisting a new-and-improved vision of Catholicism on believers, so that the true encyclicals would seem untenably old-fashioned. Then the fraud was revealed, challenging authority from the opposite direction by eroding the credibility of all papal dogma, including proclamations on the official Web site. (Might vatican.va *also* be a spoof?) *Vaticano.org* is a hack on faith.

This double action of fantasy and disillusionment has been used often in net art and has proven resilient. For instance, in 2011 the new media artists Julian Oliver and Danja Vasiliev invented a gadget that allows them to hijack the Wi-Fi signal in a library or Internet cafe and to remotely edit the content of news sites such as nytimes.com so that anyone in the room browsing the *New York Times* on a wireless device sees modified headlines. Since the hack is strictly local, the news sites are never aware of the override. And since the appliance is open-source—with blueprints freely provided online—there's a chance the news has been hacked at any hotspot worldwide.

Oliver and Vasiliev dubbed their work *Newstweek* and on the project Web site describe it as "a tactical device for altering reality on a per-network basis." Like the modifications to the Vatican Web site, their alterations often take the form of wishful thinking. (In one case, they had Wikileaks founder Julian Assange being nominated U.S. Secretary of Defense.) But the differences between *Newstweek* and the Mattes's attribution art are as significant as the similarities. Here the content is decidedly secondary to the concept. The undercurrent of anxiety derives from the fact that the hack is not isolated—unlike *Vaticano.org*—and responsibility cannot be traced to any single source.

Newstweek is the reductio ad absurdum version of citizen journalism, in which everyone is an autonomous news organization.

It's an uncontrolled experiment in the democratization of information, in which anyone can potentially be a participant, voluntarily or not.

Precisely where the art resides, and who are the artists, are questions without definitive answers in the case of *Newstweek*, especially since the open-source plans allow anyone to modify everything, from the headlines to the capabilities of the device. In that respect, *Newstweek* is the online analogue of *Obey Giant*. All that can be said of such projects is that they disrupt the status quo for no purpose other than to question it. To appropriate a term from Immanuel Kant, they are animated by *Zweckmäßigkeit ohne Zweck*—purposeful purposelessness.

V.

Zweckmäßigkeit ohne Zweck is a perfect description of art. Purposeful purposelessness is appealingly broad, encompassing activities that aren't conventionally artistic, such as the chess matches favored by Marcel Duchamp. Yet *Zweckmäßigkeit ohne Zweck* is also informatively narrow. Art forgery is not purposeless.[9]

That is why forgers cannot ultimately replace artists, even if their work has been superior to what artists have done in the past. Art must take up the forger's means without the forger's goals, to

9. Much of the most radical contemporary art fails for the same reason. In 2009, for instance, the artists' collective Futurefarmers was commissioned by the San Francisco Museum of Modern Art to teach families to plant crops in the wasted spaces around their homes. There was genuine value in helping people plant their land with potatoes, fava beans, and bok choy, but labeling the practice *art* in no way changed the meaning or effect. The fact that anything can be categorized as art does not make everything artistically interesting.

work on the far side of legitimacy without the limitation of making a point or a buck.

The far side of legitimacy is not necessarily illicit. To act on our anxieties, art must break mores. In some cases, those mores may be enforced by law, yet the full range of human behavior is beyond the imagination of legislators and judges, whose work is essentially reactive. Artists can experiment with possibilities outside our current reality.

Given the unlimited potential of experimentation, it comes as no surprise that the strongest provocations in the 21st century take the form of pure research, more often associated with the sciences. Artists such as Oron Catts and Ionat Zurr of the collective SymbioticA work in a fully equipped laboratory, where they have grown frog steaks in petri dishes using standard tissue-culturing techniques. Their *Disembodied Cuisine* paralleled research by NASA—where scientists were investigating protein sources for long-term space flight—but broke rank with staid scientific protocol in 2003, when Catts cooked and served his lab-grown steak at a dinner party. The frog from which the muscle cells had been cultured was still alive and present to witness the feast. The distinction between life and death has never seemed more tenuous.

And yet more incendiary permutations on *Disembodied Cuisine*—such as disembodied cannibalism—might roil society at any time. Like the coding behind *Newsweek*, SymbioticA's methods are all open-source and actively spread through workshops led by Catts and Zurr.

A salient feature of experimentation, this free license to replay and remix is central to the scientific method. Yet in professional scientific circles, the potential to profit from spin-off technologies encourages secrecy and intellectual property protection. The open exchange of ideas has been rebranded as piracy. To the extent that enlightenment principles are the

ideals of science, artists such as Catts and Zurr act more scientifically than scientists.

One especially guarded realm of scientific research is genetics, which can inspire lucrative pharmaceuticals, food crops, and even flowers. In 1992, the Australian company Florigene patented a sequence of petunia DNA that could be implanted in carnations and roses to make them blue. These genetically modified organisms (GMOs) were greenhouse-cloned and sold to florists precut, ensuring that the Florigene holding company Suntory was the only source of the vastly popular flowers for nearly two decades. Then in 2009, the artists Shiho Fukuhara and Georg Tremmel tested the premises of this scientific monopoly. They reverse-engineered the plants and released blue carnation seed into the wild.

As Fukuhara noted on the artists' Web site, they were giving the plants a "chance of sexual reproduction" denied to them by Suntory. Living this wild new life, the flowers infringed on Suntory's intellectual property by making countless unauthorized copies of their patented DNA. The pirated flowers became pirates in their own right just by attempting to live a natural life. Nonmodified carnations were potentially also implicated by cross-pollination. The intellectual property protection of life was put to the test by the disobedience of flowers.

When Fukuhara and Tremmel exhibited their reverse-engineered carnations at the Ars Electronica Festival in Linz, Austria, local officials required that the plants be locked behind bulletproof glass, under constant surveillance by security guards. The precaution had nothing to do with patent law and everything to do with anxiety about GMOs that might mix with the native flora of Linz. The boundary between natural and artificial is permeable; that's why the protection of guards and bulletproof glass was deemed necessary by the Linz government. But the permeability inclines less literal minds to explore the inevitably hybrid future

wrought by all biotechnology. Releasing blue carnations is an experimental exploration of that future. If it is uncontrolled and irresponsible, that is because the subject under examination is messy and perilous.

Zweckmäßigkeit ohne Zweck is the ultimate artistic license. Mixing disciplines and refusing to be disciplined, purposeful purposelessness calls everything into question. Full exercise of that license was not an option for Lothar Malskat and Alceo Dossena, Han van Meegeren and Eric Hebborn, Elmyr de Hory and Tom Keating, whose grand provocations were mired in motivations of vengeance and profiteering. Unfettered questioning was also beyond the capacity of Elaine Sturtevant and Andy Warhol, even Marcel Duchamp, all of whom ultimately were creatures of gallery and museum. If it has ever been achieved, it was accomplished out of pure curiosity by the man who first made the Mona Lisa, Leonardo da Vinci.

Leonardo's curiosity was deeply subversive. His human dissections were deemed acts of desecration and condemned before Pope Leo X. His astronomical observations would also have caused trouble, had they been more fully developed. Though he never claimed that Earth orbited the sun, he deduced that the world would appear from the moon as the moon did from Earth: The impression of motion was relative to where the viewer stood. More generally, Leonardo rejected authority, ancient and contemporary. He called himself a disciple of experience, but he was equally an apostle of investigation.

If art is good for anything, it's a means of opening the mind. The time has come to dump the Mona Lisa and dismiss Leonardo the talented painter. Fearless artists must resurrect and reinvent Leonardo the renegade scientist.

FURTHER READING

Arnau, Frank. *The Art of the Faker: 3,000 Years of Deception*. Boston: Little, Brown, 1961.

Belting, Hans. *Likeness and Presence: A History of the Image before the Era of Art*. Chicago: University of Chicago Press, 1994.

Belting, Hans. *The Unknown Masterpiece*. Chicago: University of Chicago Press, 2001.

Bockris, Victor. *Warhol: The Biography*. Cambridge, MA: Da Capo, 2003.

Cabanne, Pierre. *Dialogues with Marcel Duchamp*. New York: Viking, 1971.

Dolnick, Edward. *The Forger's Spell: A True Story of Vermeer, Nazis, and the Greatest Art Hoax of the Twentieth Century*. New York: HarperCollins, 2008.

Dutton, Denis (Ed.). *The Forger's Art: Forgery and the Philosophy of Art*. Berkeley: University of California Press, 1983.

Evans, David (Ed.). *Appropriation*. Cambridge, MA: MIT Press, 2009.

Fay, Stephen, Lewis Chester, and Magnus Linklater. *Hoax: The Inside Story of the Howard Hughes–Clifford Irving Affair*. New York: Viking, 1972.

Friedlander, Max J. *Genuine and Counterfeit: Experiences of a Connoisseur*. New York: Albert & Charles Boni, 1930.

Goodrich, David. *Art Fakes in America: The Lively Business of Making, Buying, and Selling Fraudulent Art from Colonial Times to the Present*. New York: Viking, 1973.

Grafton, Anthony. *Forgers and Critics: Creativity and Duplicity in Western Scholarship*. Princeton, NJ: Princeton University Press, 1990.

Grass, Gunter. *The Rat*. San Diego, CA: Harcourt Brace Jovanovich, 1987.

Haywood, Ian. *Faking It: Art and the Politics of Forgery*. New York: St. Martin's Press, 1987.

Hebborn, Eric. *The Art Forger's Handbook*. New York: Overlook, 1997.

Hebborn, Eric. *Confessions of a Master Forger: The Updated Autobiography*. London: Cassell, 1997.

Hoving, Thomas. *False Impressions: The Hunt for Big-Time Art Fakes*. New York: Simon & Schuster, 1996.

Irving, Clifford. *Fake: The Story of Elmyr de Hory, the Greatest Art Forger of Our Time*. New York: McGraw-Hill, 1969.

Irving, Clifford. *The Hoax*. New York: Permanent Press, 1981.

Irving, Clifford. *Howard Hughes: My Story*. London: John Blake, 2008.

Jackman, Ian (Ed.). *Con Men: Fascinating Profiles of Swindlers and Rogues from the Files of the Most Successful Broadcast in Television History*. New York: Simon & Schuster, 2003.

Jeppson, Lawrence. *The Fabulous Frauds: Fascinating Tales of Great Art Forgeries*. New York: Weybright and Talley, 1970.

Jones, Mark (Ed.). *Fake? The Art of Deception*. Berkeley: University of California Press, 1990.

Keating, Tom, Geraldine Norman, and Frank Norman. *The Fake's Progress: Tom Keating's Story*. London: Hutchinson, 1977.

Kilbracken, Lord. *Van Meegeren: Master Forger*. New York: Charles Scribner's Sons, 1967.

Kurz, Otto. *Fakes: Archeological Materials, Paintings, Prints, Glass, Metal Work, Ceramics, Furniture, Tapestries*. New Haven, CT: Yale University Press, 1948.

Lenain, Thierry, *Art Forgery: The History of a Modern Obsession*. London: Reaktion, 2011.

Lopez, Jonathan. *The Man Who Made Vermeers: Unvarnishing the Legend of Master Forger Han van Meegeren*. Orlando, FL: Harcourt, 2008.

Magnusson, Magnus. *Fakes, Forgers & Phoneys: Famous Scams and Scamps*. Edinburgh, Scotland: Mainstream, 2006.

McShine, Kynaston. *The Museum as Muse: Artists Reflect*. New York: Museum of Modern Art, 1999.

Mills, John FitzMaurice, and John M. Mansfield. *The Genuine Article: The Making and Unmaking of Fakes and Forgeries*. London: British Broadcasting Corporation, 1979.

Radnóti, Sándor. *The Fake: Forgery and Its Place in Art*. Lanham, MD: Rowman & Littlefield, 1999.

Sassoon, Donald. *Becoming Mona Lisa: The Making of a Global Icon*. Orlando, FL: Harcourt, 2001.

Savage, George. *Forgeries, Fakes, and Reproductions: A Handbook for the Art Dealer and Collector*. New York: Frederick A. Praeger, 1963.

Schüller, Sepp. *Forgers, Dealers, Experts: Strange Chapters in the History of Art*. New York: G. P. Putnam's Sons, 1960.

Schwartz, Hillel. *The Culture of the Copy: Striking Likenesses, Unreasonable Facsimiles*. New York: Zone, 1996.

Sox, David. *Unmasking the Forger: The Dossena Deception*. London: Unwin Hyman, 1987.

Tietze, Hans. *Genuine and False: Copies, Imitations, Forgeries*. London: Max Parrish, 1948.

Tomkins, Calvin. *Duchamp: A Biography*. New York: Henry Holt, 1996.

Vasari, Giorgio. *The Lives of the Artists*. New York: Oxford University Press, 1998.

Waldron, Ann. *True or False? Amazing Art Forgeries*. Winter Park, FL: Hastings House, 1983.

Warhol, Andy. *The Philosophy of Andy Warhol*. San Diego, CA: Harcourt Brace Jovanovich, 1975.

Warhol, Andy, and Pat Hackett. *POPism: The Warhol '60s*. San Diego, CA: Harcourt Brace, 1980.

Weschler, Lawrence. *Boggs: A Comedy of Values*. Chicago: University of Chicago Press, 1999.

Wright, Christopher. *The Art of the Forger*. New York: Dodd, Mead, 1985.

Wynne, Frank. *I Was Vermeer: The Rise and Fall of the Twentieth Century's Greatest Forger*. London: Bloomsbury, 2006.

ACKNOWLEDGMENTS

I am grateful to John Dorfman and Sarah Fensom for publishing my writings on art forgery in *Art & Antiques*, and to Elise Capron at the Sandra Dijkstra Literary Agency and Brian Hurley at Oxford University Press for helping to bring *Forged* from conception to press.

INDEX

032c, 166

Abgar, 11
Abstract Expressionism, 23
Academy of Motion Picture Arts and
 Sciences, 128
Aczel, George, 97–98, 107
Adenauer, Konrad, 32, 42, 43, 48n10
Adulteress, The, 90
aesthetics, 20–25
 Egyptian, 6–7
 modernist, 70
 Nazi, 84–85
Aesthetics, 95
AfterSherrieLevine.com, 166
After Walker Evans (Levine), 164–166
alcohol test, 71, 73
alienation, 21–23
Allegory of Faith, The (Vermeer), 77–79
America, discovery of, 36
Andrea del Sarto, 1–3, 24
Andress, Ursula, 109
Andre the Giant, 169
Anne (junk dealer), 143
Annigoni, Pietro, 137
Annunciation (Simone Martini), 55, 65
Anschluss, 86

antiart, 162–163
antiques, 6, 13, 16, 94, 106n9
 antiquarian connoisseurs, 98
 antique dealers, 54, 153n13
 fakes, 18, 20–21, 62, 64
 materials used in forgeries, 68, 102,
 103n7, 121, 149
 as sources, 61
anxiety, 3–4, 21–25, 160, 171, 174
Apollonios, 7n6
Apollo of Veii, 52
Apple (company), 169
appraisals, 123
appropriation art, 159–166
Arbeid (van Meegeren), 89
archives, 5, 128
Arensberg, Walter, 161
Arnau, Frank, 3
Arnott & Calver, 148, 153
Ars Electronica Festival, 174
arson, 96
art
 appreciation of, 4, 152
 dealers, 97–98, 121–122, 139, 148
 historical context, 100–102
 meaning of, 16, 165
 messages in, 163, 169